OTHER THAN THE NORM

VOLUME XI
Summer 2016

PUBLISHER Visual Adjectives
EDITOR-IN-CHIEF Paula Andrews Powles
MANAGING EDITOR Michael Jack
ASSISTANT MANAGING EDITOR Zahara's Tangled Web

ART
Feature Editor: Zahara's Tangled Web
Isolde de Mortimer
Noel Rivera
Yasaman Vrd'dhi

ENTERTAINMENT
Feature Editor: Michael Jack
Alexis Marshall
Fairlyinnocent
Hyde Falkenstine

FASHION
Feature Editor: Kathleen Sharkey
Amy Townsend
Emily Bielby

FILM & LITERATURE
Feature Editor: XXX Zombieboy XXX
Axel Karenta
James Donnelly
Jesse Orr
Lisa Fremont

LIFE & STYLE
Feature Editor: Jezibell Anat
Joseph Zuchowski

MUSIC
Feature Editor: Asylum Attendant
Chirality
Dawn Wood
Sergio Manghina
Sonnett57
Trixxi Divine

TECHNOLOGY
Feature Editor: Zannie Campbell
Nikki Lyka

CONTRIBUTORS
Annabella Rios
Ethicus
Omen

Subscribe

Never miss an issue.
Have Carpe Nocturne Magazine delivered directly
to your front door or office four times a year.
subscribe@carpenocturne.net

Carpe Nocturne Magazine is available in
Digital and Print editions!
Available in print at Amazon.com, BarnesandNoble.com
and other retailers.

Carpe Nocturne Magazine Volume XI · Summer 2016
is a publication of Visual Adjectives, LLC
and published four times a year.
All reviews and coverage expressed in this publication
are the opinions of the writer and/or those being interviewed
and may not be shared by Visual Adjectives.
Copyright © 2016 by Visual Adjectives, LLC.
All rights reserved.
14280 Military Trail, #7501, Delray Beach, FL 33482, USA.
No work may be copied or reproduced without
the express permission of the editor or publisher.

Correspondences should be addressed to:

CARPE NOCTURNE MAGAZINE
14280 Military Trail, #7501
Delray Beach, FL 33482 USA

E-mail: editor@carpenocturnemagazine.com
www.carpenocturnemagazine.com
p: 561-809-3834 | f: 904-701-6272

SUMMER 2016
Contents

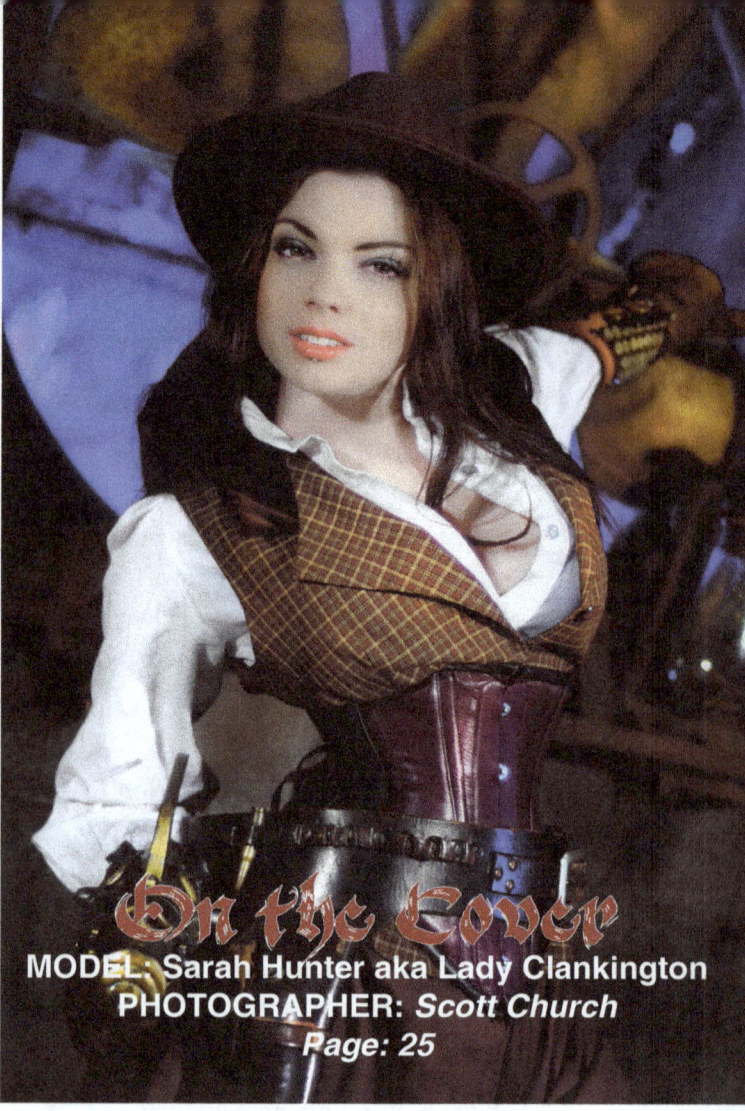

On the Cover
MODEL: Sarah Hunter aka Lady Clankington
PHOTOGRAPHER: Scott Church
- Page: 25

COLUMNS
- 6 | THE ALCHEMISTS' CLOSET — *Wound Care*
- 11 | ROADKILL — *A XXX Zombieboy XXX Comic*
- 24 | SANCTUARY OF THE STRANGE — *Desexualization of Crossdressing*
- 43 | XXX ZOMBIEBOY'S XXX TOP 13 — *Werewolf Films*
- 23 | BLOODY MARVELOUS — *Kava*
- 66 | SHUFFLING THE STARS — *Zodiac Tarot Predictions*
- 80 | DARK CORNERS — *From the Darkest Corners of Our Imaginations, Soar the Most Beautiful Creations*
- 82 | FICTIONAL ANECDOTES — *The Life Mechanism*
- 87 | LOST FAVORITES — *Harfra*
- 92 | CHAINED SHADOWS — *A Gathering of Things in Noir Style*
- 93 | DEARLY DEPARTED — *Prince*
- 106 | SOUNDS OF THE LIVING DEAD — *Album Reviews*
- 110 | GOTHIC BREWER'S GUIDE — *Because Black is a Thirsty Color*
- 112 | HOW NOT TO GET EATEN — *Zombiebite*
- 113 | THE VOICE OF THE NEW DARK CULTURE — *I Am Mental*

ART
- 4 | ETHEREAL GARDENS — *Art for Victorian Gardens*

ENTERTAINMENT
- 8 | AGAMACON — *Grassroots Geekdom in the Southeast*
- 12 | DAN SPERRY — *Shock Illusionist*
- 16 | WICKED
- 20 | JENEVIEVE VAN-VEDA — *The Creativity of a Dark Romantic*
- 25 | LADY CLANKINGTON — *Putting an O in Steampunk*
- 29 | SUB-GENRES OF STEAMPUNK
- 30 | STONEBURNER — *The Mouse Tour Hits Atlanta*

FASHION
- 32 | TOP HAT TUTORIAL
- 34 | CORSETS
- 36 | HEAD'N HOME — *Handmade Hats*
- 38 | GIZMOS AND GADGETS
- 40 | GLOWEES AND LULU DEUX MILLINERY
- 41 | ROMANTIC THREADS — *Custom Made Fairy Tales*
- 45 | VISCERAL ATTRACTIONS — *Photography*

FILM & LITERATURE
- 68 | CAPTAIN AMERICA: CIVIL WAR — *6 Things the Fans Wanted*
- 71 | GOTHAM BY GASLIGHT — *A Look Back with the Writer*
- 77 | LINNEA QUIGLEY — *Embracing Her Inner Scream Queen*
- 79 | TORN CURTAIN — *Cat People*

LIFE & STYLE
84 | FREYA, GODDESS OF THE NORTH
88 | BELLY DANCE CONTRADICTION
Belly Rolling with the Punches
90 | THE VERY STEAMY POWDER ROOM

MUSIC
94 | VALENTINE WOLFE
95 | BOURGEOIS & MAURICE
96 | HEATHEN APOSTLES
99 | HELALYN FLOWERS
102 | KERLI
Building an Army of Love
105 | AMAZING TRACKS
108 | SOUNDS OF SEATTLE
Tragedy of Addiction

TECHNOLOGY
114 | GUILD LEADERS
119 | A WRITER AND TECHNOLOGY

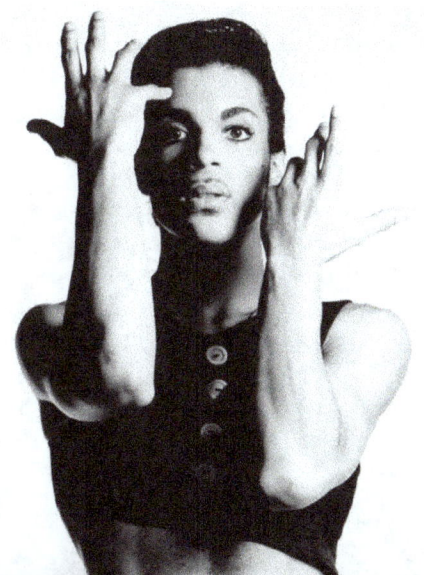

ART
Ethereal Gardens

Ethereal Gardens

The image is classic Victorian romance: an elegant lady with her parasol open, strolling through a lush garden, admiring visual delights and inhaling the intoxicating fragrance of climbing roses and hanging clematis. Elaborate gardens are as old as time itself, but the gardens of the Victorian era were truly a sight to behold. They were textured and signified a life of prestige and pampering. These gardens contained beautiful sculptures and details that transformed the entire landscape into an organic, living piece of art.

Today's fast-paced lifestyles make it challenging to really enjoy pursuits such as gardening for hours every day. However, there are ways to add a touch of Victorian class (or even Steampunk whimsy) to modern landscapes by including pieces of yard art that are interesting and unique, as well as functional. It's helpful to think of all the structures in the garden as pieces of art, which will help guide you to pieces that reflect your personality.

Many Victorian homes made use of large spheres, which were actually popular in European gardens many centuries earlier. These spheres were known as witchballs or gazing balls, and they were used around gardens and entry ways to ward off evil spirits. These were sometimes placed on pedestals or in fountains and were made of blown glass, sometimes with a cracked metallic coating. These reflective orbs are still available today through many festival artisans, as well as online, and they continue to provide beautiful reflections when added to a garden space, no matter the size. While the original spheres are beautiful on their own, consider purchasing an oversized one that has been painted with a beautiful design or group a cluster of various different colored orbs to create some visual interest.

Fountains and sculptures were frequently used as focal points in gardens. Guests would wander under the watchful gaze of cherubs and angels, and these pieces can still bring a sense of serenity and peace to an outdoor area. But by using metal art in a garden, you can infuse the space with a more Steampunk vibe, versus the romantic feel of classic plaster sculptures. Metal birdbaths and fountains also create a more modern look, as well as entice wildlife to visit your yard's water space. Some beautiful examples of more classic plaster sculptures can be found online as www.designtoscano.com and metal art can be found from www.windandweather.com.

Just because an item serves a purpose, such as a metal weather vane or iron sundial, doesn't mean the item should be boring. There are some interesting pieces on www.yardenvy.com, and festival metalworks artists often have the ability to create a custom piece, if you don't mind waiting for something special. Again, it's about bringing your own artistic vision to your home's exterior. Metal pieces are durable and can even be included in more urban spaces (like patios with planter boxes) by choosing smaller versions of hanging iron lanterns

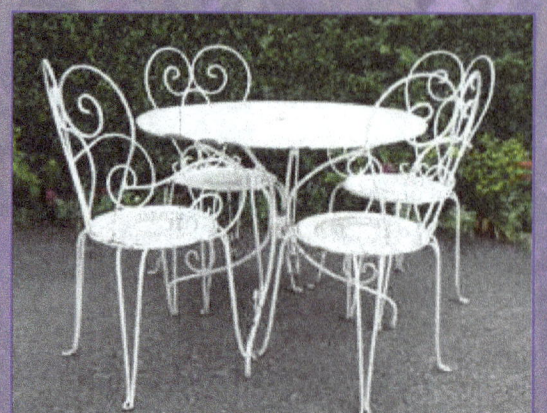

ART
Ethereal Gardens

Art for Victorian Gardens

By Zahara's Tangled Web

or bird feeders.

If you're looking for ways to incorporate seating into your garden, consider adding a small wrought iron table and chair set or bench. These can be sealed to withstand various climates and painted a variety of colors, and they provide a serene area for morning reflection or evening star gazing. To create height in your garden, consider adding a metal or wooden trellis or archway. These are perfect for climbing flowers, such as delicate clematis and roses or fragrant hydrangea and honeysuckle. An archway can designate the entry to a garden or serve as a focal point, especially when positioned opposite the seating area. Be sure that the seating area is not surrounded by flowers that attract bees, or you may not feel as comfortable sitting there!

If you have a larger space and want to keep an earthier feel in your garden, a wooden pergola could be included as a shady refuge for hot summer days. Unlike a roofed structure such as a gazebo, pergolas were popular during Victorian times as a means of getting flora to climb overhead, with benches frequently located beneath them. To update this idea, consider covering the top of the pergola beams with lightweight fabric (such as muslin), tiny lights or climbing vines and flowers. This will provide shade, but not necessarily shelter from rainstorms.

For yards that are flat and large, you may consider adding a walking path or small labyrinth. Many Victorian gardens had elaborate path designs and some had massive labyrinths made of hedges. A similar feel can be gained without going to much trouble or expense. Simply choose inexpensive, flat stones or pavers and dig enough space to nestle them in your yard. The path doesn't have to be overly winding, but just enough to guide through certain areas, perhaps ending at the seating area or bird bath.

Almost any structure used outdoors can be considered a work of art. Birdhouses, hummingbird feeders, planters, sheds and tables can all be repurposed and decorated as interesting treasures. Simply take care to make sure the items can withstand the elements, and you'll have an interesting outdoor area for years to come.

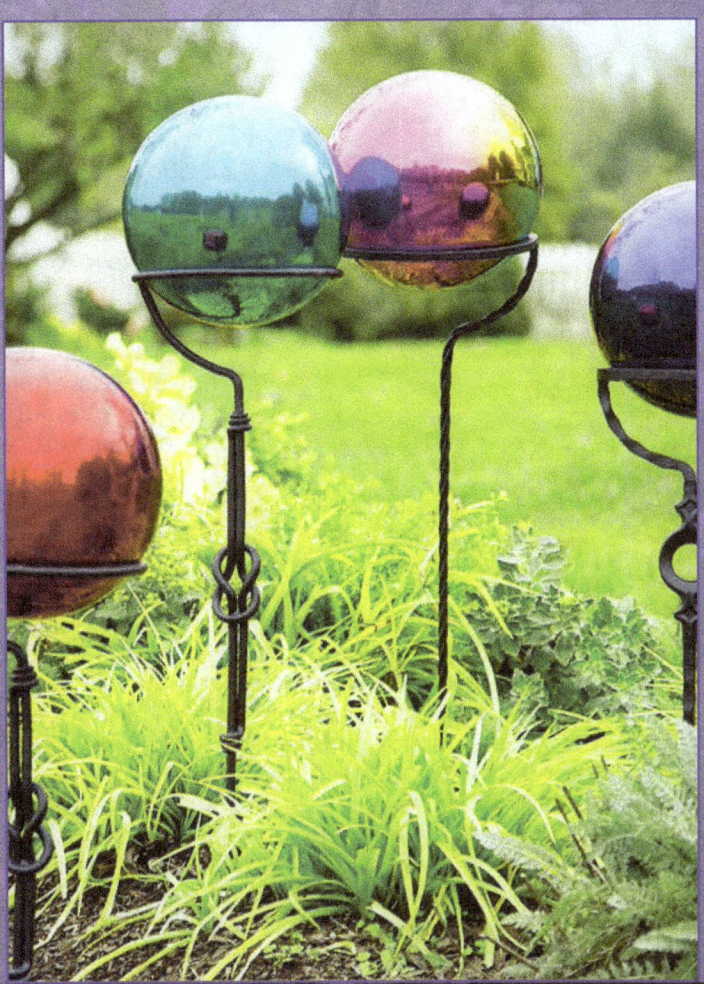

THE ALCHEMISTS' CLOSET
Wound Care

Wound Care

By Michael Jack and XXX Zombieboy XXX

So you got a cut? It's really not the end of the world, or at least it shouldn't be. An untreated wound can lead to many long-term problems, including loss of limbs or even death. Now that is severe, I know, and with today's medicine, there is no reason for it to come to that. People weren't so lucky a hundred years ago. Just simply taking proper care of a cut, and knowing what products to use, is enough to make the entire situation a minor inconvenience. In this issue of The Alchemists' Closet, I will take you through the simple steps of avoiding any long-term complications of having a wound.

The first thing you want to do with any cut is to stop the bleeding. I hope this is already common sense to everyone. The length of time it takes to stop the bleeding widely varies depending on the site of the injury, the size, and the depth of the wound. If the injury is on an arm or a leg, holding it above the heart will help, because it decreases blood flow to the appendage. The first thing you really want to do, however, is apply direct pressure to the cut with a clean rag, gauze, etc. This alone should do the trick. Adding something cold (like an ice pack) will quicken the process, and aid in taking down any swelling, but is usually not needed. If neither pressure nor cold is stopping the flow of blood from your cut, there is a more effective option. Over the counter, there is now available a whole variety of blood clotting powders. These products use the same technology as field medics and emergency room doctors have been using for years. They are safe, effective, and should be essential in every first aid kit, especially if you spend significant time away from civilization. Just to name a few, there are Bloodcease, Bloodclot, and Quickclot, and they are available in any drug store.

So now you stopped the bleeding. Hurrah! Next you want to clean the wound. Warm water and antibacterial soap should suffice for now. You want to make sure all dirt and debris are removed from the wound. If you are afraid the wound is too large or too deep, don't take a chance, and go see your doctor. If you are certain the wound isn't worth paying your office visit copay, and can handle it on your own, then proceed to the next step...further cleaning. Soap only does so much, and really with any cut, the main concern is preventing infection. You can use alcohol on the wound for further cleansing, but it'll burn like hell. I always recommend hydrogen peroxide. This bubbling genius of a product doesn't hurt, or only mildly stings, and will do the trick of ridding your wound of any nasty bacteria still left inside after washing. Once you applied the peroxide, and given it a minute or so to work, it's time to concentrate on the maintained care of the wound.

I cannot stress enough that biggest concern with any cut is preventing infection. That is why you should always keep a good antibiotic ointment handy. I do say ointment, because it sticks to the wound better, and therefore, works better. There are a lot of choices, but I always go straight for Neosporin, or any generic triple antibiotic ointment. Why? Well, Neosporin combines Bacitracin with Polysporin (the other two popular antibacterial ointments), and therefore gives a wider range of protection against more bacteria. More is better in this case. You want to apply a generous layer of the ointment, and cover it with a bandage or gauze. The barrier will help protect the wound from any more dirt getting into it, and the wet ointment will help to prevent scarring by keeping the skin hydrated. You should change your bandages twice a day, clean with peroxide, and apply another generous portion of antibiotic ointment before bandaging the wound up again. You can eliminate using the peroxide after a day or two, and just stick with soap and ointment.

As you continue the maintenance of your wound, there are several things to look for. Number one, if the cut starts to emit a foul smell, go to see a doctor. It's infected, and you will need antibiotics. If the wound exudes pus, go to see a doctor. It's infected, and you will need antibiotics. If the cut simply oozes a sticky clearish-brown substance, it is nothing to be worried about. This is called weeping, and it's normal. Just keep an eye on the wound to make sure it doesn't get worse. If the cut is slightly inflamed, it's nothing to be concerned about either. Again, just keep watch it doesn't get worse. If the cut is painful, becomes hot to the touch, or you begin spiking a fever, guess what? The wound is probably infected. Go see your doctor because you will probably need antibiotics.

Although this all might sound very complicated, it really is not. Just remember the basic steps…stop the bleeding, wash the wound, use peroxide, apply an antibiotic ointment, and cover the cut with a bandage. Watch the wound for any drastic changes, and don't hesitate to see your doctor if you notice any. Ninety-nine percent of the time you won't if you followed these steps.

Now, Mike having said all of that so eloquently, lets say you find yourself in a mountain cabin far away from it all (best case) or the dead have risen, the Old Ones have awoken and a bunch of skinny kids are running around yelling "Witness me! Shiny and chrome!" (worst case). In other words, the fit has hit the shan and your local CVS is not so accessible. Let us explore some alternatives for wound care.

A lot of the same principles apply, as do the approaches to wound care in the field. You have to stop the bleeding, you have to clean the wound, and you have to keep it clean. However, you have no clot powders, no Neosporin, and no doctor to copay. In the field a wound can turn septic quickly so you must act quickly. First, stop the bleeding. I always carry a spare bandanna or a shemagh in the field with me if nothing else. Apply pressure and again raise above the heart if possible. Next, cut clothing away from the wound. Clean the skin around the wound as best you can. Then clean the wound with lots of water, preferably under pressure (referred to as irrigation) or… wait for it… with urine. I am not kidding. Fresh urine will work if water is not available. A Ziploc bag full of sterile water can be punctured and used to create a pressurized water flow to irrigate deep wounds. Having cleaned and irrigated the wound, apply a wet and clean dressing to the injury and cover with a dry dressing and if possible, tape. This is called a "wet-to-dry" dressing. This helps to keep the injury hydrated and also helps to ease the pain.

Now we have all seen movies where you heat up your handy Bowie knife in the campfire and then after a manly helping of whiskey, you cauterize the wound. Don't do this. In the field it is best to "open treat" the wound. This means neither cauterizing it nor suturing it. You allow it to drain any puss that may occur due to infection.

Keep in mind; this section is about being in the field. Not anywhere near medical assistance. If the wound is infected and no help is available, open treatment and allowing the wound to leak is your best option. No matter how scary or smelly it appears, it usually will not become life threatening. Having said that, you do want to keep it covered when possible with clean dressings that you change each day, again with supplies allowing.

Keep an eye on the wound and its progression. If you happen to be in the desert and there are prickly pears, peel the skin from one and apply the raw flesh to the wound before covering. This fruit has antiseptic qualities to it. Pinesap is also a natural antiseptic, particularly the balsam fir tree. You can pop one of the bumps on this tree and the resin runs freely. Spreading honey on a wound dressing is another way to increase healing and it can even help once a wound is infected.

If you do have antibiotics on hand, then it won't hurt to begin taking them immediately, within 3-6 hours of being wounded. There are also a number of natural antibiotics out there in the world. These are to be used only when prescribed drugs are not available.

Garlic has been used for thousands of years as a natural antibiotic, amongst other things. It has numerous antiviral, antimicrobial, antibiotic and antifungal properties. Garlic rocks, period. The allicin in the garlic is highly effective in warding off harmful bacteria. Simply crush the garlic and eat it. Simple as that! Oregano is much the same. Eat both and in large quantities. You may not be kissing anyone for a while, but you've just upped your chances of ever kissing anyone again.

Garlic and oregano are not alone. Cabbage, honey (especially manuka), eucalyptus, turmeric, ginger, onion, cardamom, apple cider vinegar, Echinacea, cinnamon, grapefruit seed extract, horseradish, and coconut oil all have strong antibacterial properties. Get what you can and eat it!

Seriously though, the big badaboom apocalypse notwithstanding, cut the camping trip short and see a doctor if your buddy gets careless with an axe. The copay may cost an arm and a leg but it could save you both!

ENTERTAINMENT
Agamacon

GRASSROOTS GEEKDOM IN THE SOUTHEAST
AGAMACON

By Jeibell Anat

AgamaCon (short for Artists, Gamers, and Anime Members Association Convention) is a brand new convention held the first weekend of March in the unlikely location of Aiken, South Carolina. Aiken is an elegant town, famous for its historic district and equine activities, and is part of a larger region known as the Central Savannah River Area (CSRA). The CSRA encompasses parts of South Carolina and Georgia along the Savannah River, including the city of Augusta, Georgia, most famous for the Masters Golf Tournament.

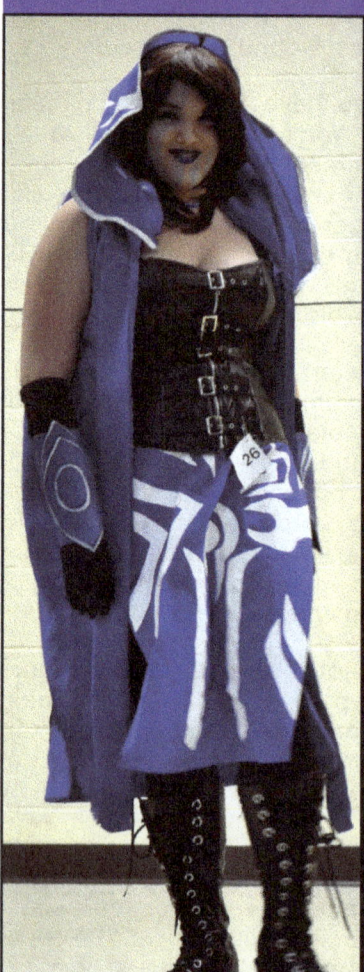

The CSRA is a few hours away from Atlanta, host of Dragon Con and many other comic book, anime, horror and literary conventions, and there are a few cons in Columbia, South Carolina as well. However, the CSRA is a much more conservative area, containing the Savannah River Site, a nuclear plant, and Fort Gordon, home of the United States Army Signal Corps. So how did something like Agamacon evolve here?

ENTERTAINMENT
Agamacon

"I have always loved going to conventions," says founder Nick Weaver. "My friend and I would take the weekend and make a trip out of town to go see what they were all about...it was nice to see that many excited, happy people just hanging out with others that had similar interests. So we had been asking the question of why there wasn't something like that here in the CSRA, and the answer was almost always 'because there isn't a market here for it' or 'Augusta could never support a convention.' So I just filed the thought away and waited until I felt there could be."

Social media has been a major force in bringing people together, and it fueled the momentum of Agamacon. "When I first posted about wanting to have one," says Nick, "there seemed to be an explosion of others just like me who thought the same thing. They wanted something like that here too, and seemed genuinely interested in making it happen."

"The group has always been about the community, what they wanted out of a convention, down to holding public votes for the name and public forums to pick 'directors' to help run things. It's become a living thing, not just a convention, but an ideal, a brand, and a family." The key to success in a smaller market is to include as many subcultures as possible. Agamacon reached out to gamers, artists, anime and cartoon lovers, writers, re-enactors, comic fans, model and trading card collectors, cosplayers, and horror aficionados.

The rest of the team behind Agamacon are April Paschal Weaver, Jason McCorkle, Candi Morgan McCorkle, and Shane Rice, who make up the board that plans the convention and smaller associated events. Sarah Johns is Volunteer Liaison and Drew Warren is Administrative Assistant. Everyone contributes to planning and participation in their own way. Sarah has assembled an effective volunteer army, a necessity for a new organization that is just getting off the ground.

Agamacon as an organization formed in January 2015, but, as Jason McCorkle elaborates, "we were trying to gather support before that. Our first event was Geek and Eat in September 2014, a vendor-based fundraising and support building event to help us give the community the multi-genre convention we have in mind. Much of our marketing was via a combination of grassroots outreach and social media. Word of mouth was by far our best friend building a base for our goals."

A lot of their promotion literally was on the street. Downtown Augusta has a monthly arts event called First Friday, and Agamacon members attended in cosplay, talking to the people they met, and leaving flyers at local businesses. Many participated in Augusta Zombie Walk. They also hosted several mini-events at the libraries, restaurants, and community spaces.

The Agamacon members were always outgoing and very nice, posing for pictures, and building alliances with other community groups. Many local people had been to other cons and were thrilled to have one in their area. Others had never been to anything like it and were delighted to find others with similar interests.

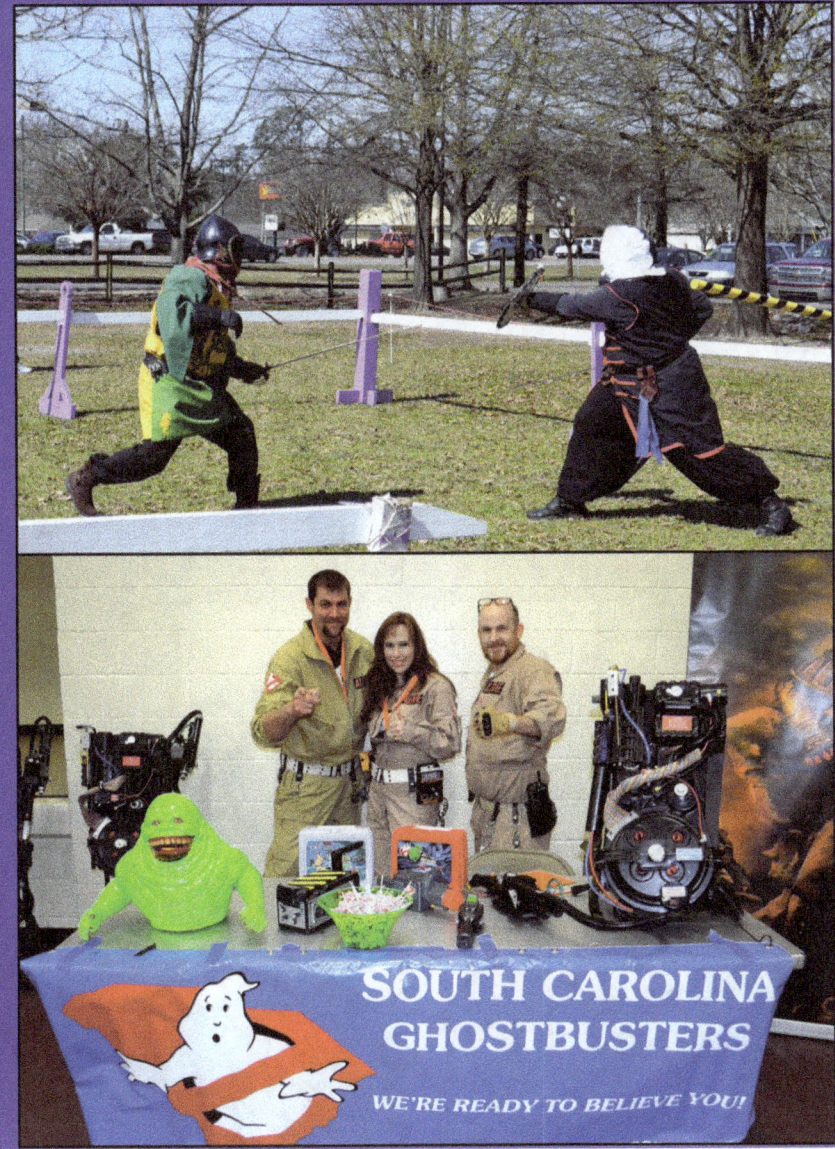

Outdoor combat at Agamacon with the Society for Creative Anachronism, photos by Candi McCorkle.

ENTERTAINMENT
Agamacon

The convention was held at the Odell Weeks Activity Center and brought in over 900 paying attendees. Agamacon focused on highlighting local talent, and many CSRA artists participated as vendors, panelists, and performers. Agamacon featured both indoor activities such as anime streaming, and panels on topics such as writing, acting, gaming, horror, and outdoor medieval combat. The con itself was family friendly, and Agamacon offered free admission of one child with an adult badge. However, there were adult-only activities in the evenings at the host hotel, including a belly dance performance and a rave.

Jason says, "The most successful note about the first was the overwhelming support from the community. We never anticipated the turnout we had. The highlights included industry guests, a cosplay contest, live action roleplaying, almost thirty discussion panels, and over forty vendors in two different halls."

Agamacon is the friendliest con I have attended, and it was well organized. Staff members were extremely courteous and helpful, and all cosplayers were treated with respect. Not all cosplayers have the resources to make elaborate costumes, and some do not conform to fashion standards. However, the focus here was on self-expression and creativity, and cosplayers of all sizes, ages, and genders were welcomed and encouraged.

The team is already at work for Agamacon 2017. They have reserved the venue, and have one guest lined up, author Dacre Stoker. Many previous vendors and guests have expressed interest in returning. Jason says, "We've been assessing our own performance since March, and we've learned a lot. We're pretty satisfied with our overall performance in 2016, and are eagerly looking forward to 2017."

For more about Agamacon, visit their website:
http://www.agamacon.com
or find them on Facebook:
https://www.facebook.com/agamacon/?fref=ts

ROADKILL
by XXX ZOMBIEBOY XXX

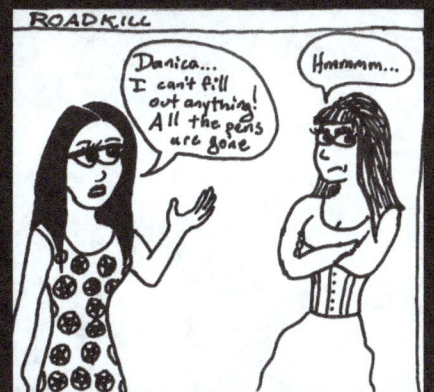

XXX ZOMBIEBOY'S XXX
TOP 13 NON-ZOMBIE POCKYCLYPSES

1) ALL OF THE MAD MAX FILMS PERIOD
2) THE QUIET EARTH
3) DAMNATION ALLEY
4) CHERRY 2000
5) CYBORG
6) HARDWARE
7) LOGAN'S RUN
8) OMEGA MAN
9) WARRIOR OF THE LOST WORLD
10) STEEL DAWN
11) WATERWORLD
12) UNTIL THE END OF THE WORLD
13) THE ENEMY WITHIN

"I just want to run away to Neverland with the audience and have an adventure".

By Emily Bielby

SHOCK ILLUSIONIST
Dan Sperry
The Anti-Conjuror

ENTERTAINMENT
Dan Sperry

Dan Sperry looks a lot like Marilyn Manson, but could also be compared to David Copperfield. He is a master eyeliner wearer, and an extremely disturbing but talented magician. We chat to him about his love of Disneyland, coffee obsession and his sometimes shocking performances.

"My style is just me," admits the anti-conjurer from Minnesota when asked about his unique style and inspiration. "I've drawn influences from lots of different sources – movies, urban legends, books, paintings, cartoons, aliens, ghosts, poems. Disney has always been a huge part of my life and just sort of taught me since I was young, that it's OK to play make-believe. So that's what I do. I wanted to be a pirate when I was a kid...I thought that was something I could do, grow up and become Captain Hook. Obviously that didn't work out too well," he laughs.

Dan has been compared to Marilyn Manson a number of times due to his choice of clothes and his looks, but believe it or not, Dan's not too deeply familiar with his music. "I don't own any of his music, and I've never been to a concert, but I respect him and appreciate him as an artist and creator. I'm more a fan of that than anything else. However, I do like some songs from his Portrait of an American Family album."

Growing up, Dan admits he watched David Copperfield from a young age. He too influenced him becoming a magician. "Copperfield is the king. He changed the game so much and still to this day does things in his shows that are so far out there, just so crazy. He was a big influence on me getting into magic."

Internationally recognized at just 17 years old, Dan made an impressive start to his career in magic. What is it about magic that inspires him to perform the shows he does? "I see magic as a really great and powerful form of artistic expression. Doing and creating the impossible allows me to not have to grow up, and in a similar way, it also allows the audience to not have to grow up as well. You can sort of metaphorically stop time and just live in that moment of when you're watching a show or a trick and forget about everything else in your life. I sometimes am living through the audience in a way where I'm seeing them react, and I want to feel like that too. I never have it be a contest of the audience VS me like as in I'm trying to trick them and make them feel tricked or dumb or anything like that, and then they get tricked and have to try to catch me and stuff. I just want to run away to Neverland with the audience and have an adventure."

For those who have witnessed one of his performances, you'll know that they're sometimes of a disturbing and shocking nature. This is all too familiar territory for Dan, who has been a lifelong fan of the macabre. "I always gravitated to the villains in movies, books, or plays because the bad guy always seemed to in some way, be the hero. I got really into horror movies and books – even comics too. My dad originally got me into old Universal Studios monster movies. I loved The Mummy and Frankenstein and had action figure statues that were Halloween decorations, but I'd keep them out all year long. I love Halloween as in the holiday, but also the movies to a degree too. I'd just wear Halloween costumes to school when I was young – even though it wasn't Halloween."

A lot of people may well remember Dan from his legendary performance on America's Got Talent, where he made a lifesaver appear out of the back of his throat, shocking the judges so much they jumped out of their seats to run to the back of the stands. I asked Dan what inspired this particular trick. "Lifesaver is still one I sort of have to do – people everywhere associate that one with me. It's kind of like my moon walk," jokes Dan. "I really get inspiration from everywhere. With lifesaver, I had heard the song Magic Moments, and I knew it could be creepy to use it in some way in my show, but I didn't know where at the time. I also remember the scene in Reservoir Dogs where Michael Madson cuts off the cop's ear while dancing around to Stealers Wheel, and I thought that was amazing and funny, yet disturbing at the same time. I was like 12 when I saw it, and knew I wanted to make that emotion somehow with magic. The song Mr. Sandman being used in the original Halloween movie is sort of the same thing too, getting back to the Yin/Yang aspect".

Although his performances are of a macabre nature, Dan adds in some humour so it's not all dark. He explains why this is important. "Primarily, it's just me and my personality. I'm not a comedian nor a comedy writer or anything like that... it is just what happens situationally when I'm presenting in my shows. I think people like to laugh as much as they like to be scared, so as tension is built with the darker themes and elements, I like to release it with some sort of humour to reassure the audience I'm not some sort of sadist getting off on them being uncomfortable," he laughs.

ENTERTAINMENT
Dan Sperry

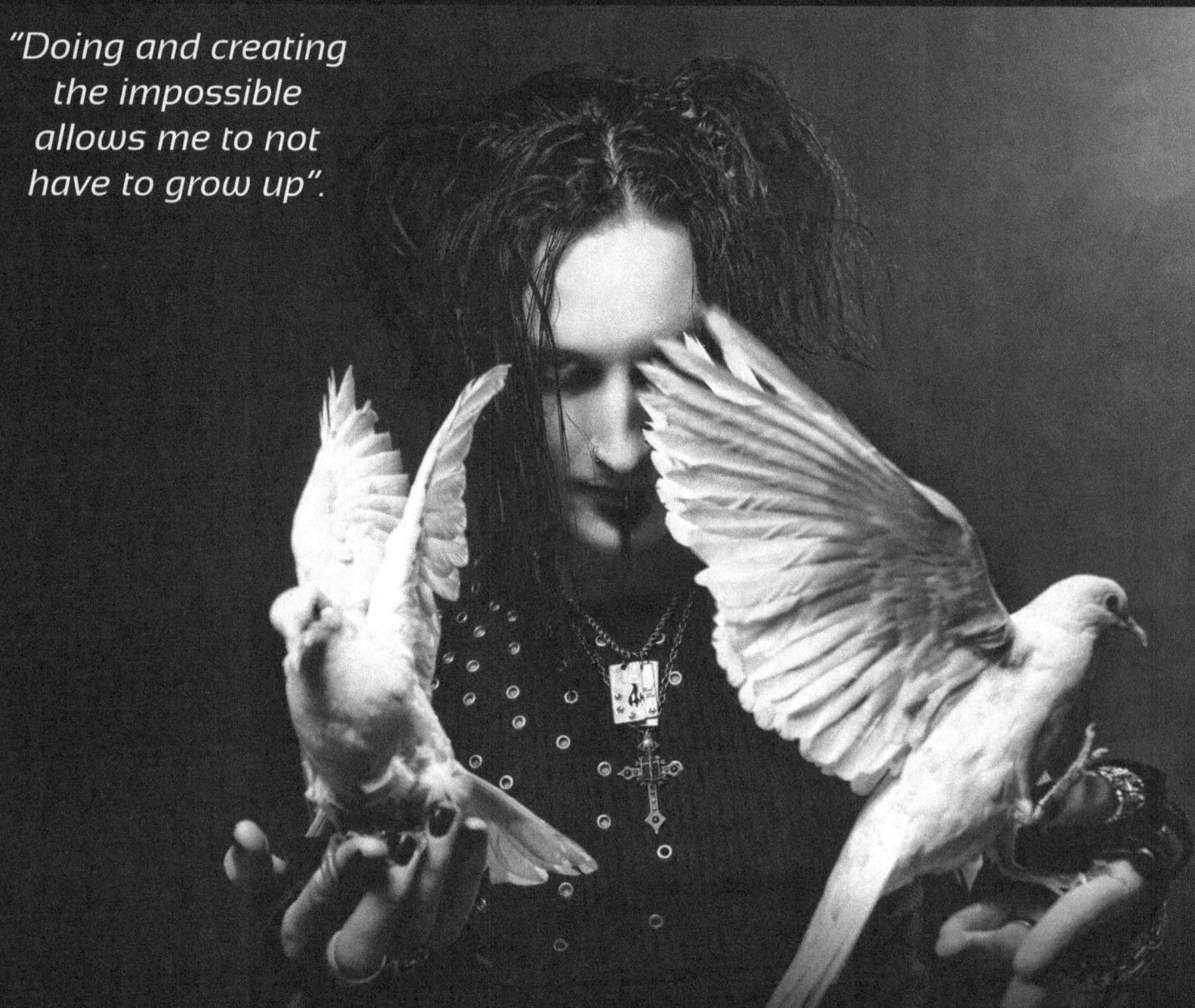

"Doing and creating the impossible allows me to not have to grow up".

A lot of Dan's tricks involve props, and I was curious to find out if he ever faces any problems travelling to and from different countries with these. "All the time!" Admits Dan. "I always find those "TSA" inspection papers in my luggage and cases, and I can tell they went through every nook and cranny of my props because they're so odd and strange. The animals can be a bigger hassle. Sadly, not a lot of the workers that work in their positions in particular cargo or traveling type shipping companies etc. really get to have much experience with animals or the type of particular equipment and things that I require to get my show on the road and travel with. If I'm not driving it, or having it put on a truck, I can have one of my guys drive. So, it can become frustrating because I have to be fully read up on all the rules and make sure I'm following them. However, because the workers don't often run into the types of things I travel with, they have no idea what to do. Then, when I try to nicely sort of explain to them what needs to be done, sometimes you run into people who get their egos bruised or butt hurt because really who ever likes somebody else trying to tell them what they need to do for their job if it's not a superior. Thankfully, nothing terrible has ever happened, but I have on a few rare occasions had to tweet at the business.

Aside from travelling to perform his famously intriguing magic shows with doves and other props to accompany him, Dan is a huge coffee fan. He tells me more about Zombie Java, a coffee company he set up. "Ever since I was young, I've been into coffee...the smell...the taste...

ENTERTAINMENT

just the whole experience of drinking coffee. I'm a total addict, so when we were on tour in South America, I was hitting up every coffee place I could find. It was there I started thinking about setting up a side business, and coffee was just a natural fit. I started researching and reading everything I could about importing coffee, roasting, flavouring, and the whole deal. On a whim, I went on Twitter and just posted something like: "Hey, what if I started a coffee brand/company called Zombie Java..." and the response was HUGE. It was amazing. and that's when I knew I had to do this. I was living in New York City at the time and doing my Off Broadway show there, and I got hooked up with the oldest coffee importing company in America. They're in Brooklyn. They import the beans for me, and we pick out how to flavour them. Then I package up the orders and ship them out. I've had people order coffee all the way in Singapore, Ireland, Hungary and everywhere. It is really overwhelming the immediate response I got when I finally released the Zombie Java product line full on. I'm definitely a big coffee junkie, wait, that's maybe the wrong word haha "aficionado", is better." When Dan is not performing or drinking coffee, he spends a lot of his spare time watching Netflix, particularly documentaries, enjoys playing his bass guitar and also makes sure to visit one of his favourite places; Disneyland. "Any time I'm off tour, I go to Disneyland or Disneyworld – I can't help it is like my calling. I've often gone even when working gigs in LA, like I'll go the morning before the gig and just sit and enjoy being there. I don't even have to ride the rides. I just soak it all in."

Having already explained that Disney was an inspiration for him, I had guessed that Dan was quite a big fan. He talks me through his 'Lost Boy' knuckle tattoos. "It's a reference to Peter Pan, but also a reference to just the idea about never growing up...that whole lost boys and Peter Pan experience in Neverland. My life motto is pretty much to never grow up. Other favourite Disney movies of mine are Tangled, Pinocchio, and probably Sword in the Stone – but really any of them are amazing. 20,000 Leagues Under the Sea is great...Treasure Island...I could list so many!"

Dan has a few dates coming up, so be sure to catch one of his disturbingly shocking performances. If you're in the UK, you'll be pleased to learn that he hopes to return very soon. "I always come so very close to making it to the UK every year, but things always fall through and I have to take a different contract sadly. Hopefully one day sooner than later I'll make it back; I haven't toured the UK in about 2 or 3 years now...plus I have family over there, so it is a perfect reason to go visit my Sister and family etc."

COMMISSION ARTWORK FOR YOUR PROJECT OR NOVEL!

PRODUCTION SERVICES
Comic Book • Graphic Novels • Illustrated Novels

CONCEPT SERVICE
Writer • Sketches • Storyboard
ILLUSTRATION SERVICE
Illustrator • Colorist
FULL SERVICE
Writer • Sketches • Storyboard • Illustrator
Colorist • Letterer • Cover • Editor
INDIVIDUAL SERVICE
Writer • Sketches • Storyboard • Penciler • Inker
Illustrator • Colorist • Letterer • Cover • Editor

by Michael Jack

WICKED
THE UNTOLD STORY OF THE WITCHES OF OZ

ENTERTAINMENT
Wicked

What happens when you discover everything you have ever wanted goes against the very core of your beliefs?

Wicked is the tale of Elphaba, the famed Wicked Witch of the West. Based on the novel of the same name by Gregory Maguire, this Broadway blockbuster follows the path of Elphaba from young student to the most hated and feared person in all of Oz. It flips the entire classic tale on its head, showing how Elphaba was the one fighting for justice and good, and the Wizard was the one who was wicked. Warning, after experiencing this story, you will never look at the Wizard of Oz the same way again.

The show opens with all of Oz celebrating the death of the Wicked Witch with the aptly titled song, "No One Mourns the Wicked." The rejoicing is being sung by the inhabitants of Oz, while a less exuberant Glinda, the Good Witch, sings an entirely different tune. She asks the poignant question, "Are people born wicked, or do they have wickedness thrust upon them?" This sets the tone of the musical. To begin the second song, a muchnkin calls out, "Glinda, is it true you were her friend?" In response, Glinda descends in her bubble, and begins to tell a story very different from the one everyone knows. It's the story of the Wicked Witch of the West.

The real story begins in college, where an unlikely pair are forced together as roommates. There is Glinda, bubbly and outrageously popular, and the strange outcast with green skin, Elphaba. The two are instantly at odds. Although everyone loves Glinda, it is Elphaba's powers that attract the eye of the Wizard. In fact, she is exactly the kind of person he has been searching for. When Glinda helps Nessarose, Elphaba's sister, with a munchkin she likes, the future Wicked Witch returns the favor by getting Glinda accepted into Wizard school, which she was initially rejected for. This sets up the very popular song..."Popular." In it, Glinda decides to help the bookish Elphaba to become liked among her peers and with the boys. When the green skinned star of the show insists she doesn't have to do that, the very comedic Good Witch replies, "I know. That's what makes me so nice."

As the story evolves, you come to learn not everything is as pleasant as it seems in Oz. There are great injustices being done to the animals, and nobody seems to care. You are introduced to a very cowardly lion cub as an example (and you will learn many origin stories in this show). When everything points to the wizard, Elphaba must make a decision. He offers her everything she has ever wanted in life...fame, status, and most of all...acceptance. She will become his right hand. Elphaba will not compromise her morals, and she decides to openly rebel against the evil wizard and his misdeeds. Somebody has to put an end to his madness. The wizard retaliates by labeling her "Wicked," and orders his troops to arrest her. The musical's biggest show stopping song, "Defying Gravity," begins. As the army closes in on Elphaba, she casts her most powerful spell to date. She rises high above the stage on an enchanted broom and sings out the ominous phrase, "And nobody, in all of Oz, no wizard that there is or was, is ever going to bring me down!" The curtains close on Act I, and the crowds jump out of their seats to cheer on the Wicked Witch of the West.

If you are fan of the Wizard of Oz, and even if you are not, you are going to love this show. It has everything. There is a tangled love story that tears a rift between the two best friends. There is a decision of going with the masses and rising to the top, or fighting for what you believe, and being labeled an enemy. There is drama when each friend chooses a different side. There is plenty of comedy sprinkled throughout, and the entire soundtrack is a big production of Broadway Pop and enchanting ballads that dip into the end of dark and foreboding. Like many classic tales, there is happy, yet somber ending. Glinda and Elphaba meet one last time. They reconcile their differences in the biggest tear-jerking song of the show, "For Good." Elphaba passes the torch to Glinda. There is a silhouette of Dorothy with a pail of water. Glinda gives the wizard an ultimatum...leave Oz forever, or be revealed for what he truly is. We all know how the Wizard of Oz ends.

Wicked the musical stands as one of the most successful shows in Broadway history, and internationally. It is already the 11th longest run show in the lifetime of Broadway, the 3rd highest grossing show of all time, and there are no signs of it slowing down any time soon. There is now a movie based on the musical in pre-production.

ENTERTAINMENT
Wicked

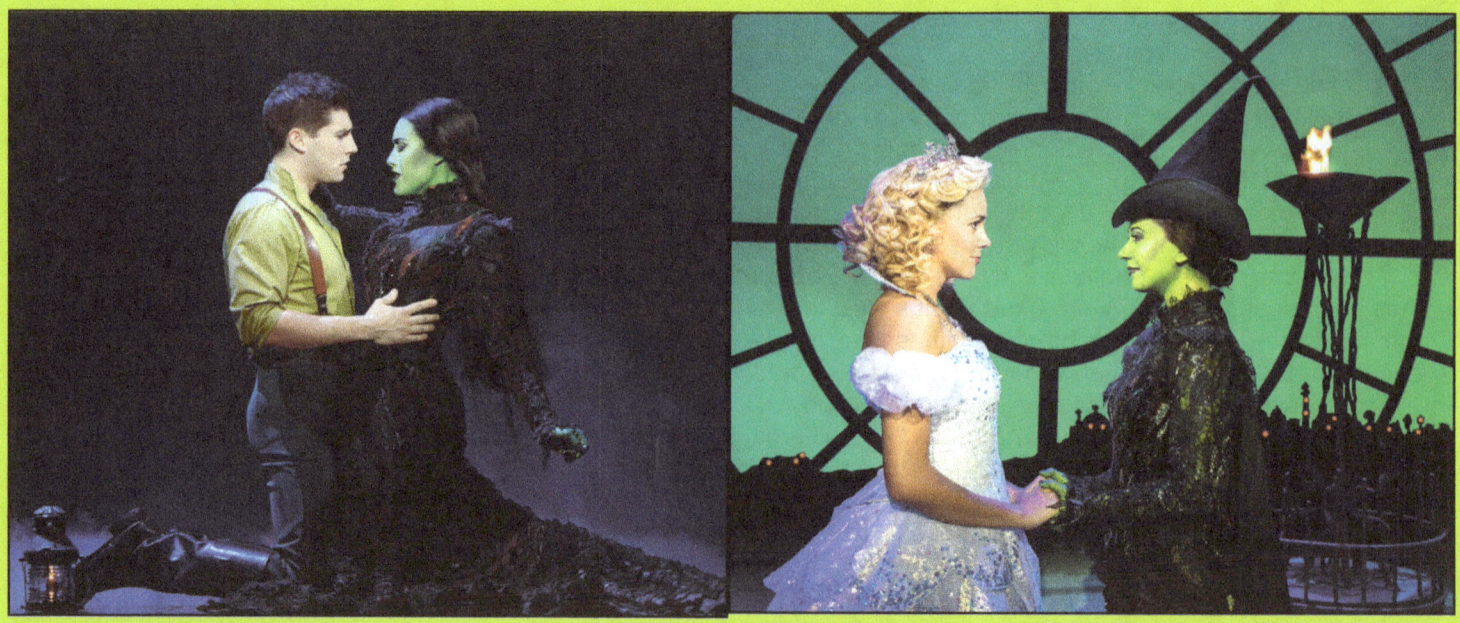

Although the cast has yet to be named, we can only hope the original Elphaba and Glinda (Idina Menzel and Kristin Chenoweth) will be the ones selected. Both were nominated for best actress for their respective role in this show, but it was Idina who brought home the Tony. The show itself stands as an American classic. I have seen it twice on Broadway, and the traveling production once in Philadelphia. It has been a truly amazing experience each time, and worth every penny I paid for the tickets. If you ever have a chance, I strongly recommend seeing it. You will leave the theater different than you came in, and you will never view the Wicked Witch in the same light again. Maybe, she wasn't so wicked after all.

You are going to love this show.

ENTERTAINMENT
Wicked

ENTERTAINMENT
Jenevieve Van-Veda

Alt model, Seamstress, Dancer and Musician Jenevieve Van-Veda leads a very creative and undoubtedly lively life. She chats to us about her love of Gothic Literature, Victorian fashion and The Damned's Dave Vanian.

"I'm a diminutive Dark Romantic, Classical liberal, whisky drinkin', book loving hermit who models," admits Jenevieve when asked about her persona. "I'm tiny and strange, so the land of alt modelling is definitely where I fit. Conventional modelling is (generally) about dimensions and compliance with the designer, whereas in alternative modelling (generally) you are the designer and the only thing to comply with is your own judgement. Sweeping generalizations aside, I would describe my aesthetic (a sadly depreciated branch of Philosophy) as Dark Romantic throughout all of my shoots…and life. The way I look is just an exterior glimpse of my worldview which is based in Romantic literature, art, and philosophy." Discussing Jenevieve's style, it's no surprise to learn that one of her biggest aesthetic influences growing up was The Damned frontman Dave Vanian. "I saw him and thought 'this is how life ought to look.' Dave Vanian stood magisterially Gothic in a sea of ripped up disbeautied Punk in '76, and he has remained thorough since. That integrity he had and kept is what still appeals to me."

Having been a fan of the darker lifestyle from a very young age, Jenevieve admits she had to be pushed in to alternative modelling because of her lack of confidence. "I wanted to be a model when I was a young girl, but turned to fashion design instead when I realised I was never going to meet the proportions of a model. When I was in my mid 20's I had a friend, a keen photographer, who persuaded me to be a 'muse.' I was reluctant and terribly aware of my imposter syndrome. Out of sheer curiosity I entered one image from my first ever shoot in to a competition and won. This is why I think alternative modelling seems to be more about character and tosses to the side the useless numbers in proportions."

Looking at a lot of Jenevieve's photoshoots, they seem to focus more on Victorian Gothic and steampunk aspect of style, design and fashion. She explains why this is. "Victorian Gothic and Steampunk are linked in literature. The Castle of Otranto by Walpole was considered the first ever Gothic novel written in 1764. So 'Gothic' as an idiom has survived for over 250 years and thrived in literature throughout the Victorian period. Steampunk is a modern term coined in the late 70's by K.W Jeter, but the concept is much older and often said to stem from Victorian period literature. Steampunk is primarily Victorian sci-fi/fantasy that cites early influences such as Wells and Verne, but I would argue that the earliest Steampunk novel was written before the Victorian period. Mary Shelley's Frankenstein genre merges the Gothic novel with sci-fi/fantasy. My introduction to Steampunk was in 2002 thanks to various literature searches and the vast caverns of the internet. I have watched it evolve and grow rapidly over the past 14 years and split itself in to more defined branches such as Dieselpunk, Regencypunk and Steam Goth etc. It's an impressively expanding culture and long may it last," she enthuses.

Both Victorian and Steampunk fashion are on the rise with many models and photographers wanting to experiment with these styles for different shoots, but what is it about this particular era that Jenevieve admires so much? "I think the Victorian values of constant self-improvement led to high standards in their outward appearance. So I consider Victorian clothing to be the apex of fashion. I do however cherry pick from all ages and zeitgeists in order to make it my own. I'm not a re-enactor, I'm more of a collector." To look at a fashion shoot it's very appealing, but for every photoshoot comes a wardrobe fit to burst with extravagant outfits and keen on the clothing used in Ghost of The Manor, Neo Edwardian and Steam Glamour shoots. I was curious to find out if Jenevieve got to keep all clothing used. "Sometimes I keep the outfits to wear on a day to day basis (I'm like this 24/7), sometimes I sell them on to produce funds for further shoots. I work on a shoestring budget, so sometimes this process is necessary but evil," she clarifies.

Jenevieve's mind is a whirring bedlam of constant ideas. She tells me she would love to create more literature themed images, and definitely continue roaming down the more engaging path of conceptual images. In a lengthy

"I saw him and thought 'this is how life ought to look', Dave Vanian stood magisterially Gothic in a sea of ripped up disbeautied Punk in '76 and he has remained thorough since".

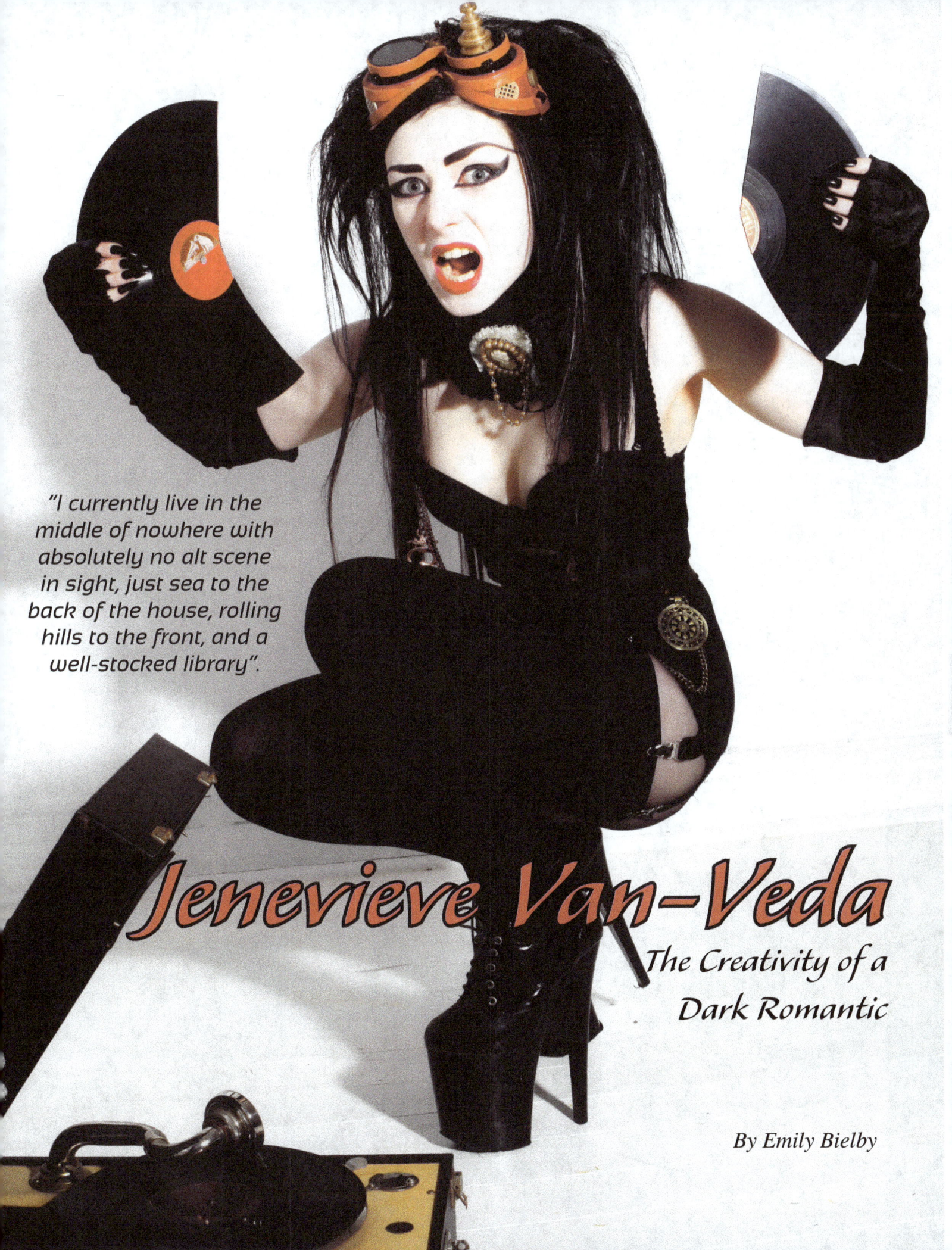

"I currently live in the middle of nowhere with absolutely no alt scene in sight, just sea to the back of the house, rolling hills to the front, and a well-stocked library".

Jenevieve Van-Veda
The Creativity of a Dark Romantic

By Emily Bielby

ENTERTAINMENT
Jenevieve Van-Veda

process, she explains what inspires the shoots and if she always goes in to a shoot knowing what she wants the final outcome to look like. "The preparation that I put in to every shoot means that I generally have complete control, so I have to have a clear vision of the final product. Some shoots are merely an aesthetic project, some are in veneration of popular icons (Bettie Page, Dave Davies, Theda Bara), in some I play a character (a doll, a secretary, a mental patient, a ghost, a murderess), some have storylines and complex concepts (The Panopticon, the murder in the red barn), in some I'm slowly stripping shot by shot, and some are just based on good old literature. One shoot was based on F. Scott Fitzgerald's 'The Beautiful and the Damned' for which I wrote the book onto an Art Deco styled cape I created. Whatever the inspiration, I always gather information like a magpie, researching the aesthetics of the era for example, but in the end I always add a little of the Dark Romantic to everything I do. It may seem like I'm a glutton for punishment as I research rather a lot and make almost everything you see in a shoot, but it gives me that inch of integrity and makes me feel less of a gothic coat hanger but rather an...I dare not say it... artist...of a kind."

> "I use fingernails against... anything breathing, wooden spoons, broken violins, cutlery drawers, shrill voices; it's crazy, locked up woman music".

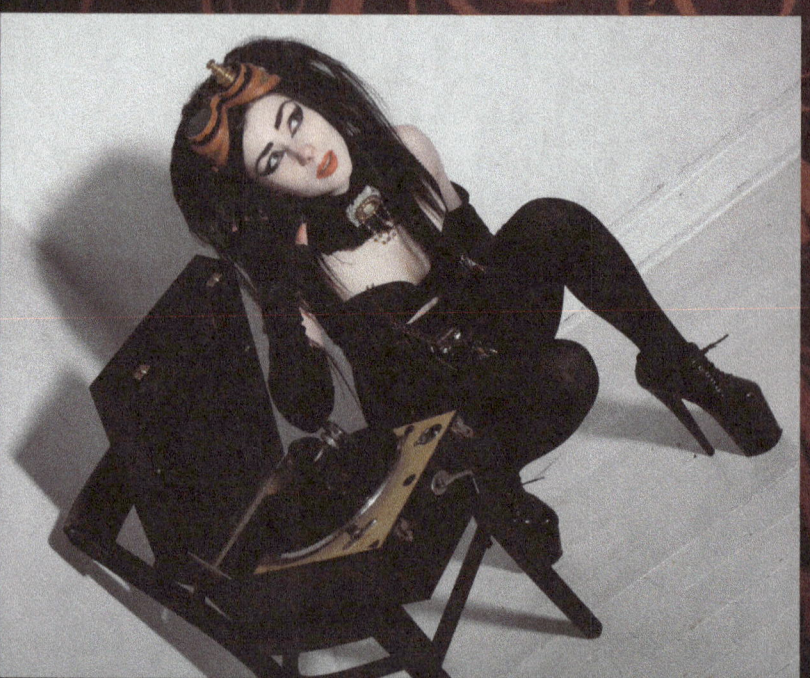

Originating from the highlands of Scotland, from a wee place called the Black Isle, Jenevieve says this is fairly remote and in some ways 60 years behind the rest of the world, was the alt scene in Glasgow just as non-existent!? "In Glasgow there were tiny, whispering pockets of something that may be termed an alt-scene," she clarifies. "I was never a part of any scene. I am actually quite the hermit and have enjoyed a great percentage of my life alone, generally with a book in hand. Which brings me to Aberystwyth, Wales where I currently live in the middle of nowhere with absolutely no alt scene in sight...just sea to the back of the house, rolling hills to the front, and a well-stocked library." Among the Scottish model's many creative talents is music making and Jenevieve describes her music as outsider music, or noise, admitting that she wouldn't expect anyone to like it. Intrigued, I asked her to tell me more. "The premise is to tell dark stories, create an atmosphere and the technique is unconventional in that everything is an instrument. I use fingernails against...anything breathing, wooden spoons, broken violins, cutlery drawers, shrill voices etc. It's crazy, locked up woman music," she laughs.

As well as juggling her modelling and music career, Jenevieve keeps herself busy dancing and sewing, stating that the first thing she sewed was a cushion in the shape of a black cat, when I was 6 or 7. "Sewing is more for shoots as I'm often pressed for time. I hope to be working away at my sewing machine this summer to create outfits for various shoots. I dance as more of a hobby and the dance style is something akin to belly dancing or perhaps a distant cousin of...or something I just made up. Imagine if you will whisking together dancehall and gothic belly dancing." For all the high her creative jobs and hobbies bring, they must make up a very hectic schedule. Jenevieve explains what keeps her going and motivates her. "The schedule is not hectic if you enjoy what you're doing, so the motivation is firstly, in the desire to create, and secondly, in the execution. Truthfully, much has been put on hold until I finish my university degree. I'm currently studying for BA Honours in Philosophy and Psychological Studies, and the workload is mountainous to say the least. I've even had to cast leisurely pleasurable reading to the side due to time constraints. Blasphemy! This summer I will be slowing down and taking some time out of study to do more shoots, make more music, more voodoo dolls, partake in various other projects, and get back to my temporarily neglected library." ■

BLOODY MARVELOUS
Kava

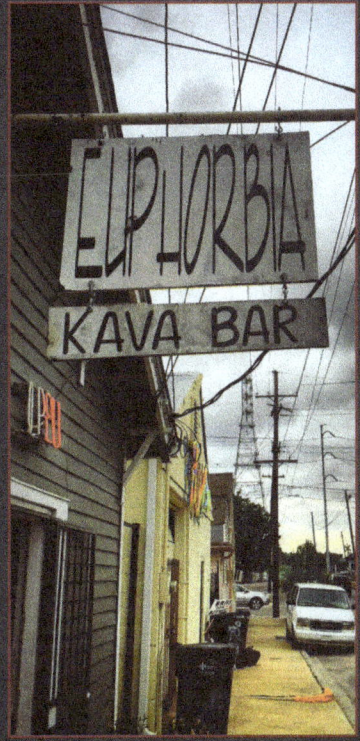

Once upon a long time ago (a year can feel that way sometimes) I was exploring Colfax Street in Denver with my lady Viola. We happened upon a wonderful little place called Kavasutra where the proprietors sold tea, Kratom drinks and Kava drinks of all kinds. There was, however, no alcohol, which I though was pretty strange for a place claiming to be a bar. At the time I had heard of kava, but it had been years since I had even approached it, and that was back when those selling it told you tales similar to snipe hunting as far as use. We gave it a shot, and discovered something that would help me survive my high stress job at the time.

Kava is wonderful for anxiety, and the bar was very relaxing with a great staff and clientele. Moving away from Denver, I was distressed to be putting Kavasutra behind me. That was until I discovered a little bar that opened off of Oak Street in New Orleans. Ashley, the owner, offered an even more relaxing "at home" environment to sit and enjoy kava drinks. Quiet, peaceful and neighborly with art and plants everywhere, Euphorbia became our new destination to cheer "BULLA!" For this Bloody Marvelous, I asked Ashley to tell us a little more about Kava drinks and about her business.

XXX Zombieboy XXX: To begin please tell us a little about Euphorbia and how it got started?
Ashley: Euphorbia is a kava bar offering natural alternative herbal intoxicants. A calm environment for patrons to unwind and socialize in a setting much like being in a friends living room, where everyone knows your name within seconds. It was started after the personal use to treat depression and anxiety suffered for years. It was an immediate change of my life as it opened my mind to positivity, leaving me with the desire to share this sacred root in hopes it may help others.

ZB: What exactly is Kava?
Ashley: Kava is the term used for both the plant and beverage prepared from the root of the pepper plant grown in the pacific islands. The active compounds are known as kavalactones, which contribute to its medicinal effects.

ZB: What are some of the benefits that a kava user can expect?
Ashley: One consuming kava will first have a tingling sensation in the mouth due to the anelgesic properties. Other effects will include relaxation with focus, decreased muscle tension, mild euphoria, increased sociability, and an overall feeling of well being.

ZB: Are there any negative effects to drinking Kava?
Ashley: There have been no negative side effects related to kava with the exception of dry skin with excessive use. The stems and leaves are toxic and have been linked to liver toxicity. The root is only part of the plant that should be consumed.

ZB: What kind of drinks and treats do you make with Kava?
Ashley: Euphorbia offers the traditional brew of powder and water as well as craft beverages such as Chai tea with cream and the Creamalada with coconut milk and kava. Also handmade raw vegan kava chocolates are available.

ZB: Are kava bars a growing business in the United States?
Ashley: Kava bars originated in South Florida around 12 years ago and are popping up around many parts of the US quite frequently. Euphorbia is the first and only kava bar in New Orleans with rumor of a soon competitor.

ZB: Other than Kava bars, where can Kava be purchased?
Ashley: Kava can be purchased online as well as in health food stores and herbal shops.

ZB: Would you share with us one recipe that our readers can try at home?
Ashley: One of my favorite recipes using kava is 8 ounces coconut milk, 1 banana, one half avocado, 1 TBSP kava, 1 TBSP cacao, and honey to taste. Blend well and enjoy the benefits.

Euphorbia Kava Bar
8726 Oak St,
New Orleans, LA 70118
https://www.facebook.com/euphorbiakavabar/

Bloody Marvelous

By XXX ZOMBIEBOY XXX

SANCTUARY OF THE STRANGE
The Desexualization of Crossdressing

The first time I saw a crossdresser I was sitting in the waiting room of my psychologist's office where I got counseling for my social anxiety and anger issues. I was thirteen, super shy, and had those judgy eyes. I was definitely freaked out by the person across from me with the blonde wig, high heels and the pleasant smile. This could have been a transgender woman, coming to therapy so she could get her gender reassignment surgery. Back then I had no idea about transgender people, so I assumed this was a male who enjoyed dressing as a woman. Sadly, I used to think that was wrong, and I'm sure this person noticed my RBF (Resting Bitch Face) and closed-off demeanor. I wish I would have chatted with this person and complimented her on her outfit. Little did I know a few years later I would become a crossdresser, too.

I started crossdressing before I was even cognizant of it. I can't remember, but apparently when I was around three or four years old, I loved my mom's red high heels. I would pretend they were Dorothy's red slippers and put them on all the time, clicking my oversized heels around the house. I think it's awesome that my parents let me have fun doing that. When I became a teenager, I hid my crossdressing because I knew it wasn't an acceptable behavior. I stole my mom's makeup and practiced in the mirror. She definitely noticed the eyeliner I was wearing on numerous occasions and wasn't happy about it. I also took my sister's hair clips and practiced walking in her high heels when I was home alone. I loved the way my feminine appearance elevated my mood. I longed to feel pretty like that all the time.

Eventually, I went all out with dramatic makeup, hair extensions and fishnets and starting taking pictures of the results. People online couldn't tell if I was a man or a woman and I thought that was cool. I received a lot of praise from people. Then, the creeps starting coming out. Men were hitting me up for sex and sending me nasty comments because they had a sexual fetish for crossdressers. I was and still am highly offended, and disgusted by being viewed as someone else's kink. Something so pure and positive to me was tainted by blatant objectification. This unwanted attention made me question ever posting crossdressing photos of myself again.

Society totally views male crossdressers as sexual deviants and freaks. They think that we all choose to look feminine in order to get sexual gratification. Do a Google search of crossdressers and all you come across are sexual photos. This stigma makes me so mad. I do not have a sexual fetish and I'm certainly not dressing up to fulfill someone else's sexual fantasy. The number of men who have asked me to dress like a woman for them is astounding. I crossdress for me and me alone. Sexualizing crossdressing has turned it into a joke/something to fear, and fuels the people who believe it's immoral. Society will never become more tolerant with reinforced negative biases about crossdressing.

Unfortunately, I don't possess the courage to crossdress out in public. I'm fairly certain that most of my family, friends and co-workers would accept me. My biggest fear is kickback from hostile strangers. I could be seriously harmed by an ignorant passerby and I also don't have the energy to deal with stares and the like. I feel like a coward because I'm not living my life authentically. I've thought about incorporating subtle feminine aspects into my daily appearance, such as minimal makeup and painted nails. The fear of what other people will think keeps holding me back from trying it out. Yet, leading a double life is so tiresome.

Crossdressing is a huge part of the sassy unicorn that I am and I don't think I would have survived without it. Donning striped stockings and hair bows raises my self-esteem and makes me feel great about myself. I exude confidence in a bold lipstick and platform boots. Why would I want to dull my personality and aura in plain men's clothing? That would be a travesty. I hope the crossdresser I met so long ago in that therapy office knows that they inspired at least one lost boy to show his true colors. My goal is to do the same for someone else, one painted nail at a time.

ENTERTAINMENT
Lady Clankington

Putting an O in Steampunk

by Michael Jack

ENTERTAINMENT
Lady Clankington

If you are a fan of Steampunk, you already know who Sarah Hunter is. If you are not, you probably have at least seen her face (or more) before. Sarah Hunter, AKA Lady Clankington, is an accomplished model, actress, and showgirl. She has appeared on many magazine covers, including Penthouse and Taboo. Her acting credits include many made for TV softcore films and she has appeared in several music videos, including "Happy Birthday, My Olde Friend," by Voltaire. As if Sarah's resume isn't impressive enough, she also works in the costume and prop shop for Brute Force Studios, and has contributed to and appeared in many books about Steampunk. So what does one do with a profound knowledge of fetishes, the adult industry, and Steampunk? Let me introduce you to Lady Clankington's Cabinet of Carnal Curiosities...the world's first line of Steampunk inspired sex toys.

The flagship design of Ms. Hunter's Carnal Curiosities is the Little Deathray. This retro-futuristic vibrating handgun is promised to deliver a wallop. As Sarah herself states, "No weak vibes here." This diabolical multi-speed pleasure device is handmade, just like all of Lady Clankington's products are. The Deathray is available in an assortment of daguerreotype colors, and there is one for every person of keen sensibility. All that is required are two C batteries, a desire for pleasure, maybe a good health insurance in case you get too carried away with the death ray, and an occasional replacement barrel for when you burn through the existing one. One note I must make is this...the trigger doesn't work. It's just for show. In Lady Clankington's words, "Would you want gunk getting inside the mechanism and gumming up the works? Ick!"

The next one of Sarah Hunter's "Infernal Devices" is the Red Zeppelin. If you are looking for something extraordinarily different, this is it! This bad boy has an insertable length of six inches, a circumference of six and a quarter inches, and weighs one and a half pounds. Oh my. Besides the unique design of the product, which looks like a big rubber zeppelin, it is unique in that it is constructed of Dragon Skin. Before you get too excited, know it is a trade name of a high performance silicon rubber. This high end material is guaranteed to satisfy internally, infernally, and most likely, eternally.

Next up on this delightful list of carnal pleasures, is Lady Clankington's Disciplinary Assurance Device. This paddle with brass rivets and sheeting is thirteen inches in length and three inches at its widest point.

ENTERTAINMENT
Lady Clankington

ENTERTAINMENT
Lady Clankington

The paddle also features a glorious cut out cog design near the top. A well swung smack can leave a purely satisfying cog mark on the submissive's bum. You can't ask for much more than that!

The last product in Sarah's cabinet is the Butt Rogers Uranium Pistol, and it is "coming soon." It is guaranteed to please, and showcases a very interestingly designed glass barrel, with multiple girths along the shaft. I don't have the specs yet, but I am willing to bet it sells fast.

Sarah Hunter has been a long time icon in the Steampunk Community. With her sense of fashion and passion for the risque', she has stood out among the masses. Sarah continues to stand out by embracing the Victorian Era's love of the erotic. Her line of sex toys are not only creative, but practical. All designs are waterproof, latex-free, and hypoallergenic. Together with the ever elusive mastermind Dr. Visbaun, Sarah hopes to send waves of a rather naughty nature throughout the steam world. All products are tested and approved by Sarah, just not the particular pieces that are sold. They are all brand new, and ready to please.

To order any of Lady Clankington's Carnal Curiosities, visit her website at:
http://www.littledeathray.com

Sub-Genres of Steampunk

ENTERTAINMENT
Sub-Genres of Steampunk

It goes without saying that Steampunk is already a sub-genre of something, that is, of speculative fiction. So, it's more accurate to say that Steampunk's sub-genres are not sub-genres of Steampunk at all, but rather derivatives of a genre called Cyberpunk.

Cyberpunk is the literary predecessor of Steampunk. The term was coined in the 1980's as a label for stories dealing with punk teenagers during the Information Age. Most of the time these stories took on a setting in the future, where computer technology has invaded every facet of humanity's daily life. The stories often have great emphasis on virtual worlds and cyberspace. Famous examples of Cyberpunk include films like Blade Runner and The Matrix. The derivatives of Cybperpunk emerged when writers began to explore other avenues of futurism and retro-futurism; creating worlds dependent on one technology. In Steampunk's case, it was steam. The other derivatives include:

Dieselpunk
A style which showcases the aesthetics that were popular during World War I and World War II. This can include pulp, film noir, art deco, and wartime pinups. If Steampunk relies mostly on steam technology, then it's safe to say that Dieselpunk might give emphasis to combustion. Famous examples of this genre include The Rocketeer and Avatar: Legend of Korra.

Atompunk
Projects the pre-digital age of 1945-1965, or more specifically, the sensibilities of the Cold War era. This includes Communism, the Space race, atomic technology, and nuclear apocalyptic scenarios. One famous example of this style includes the Fallout video game series.

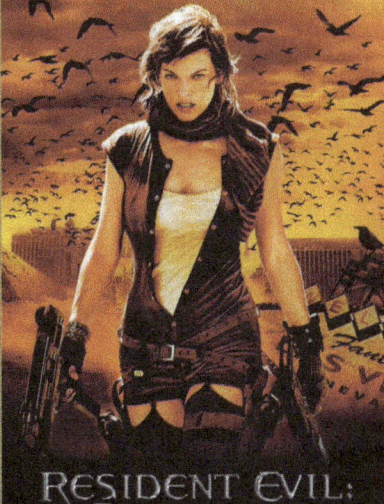

Biopunk
A futuristic derivative that emerged during the 1990's, dealing mostly with the unintended consequences of biotechnology and genetic manipulation. Many Biopunk stories are like modern retellings of Frankenstein, in that they deal with the theme of man's unwieldy power over the forces of nature. A great example of Biopunk is the Resident Evil video game series, which seems to have all the staples of the genre: human experimentation, evil megacorporations or governments out to turn a profit, and horrible monsters and/or viruses which threaten to wipe out humanity. A lot of modern zombie apocalypse stories can be categorized as Biopunk.

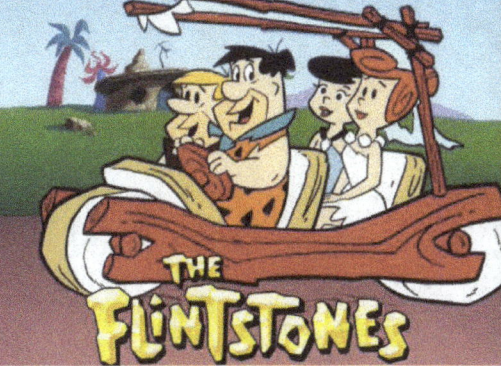

Stonepunk
It deals with the Stone Age time period as well as its technology, though usually with anachronistic elements. The Flintstones is a famous example of this sub-genre.

There are plenty of other Cyberpunk derivatives out there, but most of them are fairly young in comparison to these. Contemporary genres like Clockpunk, Nowpunk and Elfpunk might see greater exposure in the future. ■

ENTERTAINMENT
Stoneburner

STONEBURNER
THE MOUSE TOUR HITS ATLANTA!

By: Fairlyinnocent

Distortion Productions with Sedition Atlanta presented Stoneburner: The Mouse Tour at Club Famous May 4th 2016

Opening the night was local artist Zy_Gote, brought to life by producer Stan Pavlov, "fusing mixtures of different noise and industrial genres," and they were performing live for the first time. This band came through really great with a power industrial blast and a strong presence. They already have upcoming shows scheduled so they are well on their way.

Zy_Gote

Next up was Finite Automata who have a look and sound that is all their own. Full of expressive movement and harsh industrial noise, they killed it as always. You have to rock out listening to them play. They have some exciting news of touring with God Module this summer. There is a lot to look forward to from them.

Finite Automata

ENTERTAINMENT
Stoneburner

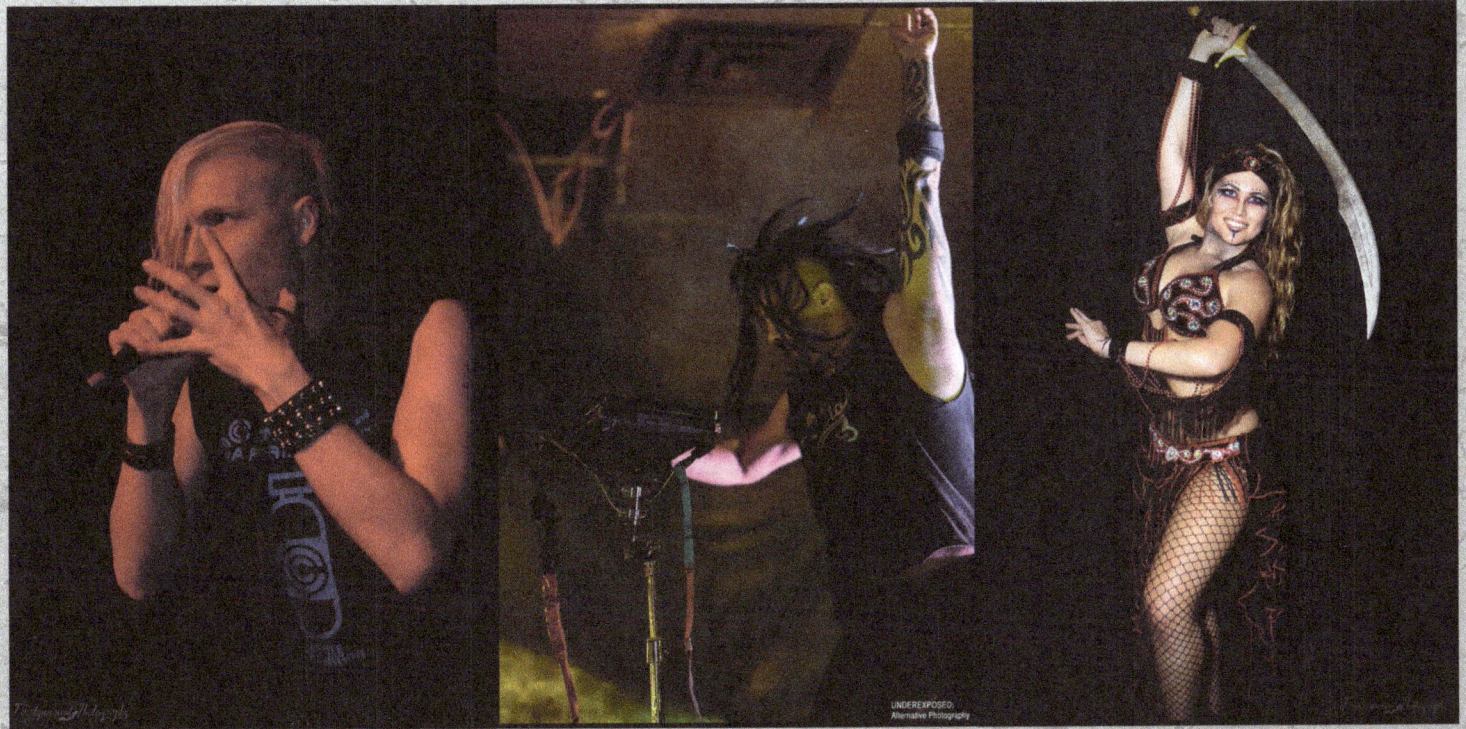

Die Sektor *Stoneburner* *Karma Karmelita*

Die Sektor took the stage next, and this performance was one that was bittersweet. This was to be the last live performance by Die Sektor's front man, Edwin Alter, as an Atlantan. He would be moving after this show to North Carolina and will be missed in the area. They blew up the stage with true Die Sektor dark industrial music! It's hard to keep up with this singer as he moves and bounces across the stage. There is no way you can help but want to move with him when listening to the sounds they put out. This was a fantastic performance, as always from these guys.

Last for the night was Stoneburner, the solo project from Steven Archer of Ego Likeness. His mix of "electronic tribal fusion" intertwined with "vocals from around the world" send you on a journey in your mind. The videos are as intense as the music itself, and match the music and vision that is being portrayed. Steven does not keep still during his shows, and even incorporated a dancer, Karma Karmelita, who was interpreting through belly dance which was gorgeous to watch. To see her moves to the tribal-electro beats with hand held fans and blade was just phenomenal.

This was an amazing night of aural and visual stimulation, and can't thank the bands enough for coming out.

Big thanks to the promoters DJ's Mod Eschar and Seraph, and VJ Anthony for pulling this night together.

Stoneburner- http://www.stoneburnerband.com/
Finite Automata- http://www.finiteautomata.net/
Die Sektor- https://www.facebook.com/Die-Sektor
Zy_Gote- https://www.facebook.com/Zy_Gote-1588849478104150/?__mref=message_bubble
https://crunchpod.bandcamp.com/album/potential-for-destruction?undefined
Karma Karmelita- www.karmakarmelita.com
Photography credits- Blake Griffin: http://unexphotography.com/ for Stoneburner, Finite Automata, and Zy_Gote photos.
Photography credits- Fairlyinnocent Photography for Karma Karmelita, and Die Sektor photos
www.fairlyinnocentphotography.weebly.com

FASHION
Top Hat Tutorial

Steampunk Mini Top Hat Tutorial

By Asylum Attendant

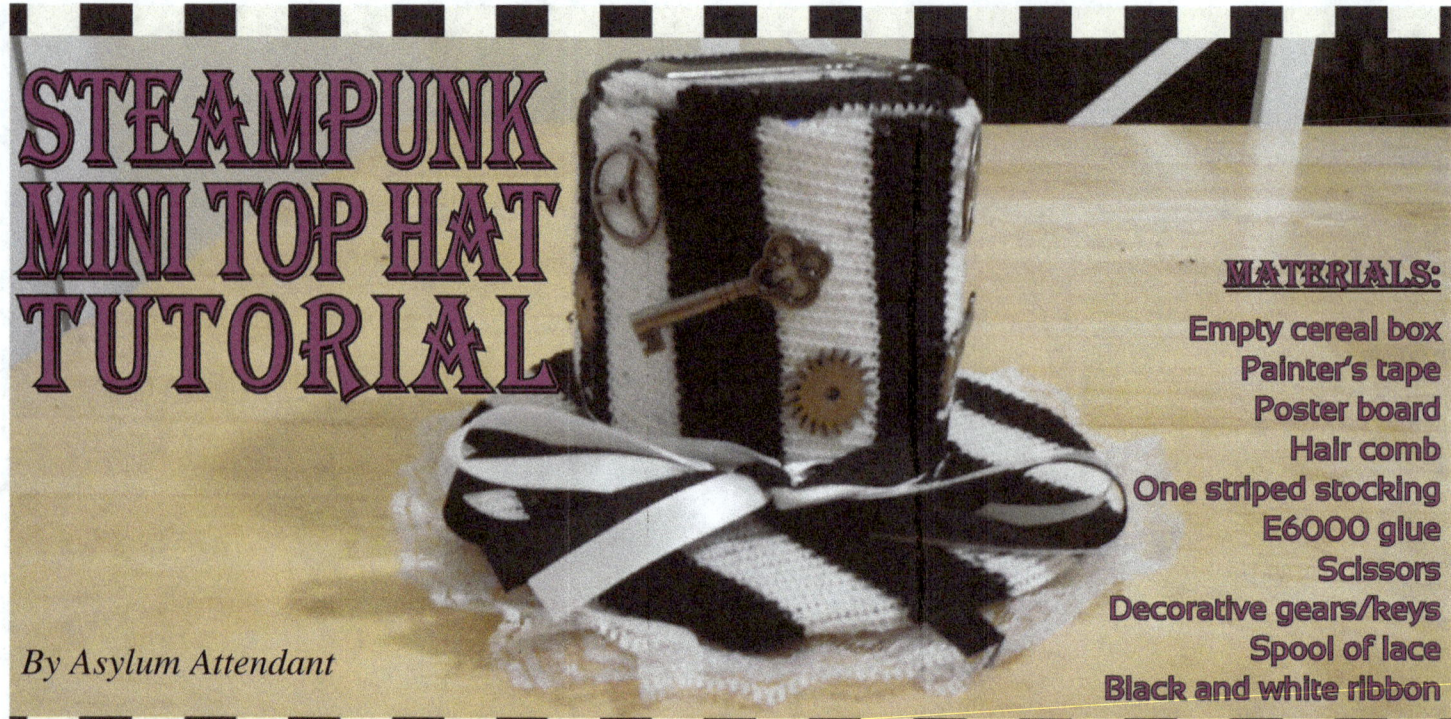

MATERIALS:
Empty cereal box
Painter's tape
Poster board
Hair comb
One striped stocking
E6000 glue
Scissors
Decorative gears/keys
Spool of lace
Black and white ribbon

I've been obsessed with mini top hats for a long time. I think they are adorable and whimsical. Sadly, most of the ones I see are cheaply made and plain looking. But, I came across an online tutorial by Natalie Paquette (http://fetishfaerie-stock.deviantart.com/art/Mini-Top-Hat-Tutorial-79563375) in which she made a beautiful Gothic Lolita mini top hat and figured I could give it a go with a Steampunk spin. I'm by no means awesome at DIY stuff, but this was not a difficult project at all. Grab an old striped stocking and a cereal box and learn how to create the most epic hat you can show off at your next tea party.

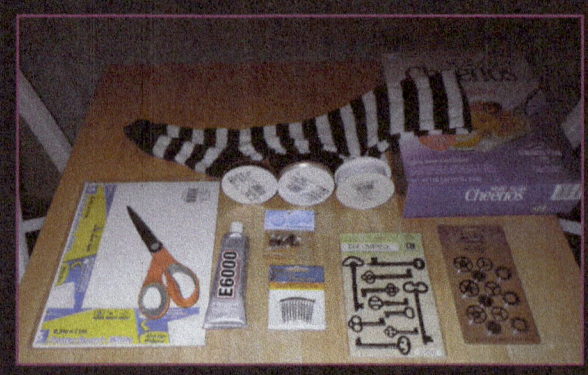

1 Let's start with the empty cereal box. You want to trace circles on the cardboard that are about five inches in diameter for the brim and three inches in diameter for the top of the hat. I just used a mug and a bowl that were roughly these sizes. Take your time when cutting out the circles to make them as even as possible. You want to cut the poster board slightly smaller in diameter that the top of the hat, but long enough to roll it into a thick cylinder to create the height of the hat. Then, you cut a hole in the larger brim circle that is slightly larger than the top circle so that everything fits easily together during construction.

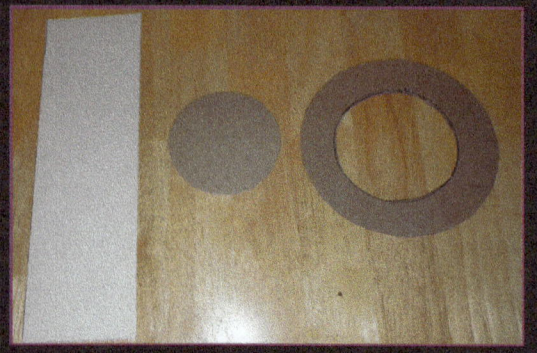

2 Next, grab that old striped stocking. I used this as the fabric to cover the hat. I have a million striped stockings, so it won't be missed. Make sure the fabric pieces you cut are large enough to cover and wrap around your circles. The long, rectangular piece of fabric that covers the poster board should be wider, but doesn't need to be as long as the poster board because it will be rolled.

FASHION
Top Hat Tutorial

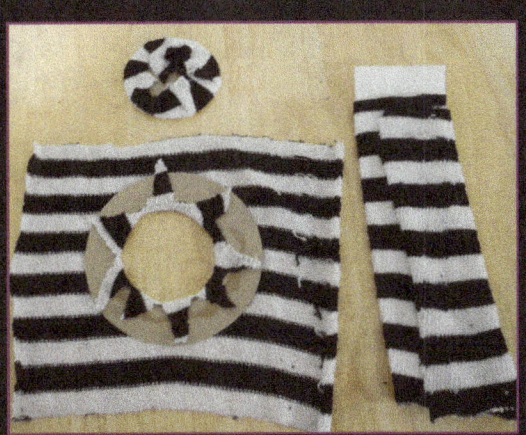

3 To cover the brim of the hat, start at the center of the fabric and cut a star pattern of eight triangles. Each triangle gets glued to the center of the cardboard circle. I used E6000 glue because it will glue anything to anything, but you could use a hot glue gun as well.

4 The top of the hat is very easy to cover. Lay the pretty side of the fabric facing down on the table when you are gluing. Then, place the small circle on the fabric, slap some glue on the edges of the cardboard and glue the fabric in place. Do the same thing with the poster board.

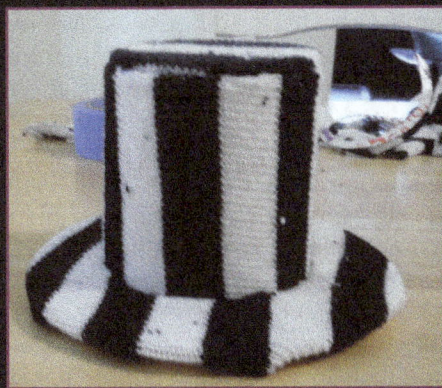

5 Now, here comes the hardest part: assembling the pieces. Painter's tape was incredibly helpful in holding the pieces of the hat together while I glued them. I actually left a lot of tape on the inside of the hate to make it sturdy. Roll the height of the hat into a cylinder that can be stuffed into the hole in the brim. Glue everything together, including the top.

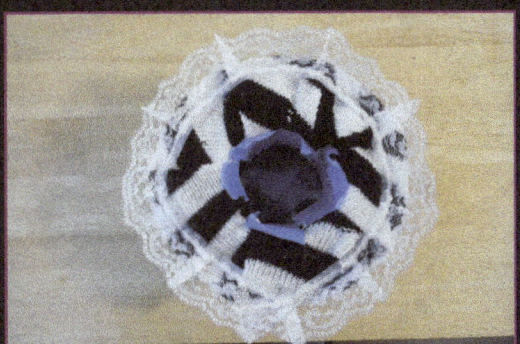

6 The most enjoyable final steps now begin. I added lace to the brim of my hat for an elegant touch. I used a spool of lace and glued the piece under the length of the brim. Then, I glued a flattened hair comb to the lace underneath the hat. My hat ended up kind of heavy, so I had to anchor it with bobby pins when I actually put it on, but the hair comb helps keep the hat on your head. I also tied black and white ribbon around the base of the hat and glued gears and keys all over the hat for that perfect Steampunk vibe. You want to make sure you decorate your hat so that the seam on the height will always be hidden in the back of the hat.

7 Photo time with my completed hat!

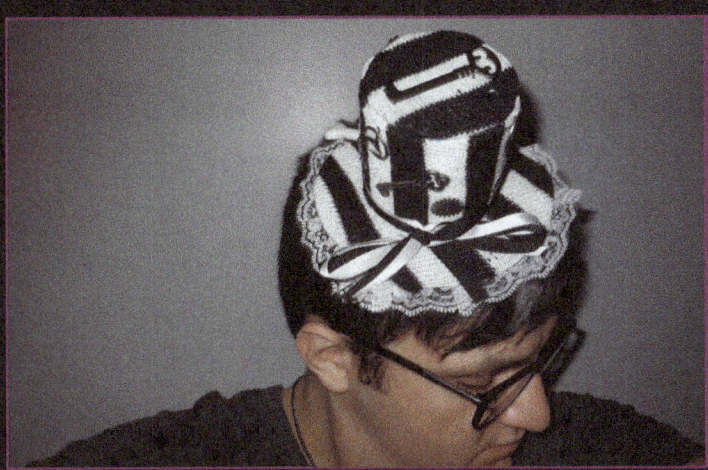

I have to say I'm proud of my first ever handmade top hat. The process took a lot longer than I expected and putting all the parts together was a challenge, but now I have a one-of-a-kind piece to show off. I hope you guys give top hat construction a try, too!

FASHION
Corsets

Corsets

by Annabella Rios

Take a second to Google "Steampunk." What's the most common feature you find among the image results? That's right, corsets. Corsets everywhere. There are a few fashion staples that seem to show up over and over among Steampunk cosplayers and aficionados, including goggles, top hats, and bustles. Where exactly do these articles come from, and why are they so popular in the genre? Well, it should come to no surprise to anyone that most of the inspiration for Steampunk fashion comes from Victorian-era clothing. It's not exactly historically accurate; a lot of creative liberties and stylistic choices are taken, but as a writer, how much of it should affect your stories? Fortunately, that's entirely up to you. You can create a Steampunk world with your own spin on the fashion.

If you plan on making corsets a primary player in women's (and sometimes men's) fashion in your story, here are some facts you may not have known about this popular bodyshaper:

- The earliest version of a corset is thought to have been made around 2000 BC, but they first became popular in sixteenth-century Europe.
- Catherine de Medici (1519-1589) is credited with introducing corset fashion to France.
- During the Victorian era there was the belief that women's bodies were fragile, and needed assistance to keep her torso held up. As a result, Victorian-era corsets were thought of as a medical necessity.
- Severely tightened corsets were known to cause asphyxiation, sunstroke, and infertility. Pregnant women were also expected to wear them, resulting in babies with deformities and cardiorespiratory issues.
- Following the French Revolution, women temporarily gave up the wearing of corsets for looser clothing, possibly rebelling against symbols of aristocracy as well as hoping to represent new political ideals.
- Corsets were not always used to accentuate a woman's form. Prior to the 1800's they were used to hide rather than shape, and it was during the post-French Revolution resurgence that the corset was used to create the idealized "hourglass figure."

FASHION
Corsets

Be sure not to get caught mislabeling your character's clothing! There are several types of pieces that have been used to accentuate or bind the female form throughout history. You may find that you've been calling pieces that aren't corsets, corsets.

Corseted tops – strictly speaking, these are not "real" corsets. Often worn in today's modern world, these are the kinds of corset-looking tops that line the racks of Hot Topic and occasional Halloween costumes. They usually contain only enough plastic boning to last one to two wears. They stay on with bra-style hooks, and the lacing used is usually for decorative purposes and aren't intended to be functional.

Bustier – these can be considered another modern contraption, and in a lot of ways the bustier is the technological successor to the historical corset. Today, they're used for long term wear, and are made of spandex. Like the corseted top, the boning is made of plastic, but it's a lot stronger. Bustiers are also exclusively worn as underwear, often to accentuate and contain the bust under formal wear such as a wedding dress.

Bodices – if the bustier is considered the corset's successor, then it's safe to say that the bodice is its predecessor. Before the rise of the corset, bodices were worn by women, mostly in medieval and Renaissance Europe. These are the highly decorated corset-looking things you find bar wenches wearing at your local Renaissance Festival. They come in different styles and worn as outerwear, often over a peasant blouse. Sometimes they having boning, sometimes they don't. You can usually tell a bodice from a corset by the shoulder straps that corsets lack.

Overbust corsets – the meaning is in the name. This is a corset that goes over the chest, providing support of the breasts and often creating the busty cleavage look that modern wearers go for when trying them on.

Underbust corsets – Unlike the overbust, the underbust corset sits directly under the breasts. This style is used to compress the waist, rather than the chest.

Waist cinchers – a smaller version of the underbust that covers a smaller area. They have a less boning and only provide compression, rather than support.

Keep in mind, each of these styles also have their historical and cultural variations, but for the purposes of your Steampunk writing, you should now have a better idea of what your aristocratic noble lady might be wearing on her way to the opera.

FASHION
Head'n Home

Head'n Home

Handmade Hats

By Kathleen Sharkey

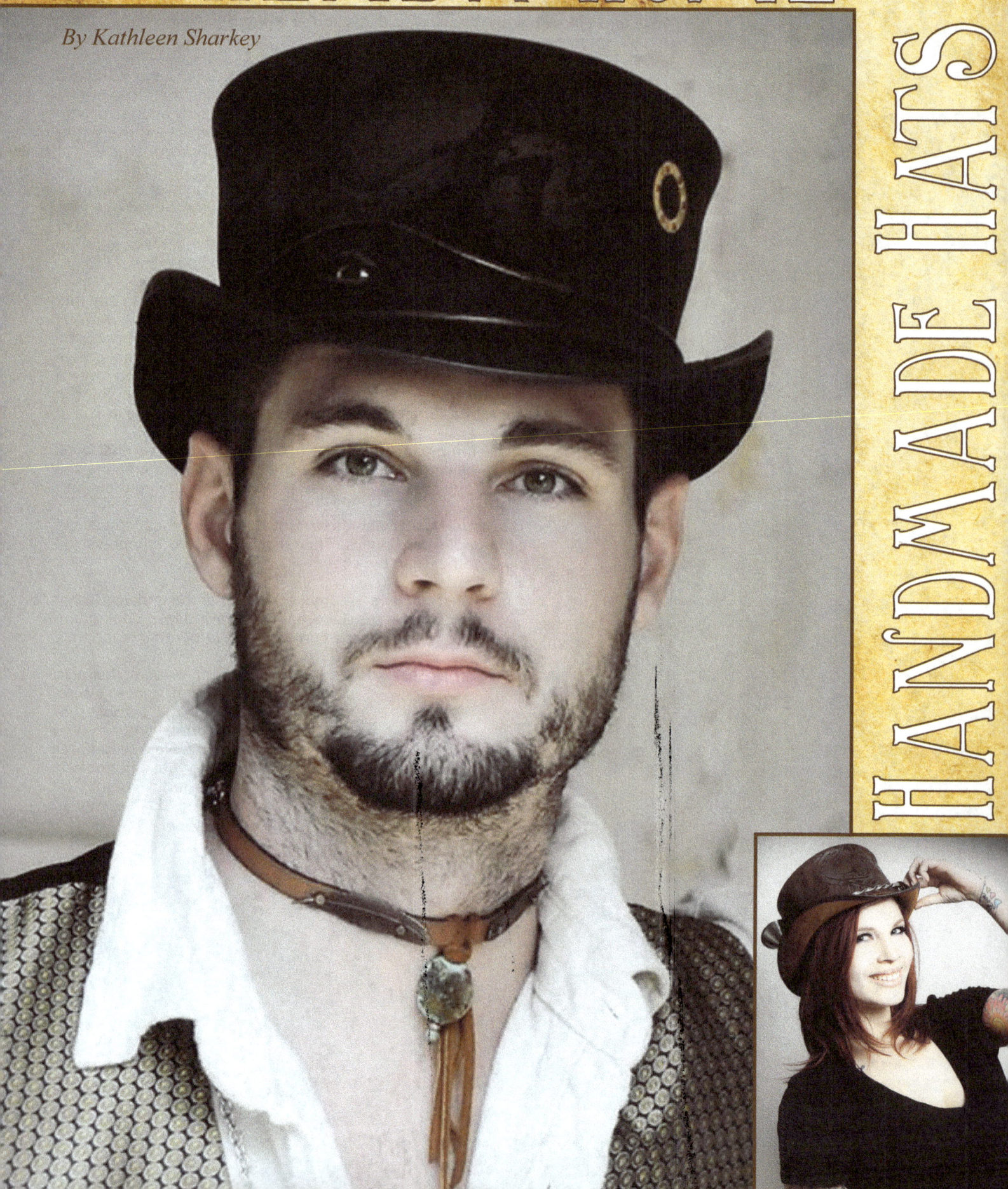

FASHION
Head'n Home

Have you ever walked through a place where costumes were being sold, be it a con or faire, and suddenly been stopped dead in your tracks when you saw that perfect piece? The quality was phenomenal, the beauty was intense and the person selling the merchandise glowed with pride. When I came across Head'N Home Hats at a recent Steampunk even this is what happened to me. The smell of high quality leather hit me first and then the variety of colors and designs, there had to be almost a hundred hats on racks that reached seven feet high. It was an all-encompassing sensory experience; the feel of the leather was soft and supple while the sounds of awed (and I mean that in the original sense of the word) patrons surrounded me on four sides. It was patently obvious that Dan, the seller of these fine works, was truly proud of the merchandise that he was selling and looking at the history behind these wares one can understand why.

Started by the patriarch of a budding family, Gary Watrous, in the 70's, Gary has taken the concept of a family business to the next level. He is joined in this endeavor by his son Garth, brother Lee, sister Ronia, daughter Heather and his wonderful wife Merry-Lee. This family has some of the most wonderful hats I have had the great fortune to experience. Each hat is really just that, an experience to behold.

I was at a Steampunk convention when I ran across Head'n Home, so the hats on the tall shelves were from their Steampunk line, yes they have a Steampunk line called Steampunk Hatter. These bronze, gold, brown and variety of colors are perfect, not only for the Western themed Steamer out there but also for any other person looking for durable quality for their costume. The hats are very versatile for any sex. Their designs run the gamut from basic to intricate projects that demand a costume be made around the hat. So if you are in want of an idea for a costume take a look at http://www.headnhome.com and I assure you, you can find a hat for any costume you might want to create. The prices are, I think, moderate, considering the amazing quality, but don't expect $20 bowlers on this site, these are handmade and the price projects the work that must go into each piece of art.

Oh and for those of you who are not into Steampunk let me just list the other Brands that Head'n Home carries. There are **Sol Air Hats**, which are lightweight hats for folks who need a hat to keep the sun off but still desire a modicum of style. **Ashbury Hats** are an amazing variety of designs from bohemian to swing, from biker chic to versatile statement hats, all of these hats were inspired by the San Francisco underground. **American Outback**, are hats inspired by Australian designs, but made American. **Voodoo Hatter** are for those who desire a little darker quality in their hats, to quote the website *"Badass leather top hats. The meek need not apply"*. **Double G Hats** are more western in their theme but they defiantly have a flair that is individual.

Head'n Home is the place for leather hats for pretty much anyone searching for quality and unique style. Check them out and I think you will be under their spell too.

Watsonville, CA
http://www.headnhome.com

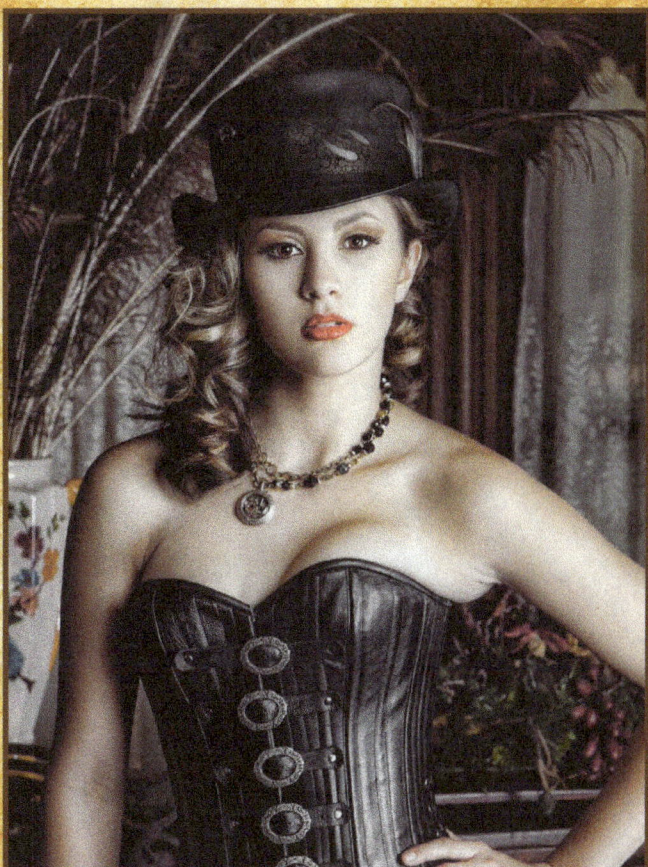

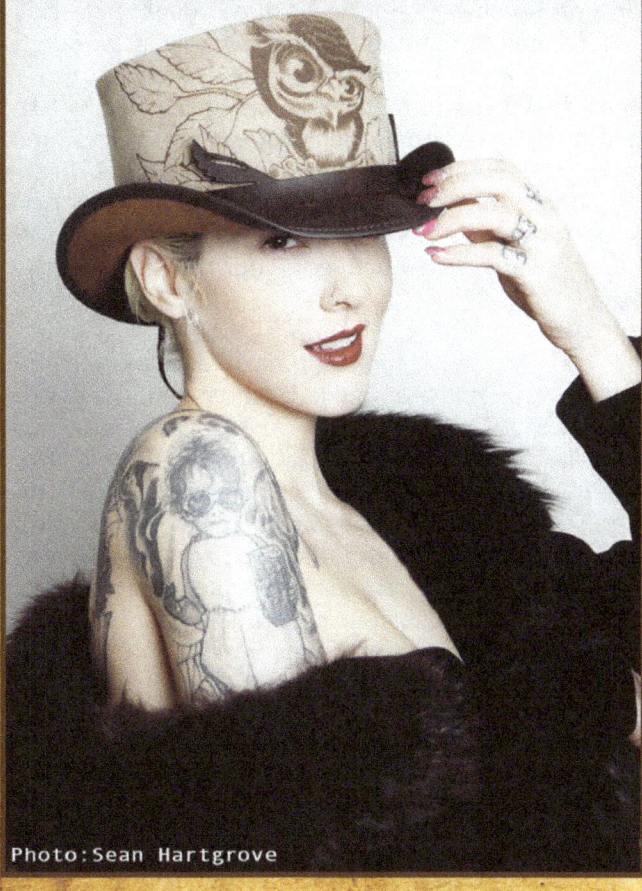

Photo: Sean Hartgrove

FASHION
Gizmos and Gadgets

STEAMPUNK GIZMOS AND GADGETS

By Kathleen Sharkey

Steampunk can definitely bring a family together. Whether working on some amazing vehicle, or building specialty items for family costumes Steampunk is a wonderful project for the whole family. So when I took my two girls, 6 months and 6 years, to a Steampunk event it was with the knowledge that I would be looking for ideas for costumes for them. The Steampunk Gizmos and Gadgets display was the booth that my eldest could not stay away from. We bought her a do it yourself goggles kit and a bowler hat, but she wanted so much more than that, and honestly so did I.

Started by a Mother Daughter team, Paige Mattern and Sandra Cavanagh, Steampunk Gizmos and Gadgets is more proof that Steampunk can be a family affair. These wonderfully talented women create everything from handmade hats and jewelry to full dresses and other apparel. They have parasol sheaths with fan cozies so that a lady need not be left without a place to put such things when not in need. The dresses are built for women of all sizes and with an open eye to color and design. Cuffs and chokers to match any costume and Steampunk'ed jewelry as far as the eye could see. We spent so much time at this booth, returning many times during the day, we even got my daughter specialty laser etched lenses for her goggles. I later found out that Paige's husband does the laser etching as well as some other specialty designs.

I think my favorite items were the new men's fashions that they had on an endcap at their booth. Looking at fashions with still a new eye I find there are few accessories available to men at these such events, and it made me very happy to see, even a small, such variety available to male shoppers. I adored the idea behind the parasol cozy and I know that when I start work on a Steampunk costume I will definitely keep their importance in mind.

It was my good luck to get to talk a little, online, with Paige Mattern after the Steampunk event and I got to ask her some questions about her side of Steampunk Fashion.

CN: When did you start making costumes?
Paige: I started making costumes 27 years ago. My mom took me to my first renaissance faire and it all started from there. There were no patterns at the fabric store so I learned how to make them from a book we bought at the faire. I learned how to draft my own starting with this book and continue to do it now.

CN: Where do you get ideas for the amazing clothes you design?
Paige: I get my inspiration for costumes from books and images I find on line, Pinterest is one of my favorites.

CN: You have amazing Steampunk outfits, have you designed costumes for any other genre?
Paige: I have designed costumes for many different eras, Renaissance, Edwardian, medieval, 40's and 50's, fantasy outfits to include a dragon, Merida, and Atlantis gowns. Civil War, Victorian and even pirate, currently I have complete a Queen Amidala.

CN: Do you design men's fashions too?
Paige: I have been making my husband's costumes for the last 10 years, mostly renaissance and Victorian, some fantasy like the dragon, and we convert his Victorian to Steampunk as well.

CN: Do you have a favorite costume piece you love to make?
Paige: My favorite piece to make, anything with a bustle, I just love bustles.

CN: Steampunk costumes seem to stay in a fairly brown palette, do you like to design Steampunk costumes in different colors?
Paige: I started off my Steampunk in the typical brown colors expected, but I have researched

FASHION
Gizmos and Gadgets

Victorian outfits and find many colors in the everyday wear and have started adding these colors to my outfits, my last one was turquoise and cream.

CN: Do you have a favorite costume?
Paige: My favorite costume is one I made from the book Period of Fashion, an 1874 gown I drafted from the book to my size.

CN: Are you working on anything new that you would like to share with our readers?
Paige: We are currently adding a few men's items to our shop, we will be adding men's vest fronts, cuff links and cravats.

CN: What costume creation advice would you give to a person new to Steampunk?
Paige: I would let them know that there is no wrong for Steampunk. There is no age limit, find something you like and add your own flare. Some people like gears anywhere and some like the gadgets, jewelry, and costumes. Some people like to be makers while others like to shop to add to their outfits. Have fun with it!

It is my fondest wish and hopeful desire that, with this inspiration, I shall begin my own research into creating a Steampunk costume for me and my family. It will be a slow process and perhaps bits and pieces of Steampunk Gizmos and Gadgets will make it into our costumes.

Fallon, NV
https://www.etsy.com/shop/SteamedGirls

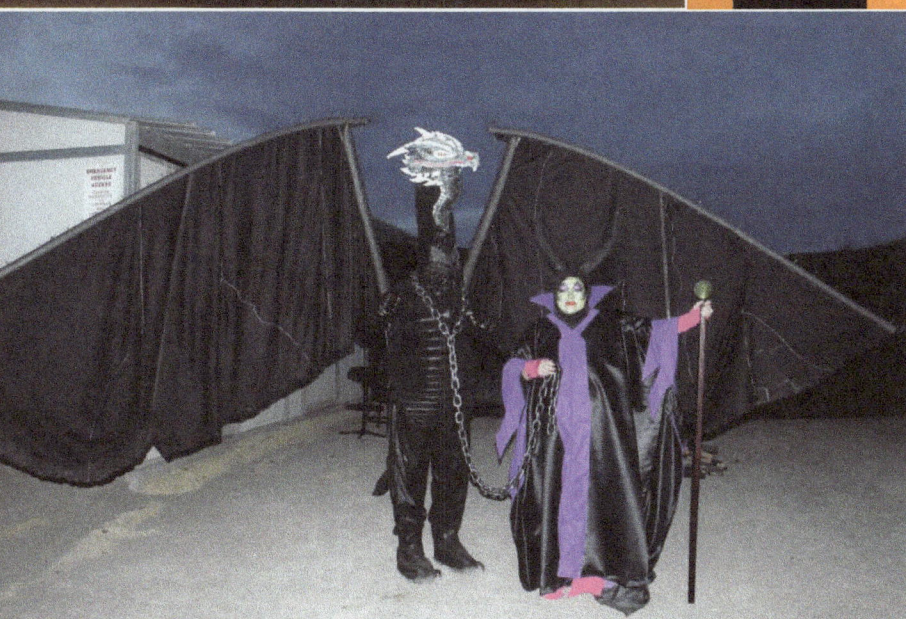

FASHION
Glowees and Lulu Deux Millinery

GLOWEES AND LULU DEUX MILLINERY

By Kathleen Sharkey

As a child of the 80's and 90's I am very attracted to black lights. I am happy to admit it, I think they are amazing. So it should come as no surprise that I was drawn so dramatically to Chris and Katie's booth. I was "fascinated" by the beautiful purple glow of their glow in the dark t-shirts, Chris was using a black light to simulate glow in the dark in the light of a very big room. It is also on purpose that I use the word "fascinate" because Kate makes some of the most wonderful hats and fascinators. The blue glow might have drawn me but the beauty of Kate's handiwork made me stop and peruse their handiwork.

Broken down into two different online stores Chris and Katie have created these wonderful fashions using their own creative backgrounds. Chris has, since a young age, created little creatures from clay and putty. Moving into polymers Chris turned to glow in the dark colors and started selling them out of Greenwich Village and the Renaissance Pleasure faire; "By far my favorite place to sell them was the adult playground known as the Renaissance Pleasure Faire at night. For hours I'd go around with a camping lantern affixed with a black light tube & my little jewelry box filled with my glowee creatures, playing trip-toy to many appreciative partiers. Often I'd be like the pied piper, leading a parade of people as I went from place to place to show off my wares, who kept repeating, "Dude…Dude…Open the box, Dude.", and then, when I'd open it, "Ohhhhhhhhhhhhh, Duuuuuuuuuuuuuuuuuuude!" Sometimes, I'd just sit with someone for the longest time, while they'd have conversations with my little glowing guys. People would buy them & name them & tell me what names they came up with for them."(From www.glowees.com) Chris has turned to glow in the dark screen printing on shirts and a variety of other media. I will freely admit that I will be buying one of the Alice in Wonderland pieces, because the Cheshire cat is meant to glow.

Kate, on the other hand, manages the business side and creates amazing hats out of her Millinery site (http://www.luludeuxmillinery.com). Katie studied in London under Rose Cory, Milliner to the Queen Mum. She has also written a variety of articles on millinery and has had one of her amazing fascinators featured in a wedding blog by Luxe Fete Event Planning and Design Studio in Miami; the "Punk. Rock. Love." photo shoot. Her amazing hats vary from brilliant pillboxes to flamboyant fascinators to wonderfully fun jester hats. These pieces would be the perfect frosting on a fun Steam costume or even a fantasy Ren costume. Katie also sells supplies of the trade for people looking to try their hands at making their own hats. Her unicorn jester hat definitely had my daughter in awe.

So if you are looking for some beautiful glow merchandise check out www.Glowees.com and if you are interested in some wonderful hat creations or for those of you interested in information on how to create your own hats please check out Katie's articles whose links you can find on www.luludeauxmillinery.com

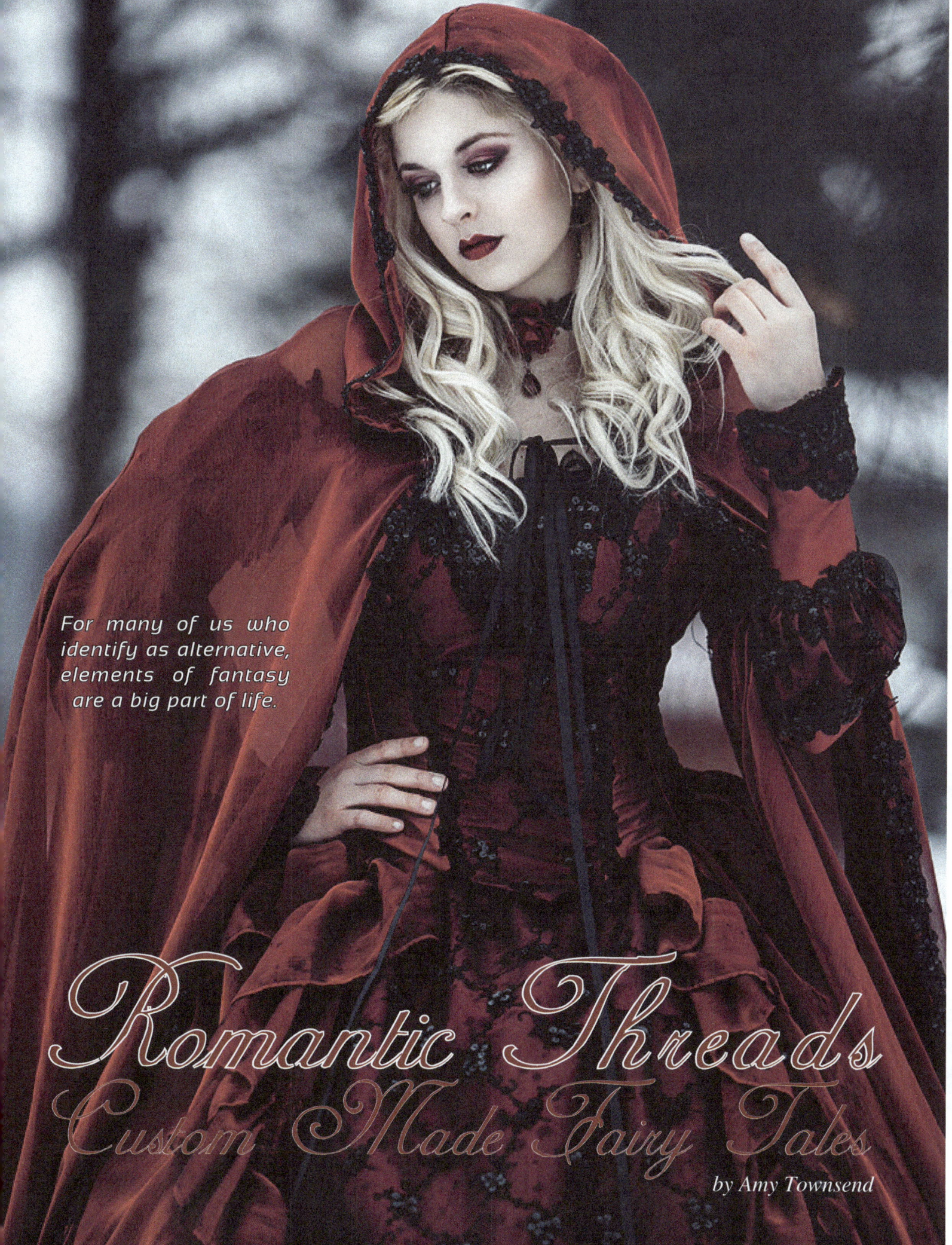

For many of us who identify as alternative, elements of fantasy are a big part of life.

Romantic Threads
Custom Made Fairy Tales

by Amy Townsend

Whether our personal preference leans towards Victoriana, Rococo or steampunk, or folkloric imagery (straight from Tolkien's Rivendell by way of the medieval period), we do not accept that beautiful, ornate clothing is the province of the royal family, the haute couture fashion house, and the socialite. Luckily for us, from a modern-day Marie Antoinette, or a be-corseted Mina Harker, to a medieval maiden draped in velvet - whatever your heart's desire, there are artists and craftspeople out there that can help us make it so.

Belinda of Romantic Threads is one such creatrix. She was born and raised in California, where she still lives today with her husband and daughter. Belinda has been making one-of-a-kind, custom gowns for over fifteen years. She works from home, which, as she explains, "can pretty much take over everything."

Belinda's breath-taking gowns include movie costume reproductions, such as her Mina gown (from perennial Goth favourite, Bram Stoker's Dracula) and others from films including Interview with the Vampire, Beauty and the Beast – her Belle gown has been a big hit – and The Phantom of the Opera. She particularly enjoys re-creating the movie gowns, taking pride in her ability to make them as accurate as she can. She also makes gowns for alternative brides, who want a themed wedding, or simply a completely unique dress, and special pieces for parties, balls, and events such as the Venice Carnivale. "I like to make Gothic-style gowns, or any gown with black on it. I can do pretty much any of my gowns in black or just about any colour, so that's nice." She wears black every day, as it happens, and jokingly refers to it as her uniform. "I have added a few polka dots recently, so that is something!"

Making clothes has been a part of Belinda's life since she was about fourteen, when she spent a summer in the Swedish countryside with her grandmother, who began teaching her how to sew. In junior high, Belinda started to make clothes for herself: "funky ruffled skirts, and things that I wore to school - I'm sure everyone thought I was a little kooky."

And then for a while, sewing was put on the back burner. Belinda says, "I really didn't pick it up again until I was getting married. Not finding anything different that I could afford, I would buy imported magazines from the UK. The bridal magazines had gorgeous-coloured and dramatic gowns that I loved. Every week I would go and look for new magazines for inspiration."

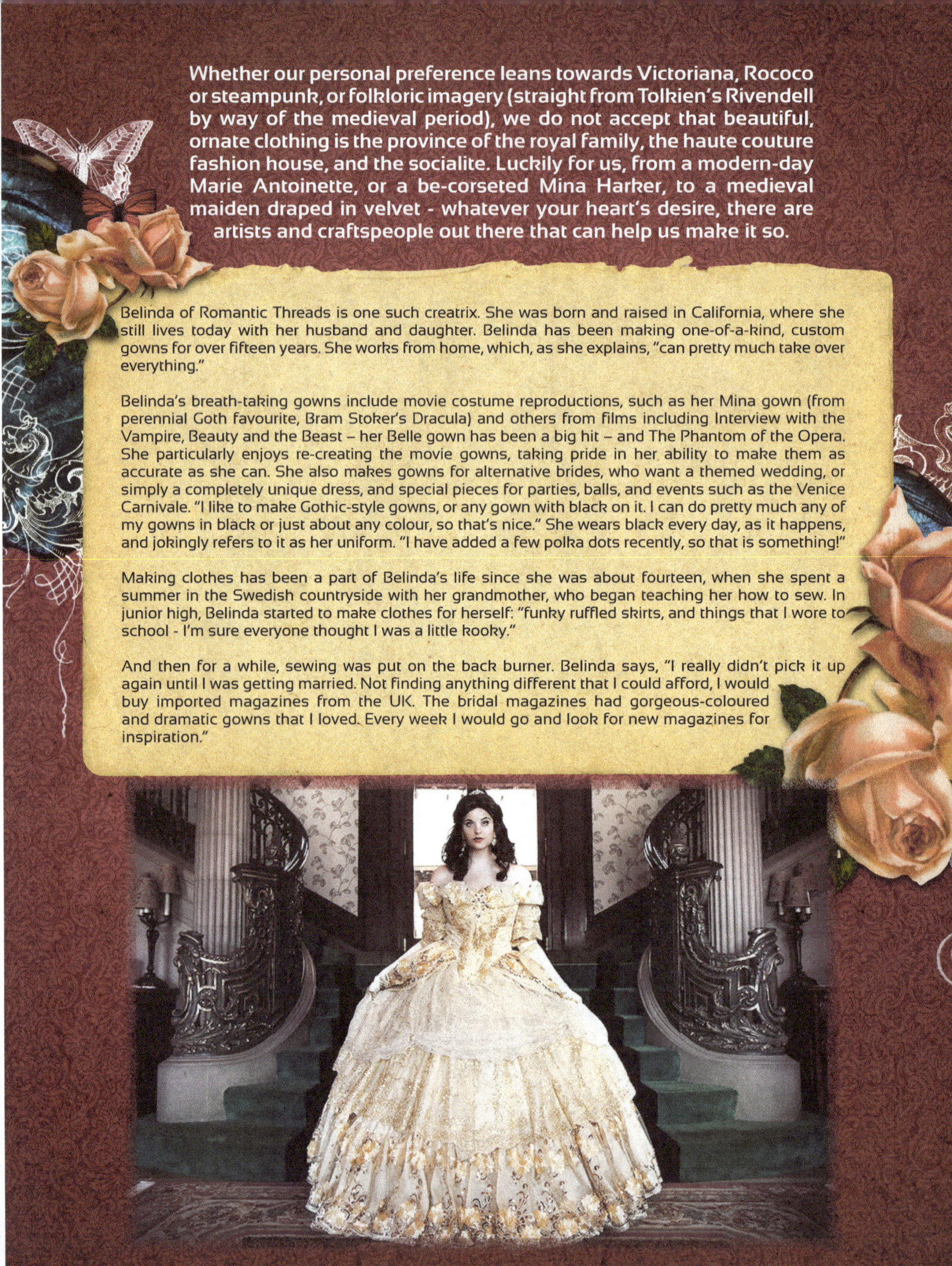

www.romanticthreads.com
www.etsy.com/shop/romanticthreads
www.facebook.com/Romantic-Threads-101887076552187/

The first gown that Belinda made was for her own wedding. "It was blush and cream, in an Antoinette style. I was married in a glass chapel in the forest in Palo Verde, CA overlooking the ocean. Candlelight service… it was beautiful," she reminisces. "The gown worked out perfectly. Everyone was saying then I should make gowns but I was too exhausted from all the wedding planning to think about it!"

But the seeds were sewn. Sometime later, Belinda began working on one-of-a-kind creations, which never failed to sell. Romantic Threads grew from there, and became an enormous part of Belinda's life. Whilst she briefly studied history of fashion design, her skills are mainly self-taught, and as she says, "The rest is all trial and error. The only way to get better is doing it over and over again. There really is no other way. You've just gotta love doing it, and work really hard." She cites her main motivations as feedback from customers - when people say that they love their gown and that the fit is perfect - and new photoshoots. And Belinda is nothing if not motivated: "I only managed to have one child because I am a workaholic, and I was literally on the floor cutting out something the night before she was born."

But these levels of dedication can certainly take their toll on the seamstress. As she admits, "The challenge is when you are a perfectionist and you do most everything yourself. There are only so many days in a week and they all blur together sometimes. In the last few years I would literally work till the wee hours of the morning almost every night, and eventually you get burned out. Your body just can only do that for so long. This year I am saying no a lot more, and actually getting some sleep most nights which is nice. The goal for me is to do more inventory, so things are ready to ship. That will cut down on stress all around and will make things easier. But the challenge is making the transition…"

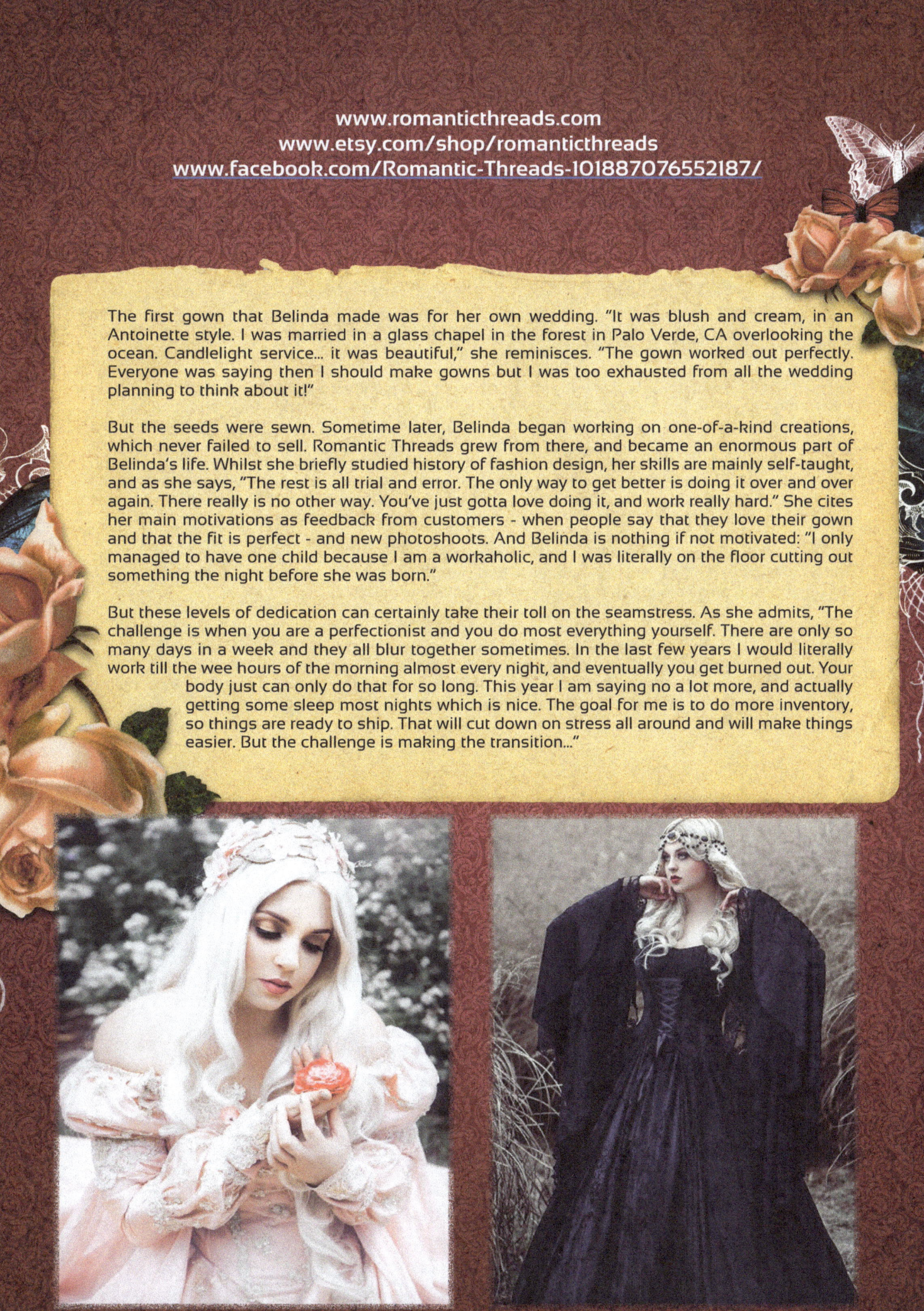

Photo Credits:

Gothic Sleeping Beauty Gown shot by Bernadette Newberry Photography, model Ai Tenshi Misha
Belle gown, photo by Gas Oven Photography, model Ai Tenshi Misha
Sleeping Beauty Gown, photo by Shelby Robinson Photography, model Ashley Ormaza, MUA Freckles Fairy Chest
Gwendolyn Gown shot by Bernadette Newberry Photography, model Ai Tenshi Misha
Mina Gown shot by LeMewPhoto.com, model Allie Schell

She also notes, "Another challenge was figuring out - stick to what you are good at. I have offered things before that I ended up pulling. I have tried custom things for people that were out of my range of things I know, and they are way too time-consuming."

Romantic Threads customers know that the beauty of a bespoke creation is exactly that - having something one-of-a-kind, tailored just for you - and with this level of hands-on craftsmanship, the devil is in the details: "I have made so many hundreds of gowns that the gown itself doesn't take long, it's the planning before. Talking with the customer, figuring out the gown, searching for the fabrics and trims. I live near the Los Angeles fabric district so I can get just about anything there. I have been going there for about 10 or more years so I know it well. Since everything is custom, some gowns take longer than others. I always have a list of orders I am working through. September/October is my absolute busiest times of the year. I do a lot of Halloween weddings and parties."

But there is always more to achieve. "What I am trying to change to this year is redoing the website, which I haven't had time to do in a long time. This year I have cut out custom items that are too time consuming, and also cutting out my lowest-priced gowns as custom."

And her most satisfying achievement to date? "I have done a wedding TV show, but that didn't do much for me honestly. I think for me personally, the most satisfying thing is the photographers I work with. I am super lucky; I have met and worked with a handful of photographers that I love. So I love doing the work on my end, sending them the gown... and seeing the beautiful results they come up with. The shoots have just been getting better and better, and that is the most satisfying part right now." ■

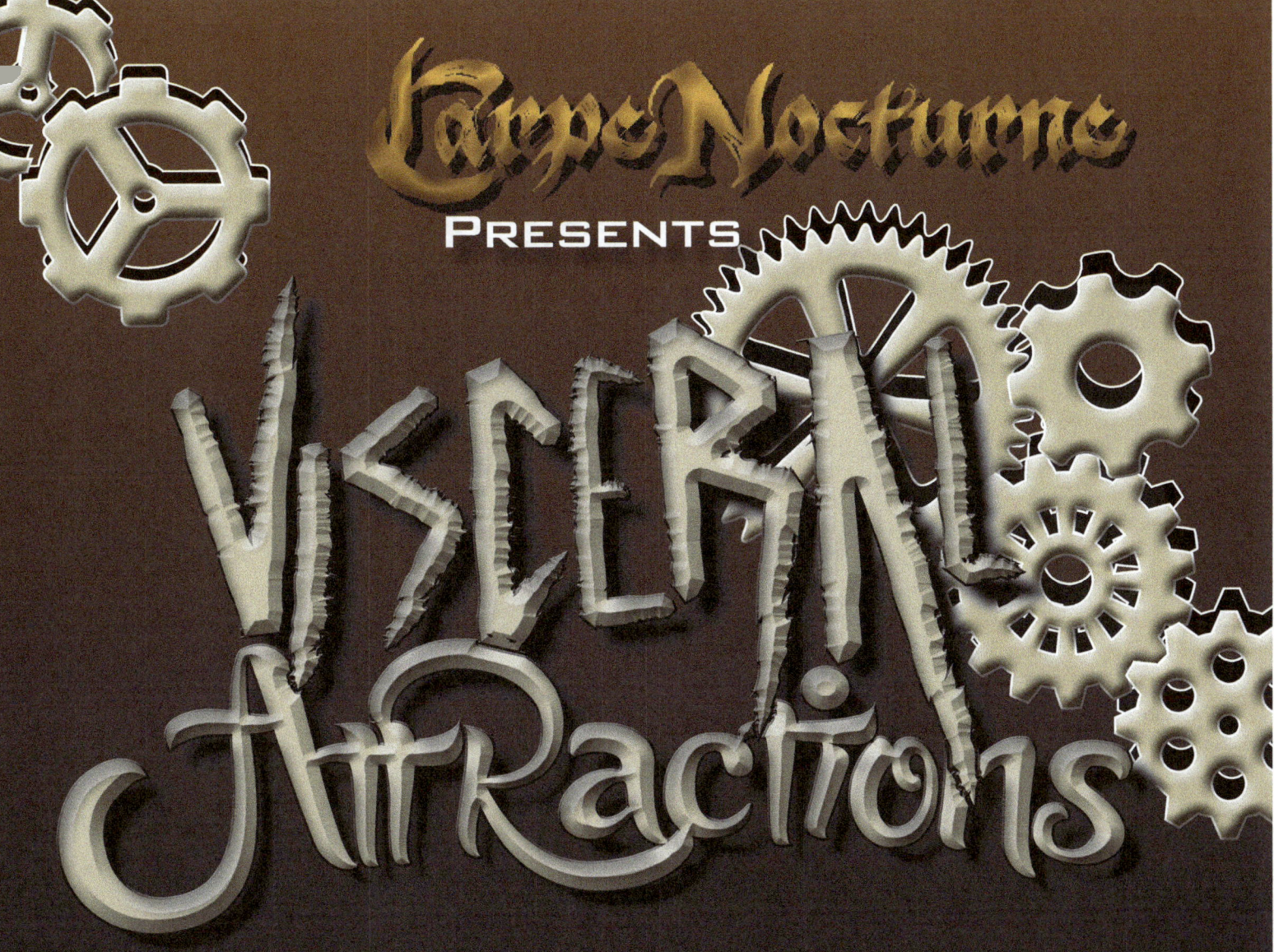

/VIS(ə)RəL/ -
coming from strong emotions; not pertaining to logic or reason

Visceral Attractions is Carpe Nocturne's official Fashion insert, spotlighting the most unique and decadent counter-culture fashion designs out there. Every quarterly issue features full page spreads of fashion, fetish and cosplay photographs to the theme of Goth, Fantasy, Sci-Fi and Steampunk.

THEMES:

Summer - Steampunk
Fall - Goth
Winter - Fantasy
Spring - Sci-Fi

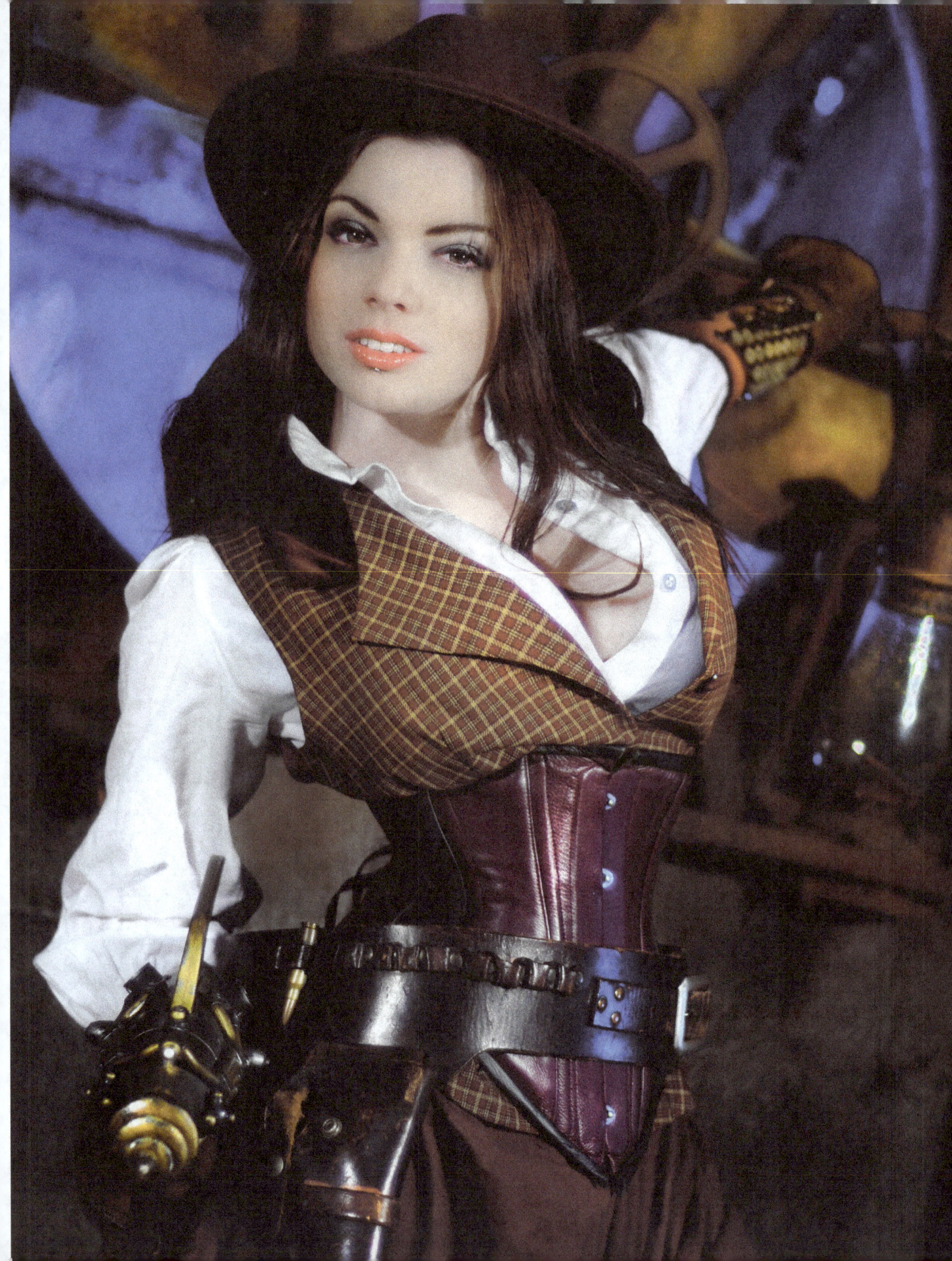

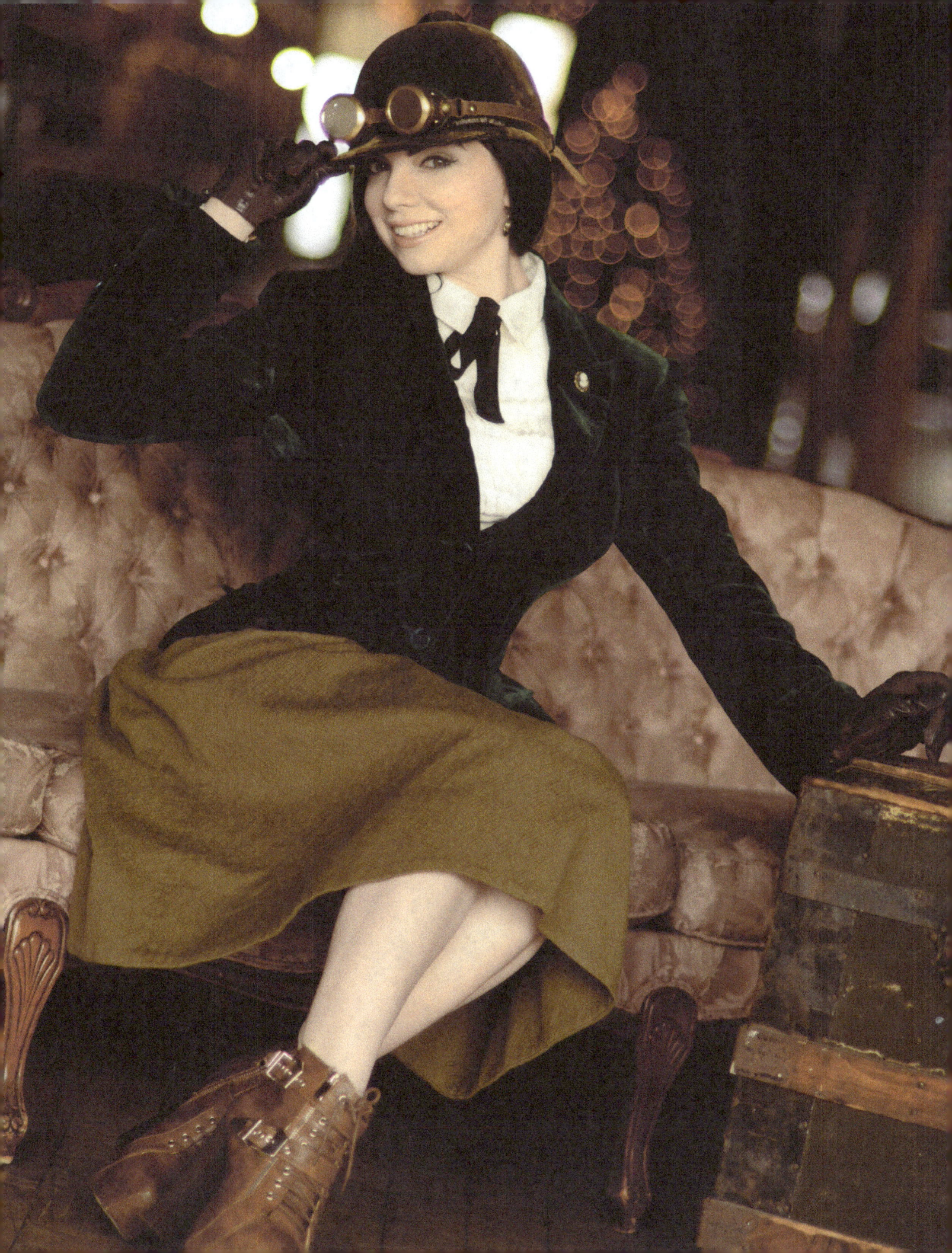

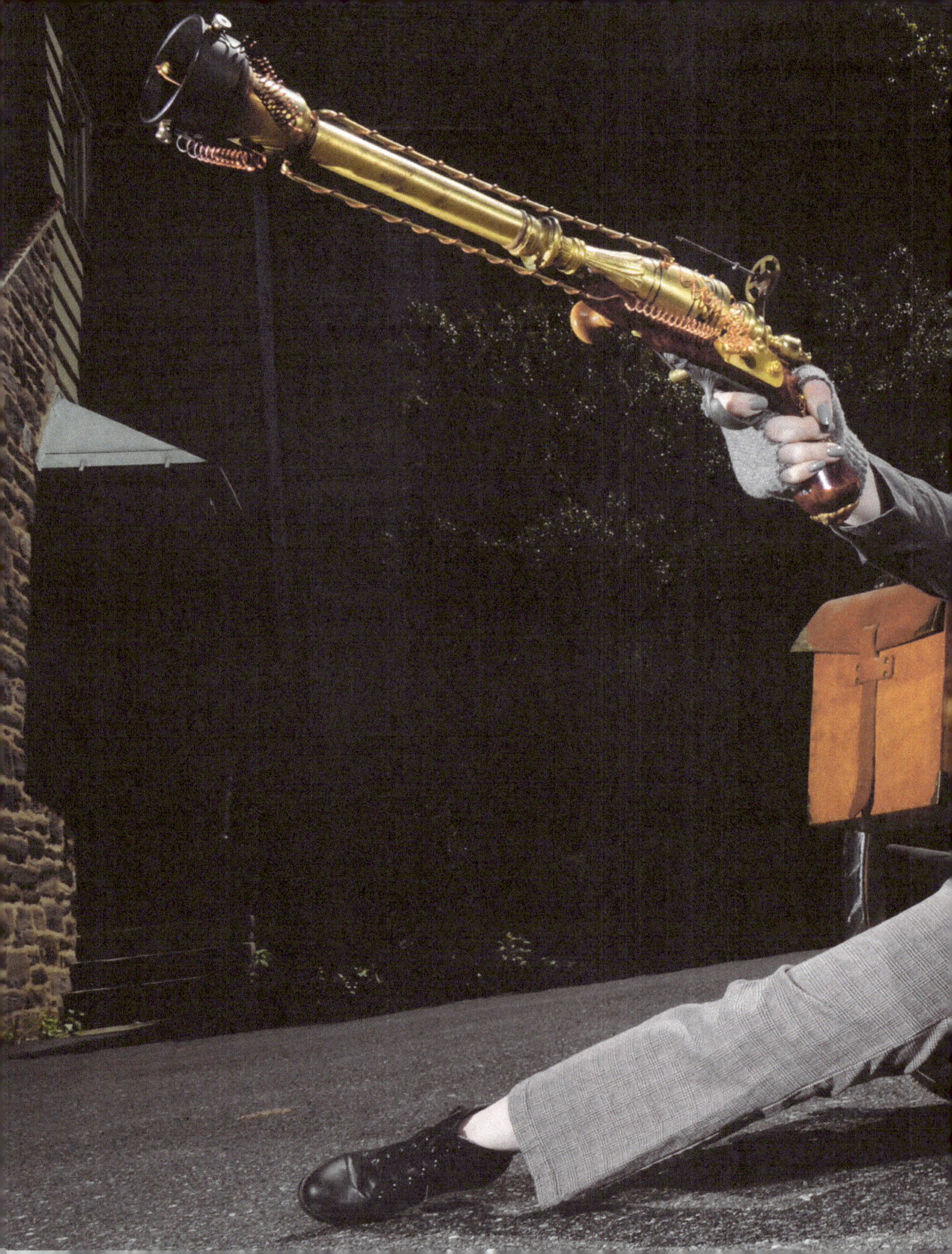

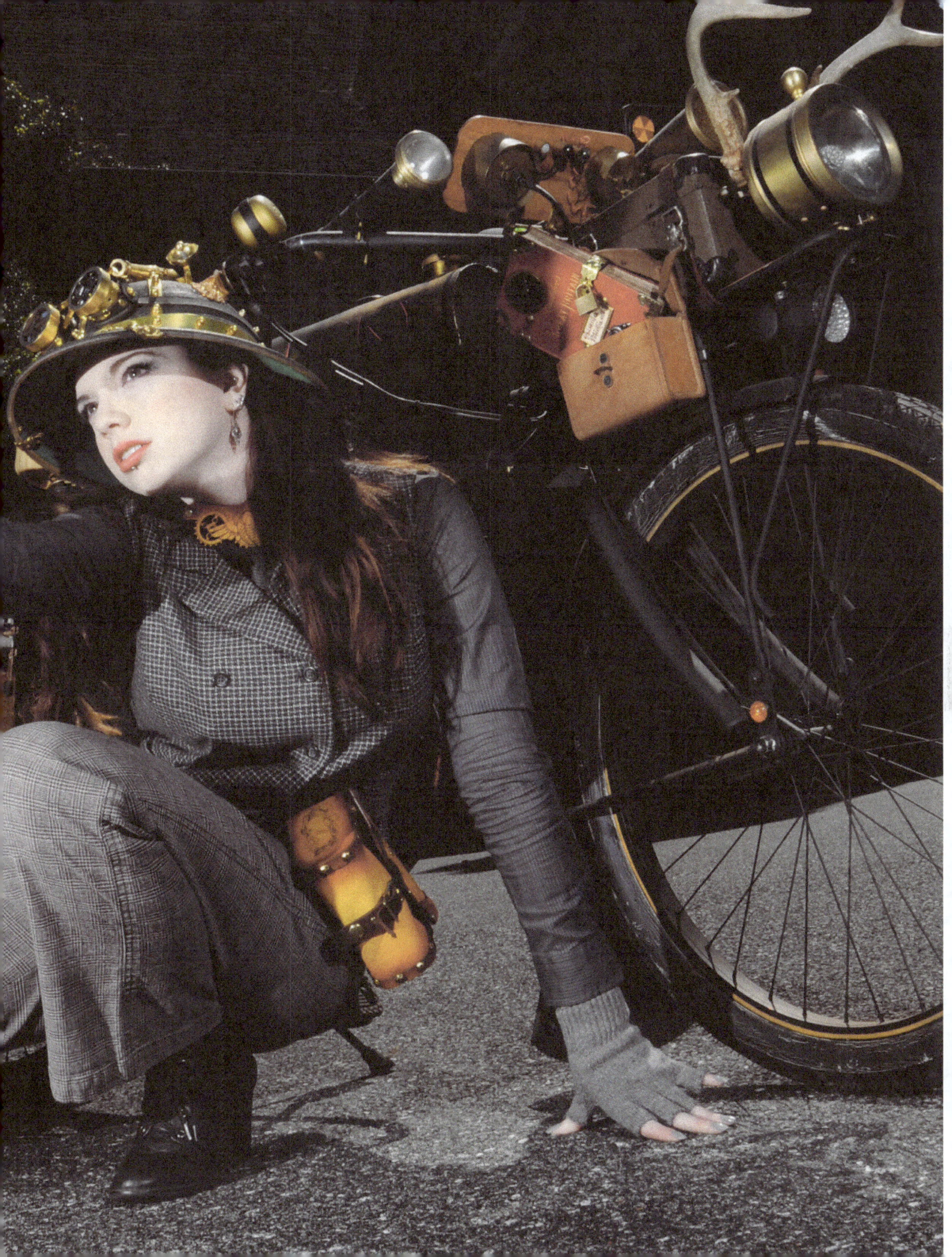

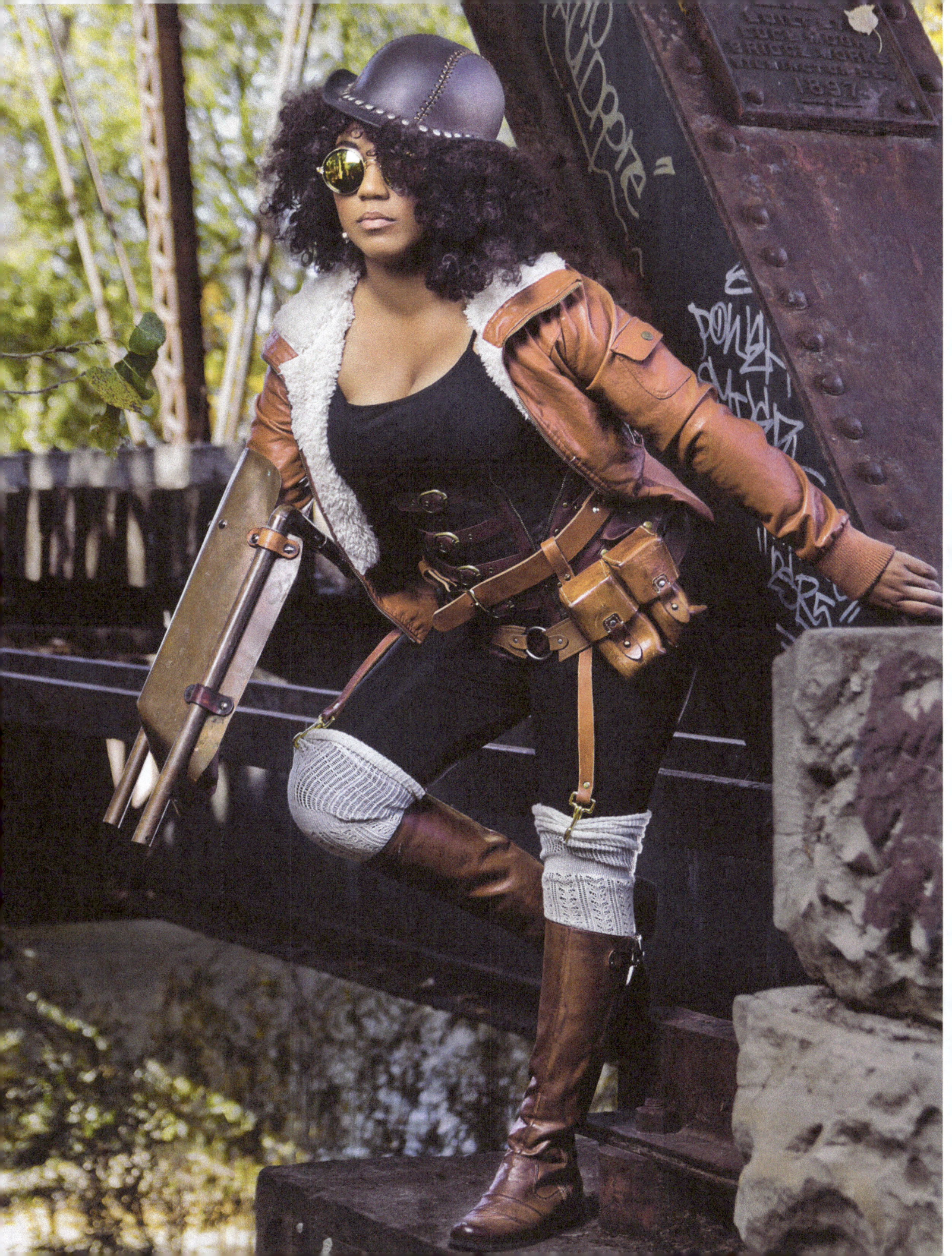

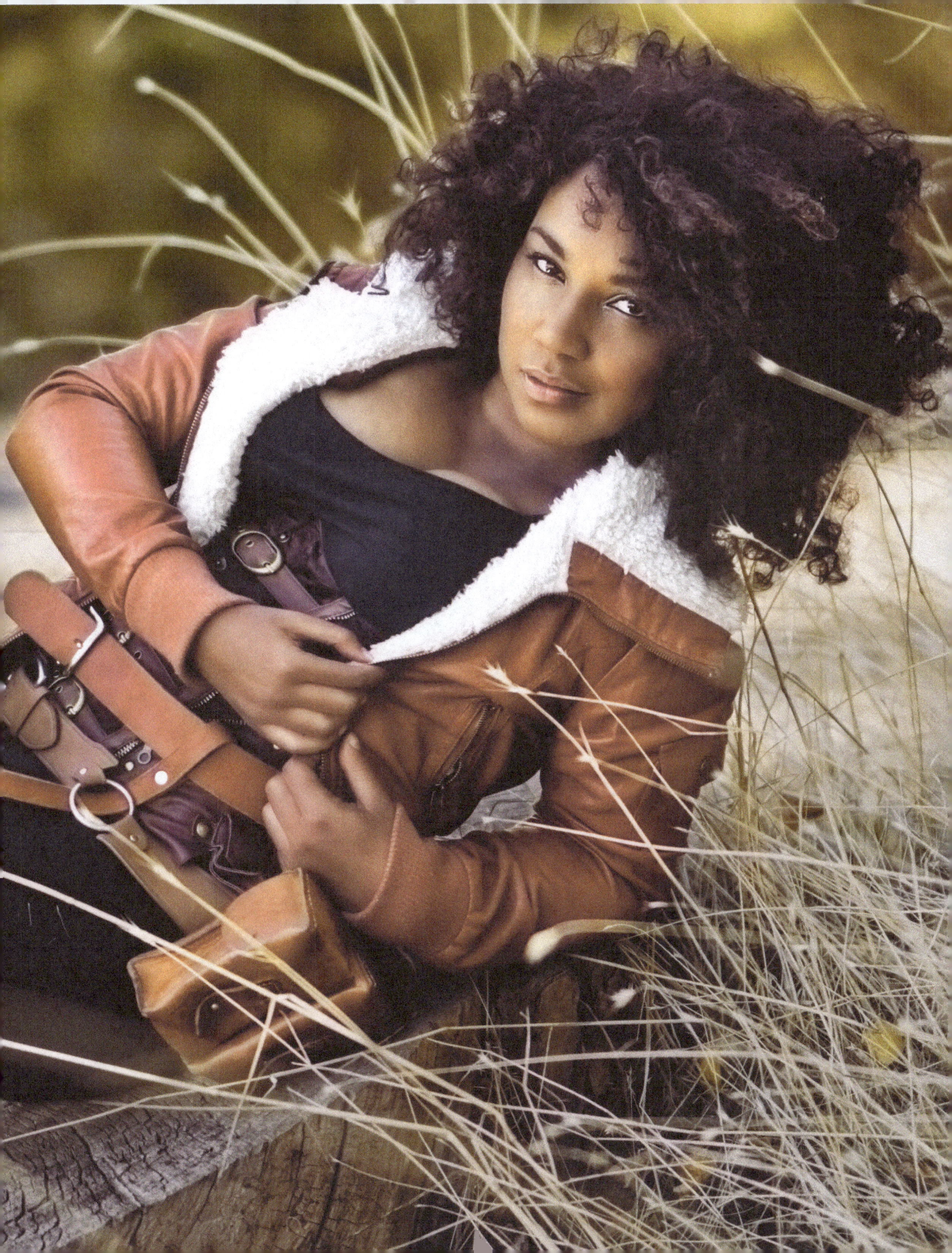

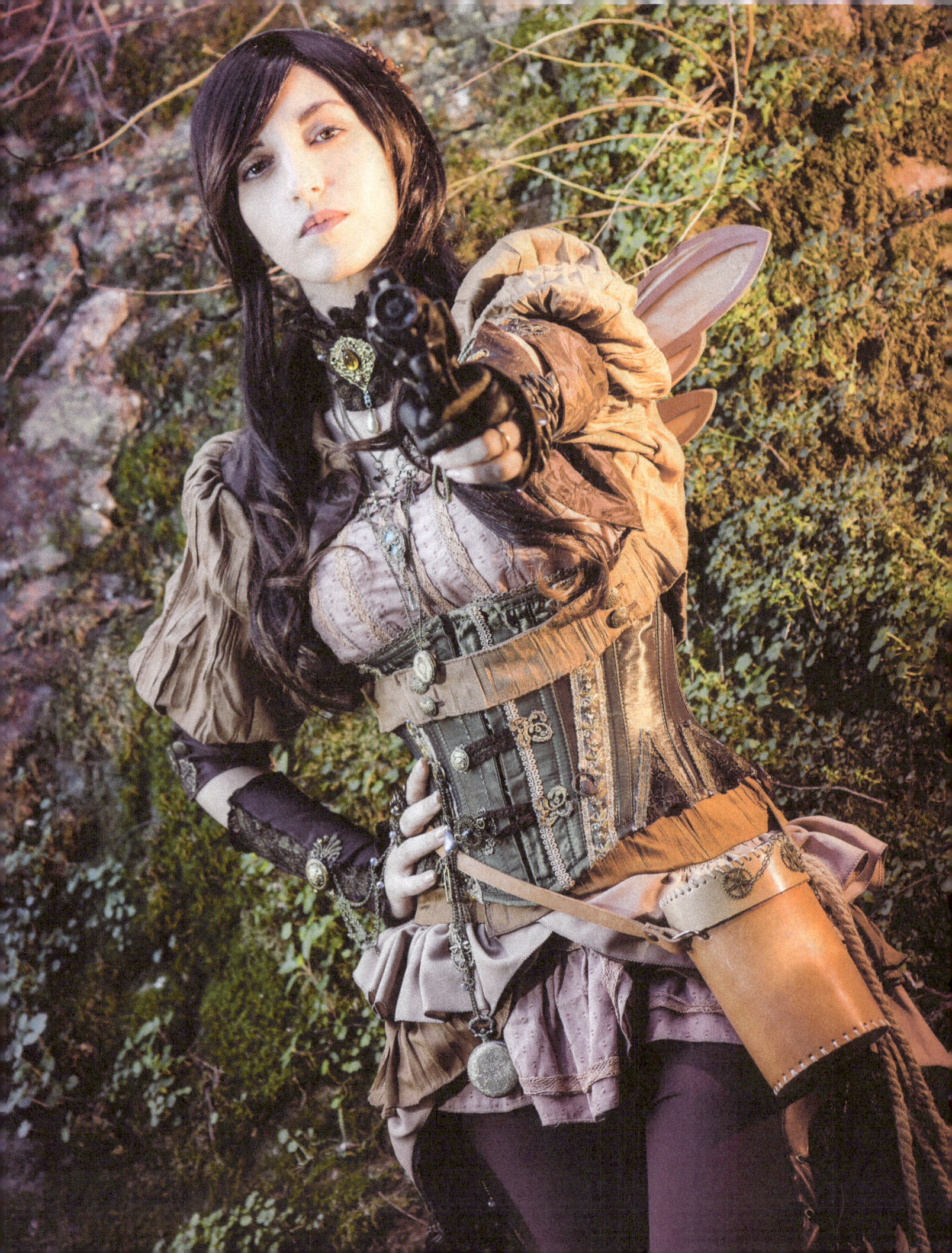

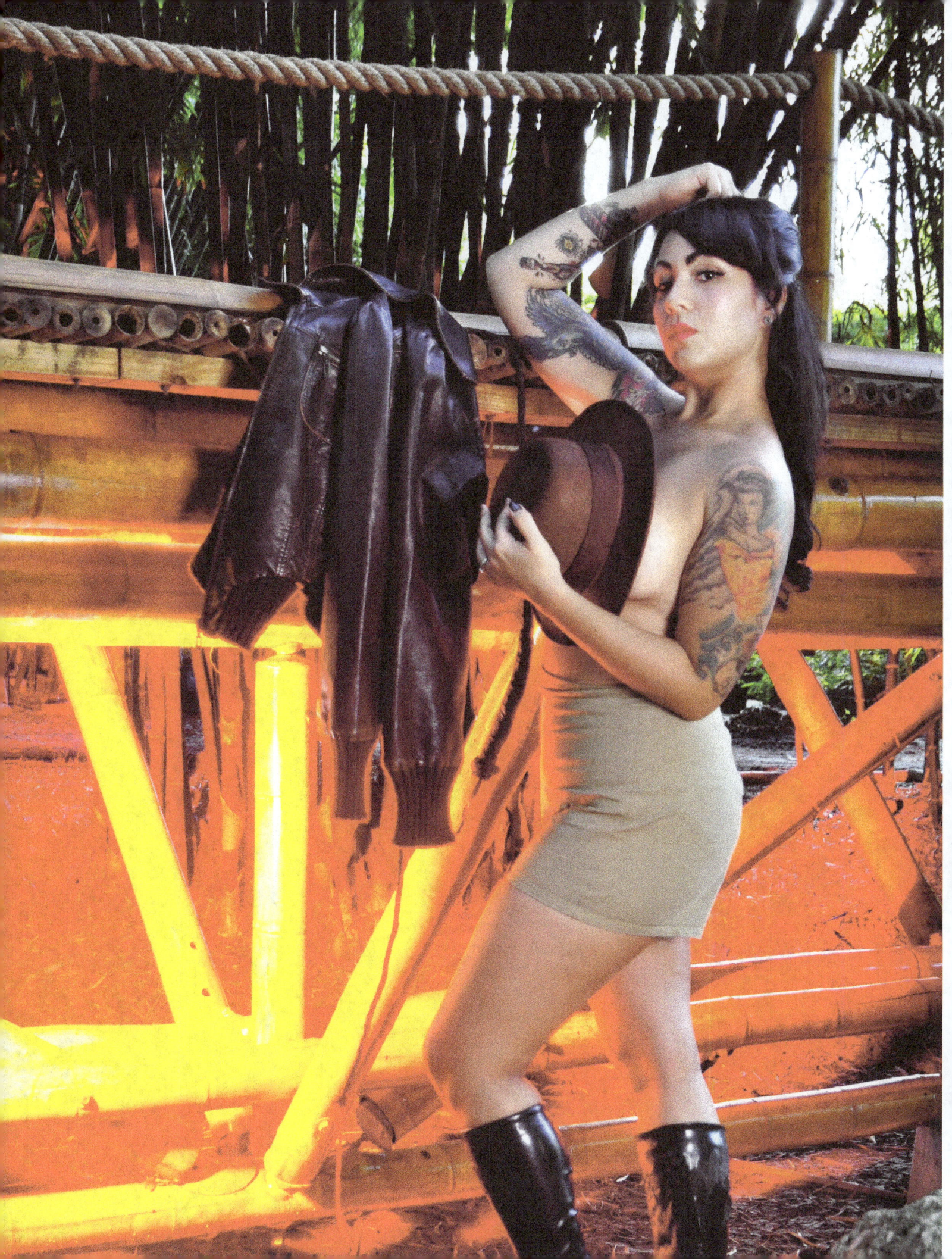

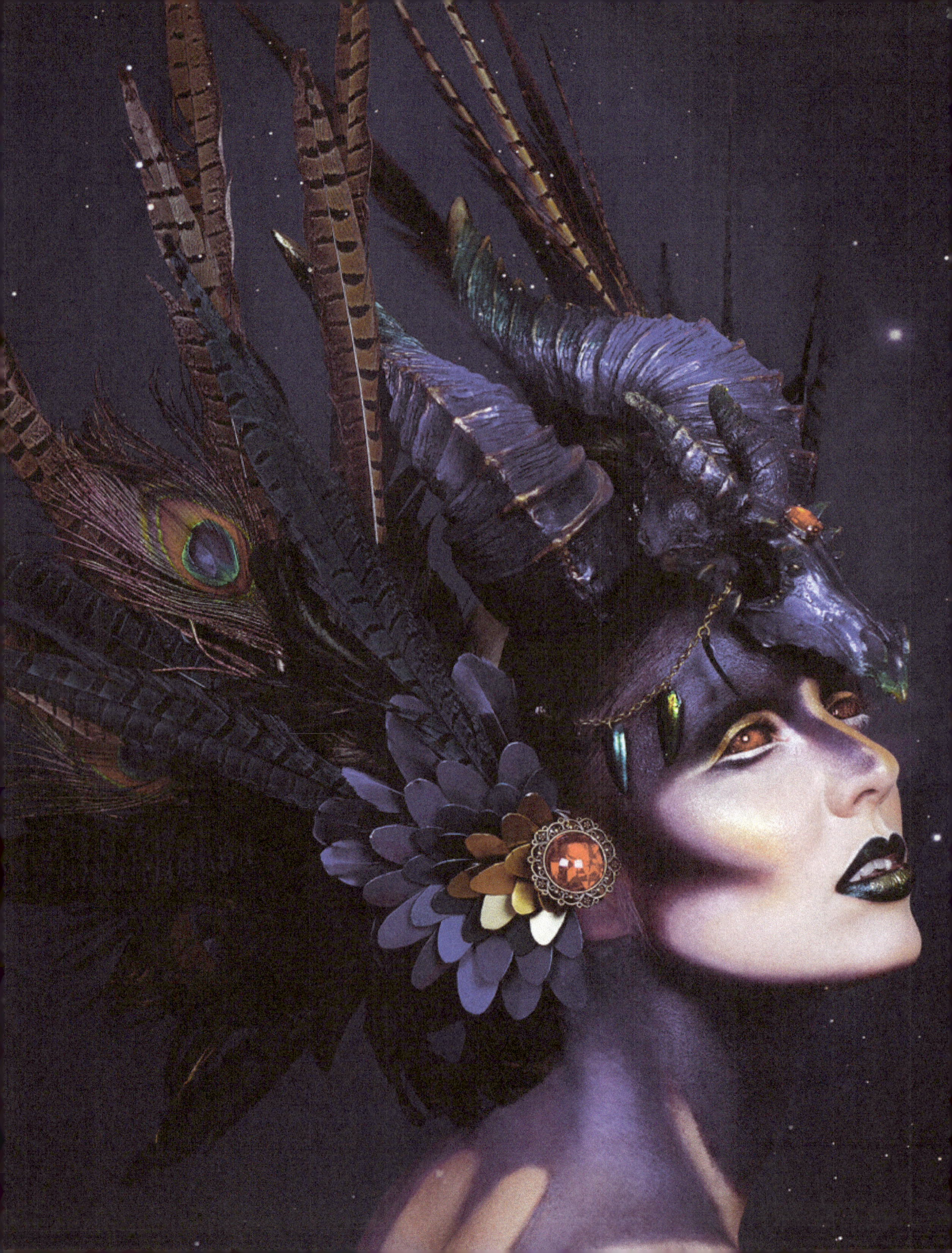

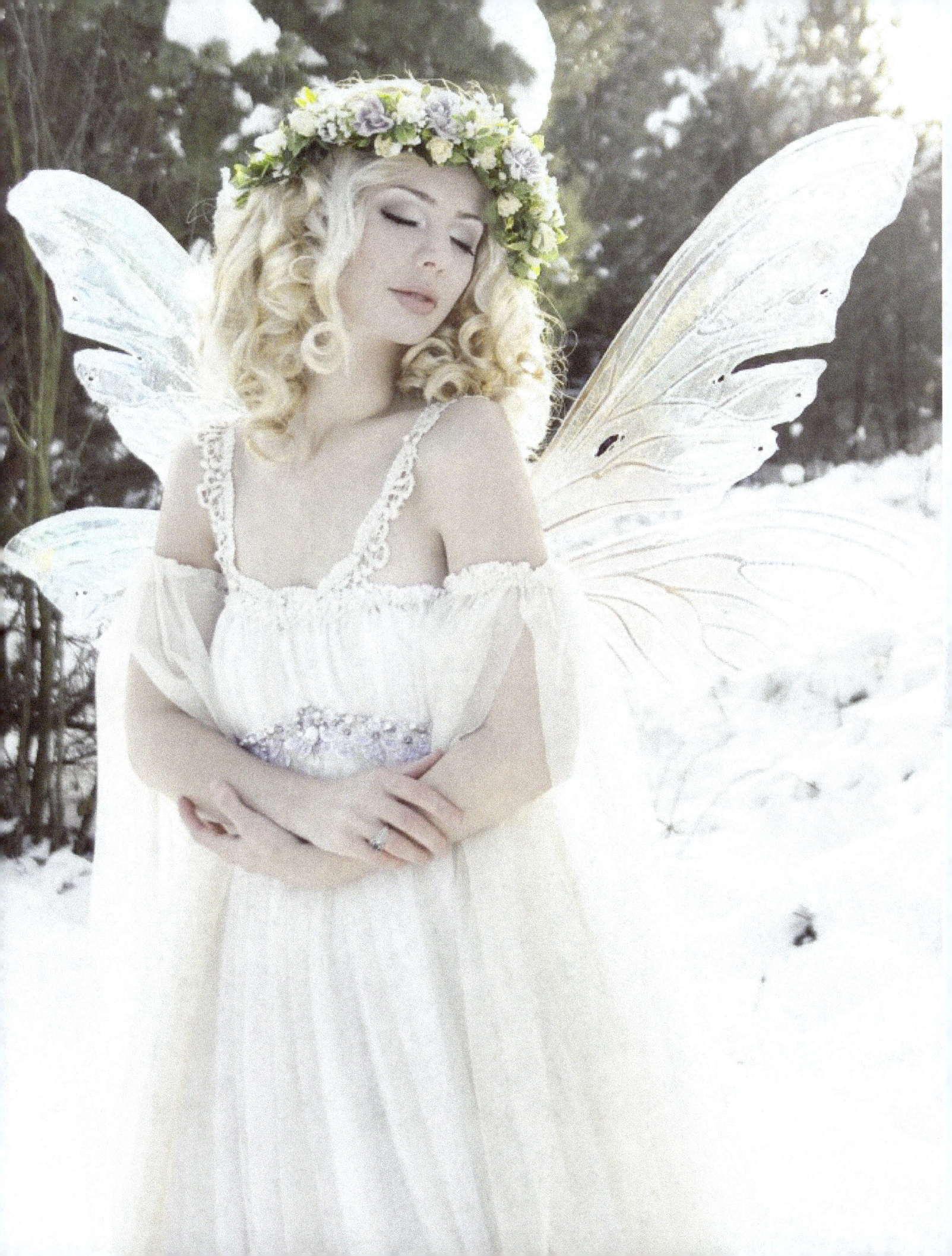

Visceral Attractions

CREDITS:

If you are a model or a designer who would like to have your photographs featured in Visceral Attractions, please contact the editor at fashion@carpenocturne.net.

Model: Lady Clankington
Photographer: Scott Church

Latex designs - Twisted Visions by Chantele Smith
www.TwistedVisions.co.uk
www.facebook.com/www.twistedvisions.co.uk
Models: Water Flower Girls

Model: Manuela P.
Francesco Ambuchi
Matteo Kutufa - www.facebook.com/MatteoKutufaPhoto
Stefania Resti

Model: Nivi
https://www.facebook.com/itsniviyo

Model: Dorian Phillips

Models: Weslyn Rae and Daniel Noe
Photographer: Rewski Photography

Designer: Fairytas
Oracle
Serenity

Model: Ramona Deville
Photographer: Dorian Phillips

April Hope
www.facebook.com/LoveLustorBust

Model: Lee Ann Luhrs
Photographer: Victoria Brown

SPOTLIGHT FEATURE

There are a lot of truly talented people out there, especially in our culture. Some use this talent simply for passing the time and personal growth, while others develop their talent to create services, works and objects for others to enjoy. Some post their creations on their website and never try to sell their works, while others use their talents to supplement or create their income. Carpe Nocturne Magazine admires, respects, and supports YOUR TALENT!

Whether you are creating to sell or only for personal enjoyment, LET THE WORLD SEE WHAT YOU'VE GOT!
There is NEVER A CHARGE to be Spotlighted or Featured!

The feature within Carpe Nocturne Magazine spotlights artists, designers, photographers, crafters and others with a creative side.

Does your work relate to the subject matter of this publication. Whether you do what you do for self-enjoyment or to sell your craft, we support you.

Contact: art@CarpeNocturne.net
Subject Line: Spotlight Feature

ARTISTS • COSPLAYERS • CRAFTERS • DESIGNERS • MODELS • MUSICIAN • PHOTOGRAPHER

Shuffling the Stars:
Zodiac Tarot Predictions
by Lexie

Aries the Ram (March 20-April 19)- Strength

Okay, Aries. First off, happy Summer! Secondly, the card pulled for your sign was Strength. Note here the image of this card. There are different kinds of strength, and the strength you're being asked to utilize this summer is the control over animal instincts. The summer is ripe with opportunities to indulge in vices, which is all well and fun, but a good dose of moderation is key here. Eating, drinking and making merry are all well and good, just make certain you don't overdo it. Also, it seems like there are going to be more than a few people and things irritating your soul this summer. This card also asks that you tame your temper as well, since that will be running hot along with the weather.

Taurus the Bull (April 20-May 20)- The Magician

The Magician here shows the figure working with the suits of the Minor Arcana: a wand (will), a sword (thought), a cup (emotion), and a pentacle (the physical). Whatever you've been dreaming up, make it happen. All the instruments for your success are there, and the opportunities are crawling out of the woodwork this season. Maybe the time wasn't right before, but it's right now. Also, creativity of all kinds will be the focus during these warm days. Whether it's painting, writing, cooking or DIY, you'll find your mind, heart and will buzzing, and your hands itching to bring it all into being.

Gemini the Twins (May 21-June 20)- The Hermit

Well, it's easy to see by looking at this card, it's not much for the partying. Don't be too shocked if you find that you aren't in much of a mood to socialize. You'll be finding yourself in a very introspective mood. Has something been feeling off? Something feels missing? This summer is the perfect time for an inward search to figure out what that something is. Also, note how the figure in the card is shining his light? During those times you are out and about with others, don't be too surprised if you start seeing those around you in a new light. The light might not be very flattering for some because the light of truth isn't always pretty.

Cancer the Crab (June 21-July 22) The World

The summer kicks off with your sign, Cancer, and this summer you will notice things going much more smoothly. People around you seem to be more understanding, and willing to help you out. As your sign is all about your home and family, you'll be more than happy during the summer with abundance of family gatherings and picnics that come with the heat and the holidays. This card is also favorable when it comes to finances.

Leo the Lion (July 23- August 22) The Wheel of Fortune

This is the same card I pulled for you during the Spring, Leo, however, this time it carries a different meaning. The Wheel of Fortune is just that: a wheel. This summer, the wheel stops on a new point. It's also a card of karma. What goes around, comes around. Past slights will be addressed whether you like it or not. But, on the plus side, your past efforts will be rewarded. You will also have an opportunity to give back to those who've helped you as well as weed out those who are just taking advantage of you.

Virgo the Virgin (August 23-September 21) Death

Okay, I see you freaking out at the image on this card, and I'm here to tell you don't. The Death card here does not mean literal death. It means change, and Earth signs aren't really big on change, but it is necessary. It means the ending of something to make way for something else. This summer, something will die, and it's something that's holding you back. An issue you've been letting fester. Once you take care of that, that's when you'll change. That Pale Rider? That's you for the summer. Death is usually represented with a scythe, and Virgo is the sign of the harvest. That discerning nature of yours will be on maximum overdrive. Your BS tolerance is at an all-time negative. If something is not for you, then it goes. That goes for situations as well as people. If you've been doing too much for others with little to nothing in the way of gratitude, then those people are in for a rude surprise. It won't matter who they are, and you're done giving chances. Toxic relationships of all kinds will be taken out with the rest of the garbage. Some might hurt, but it clears the way for people who will actually be beneficial to you.

SHUFFLING THE STARS
Zodiac Tarot Predictions by Lexie

Libra the Scales (September 22- October 22) The Lovers
For everyone that just perked up at the word 'Lovers,' please sit back down. While this card does relate to romance, it also represents choices, communication and relationships of all kinds. You might find that some of your choices may be influenced by those around you, and this card is asking you to take a step back and weigh your options. The influence of others will be strong this season, and be certain that anything you plan on doing is for your own good and not to please others who do not have your best interests at heart.

Scorpio the Scorpion (October 23- November 21) The Emperor
The Emperor represents structure, dominance, and motivation. This summer you'll have found that funk you were in and took care during the spring has gone. Now, you will have high energy, motivation and you're more than a little competitive. You're highly focused on your goals, which is awesome. But, don't overdo it. Don't overwork yourself, and try not to be too harsh with others who do not share the same goals and aspirations as you.

Sagittarius the Archer (November 22-December 21) The High Priestess
While you normally love to be out and about with others, this summer you'll find yourself loving your privacy more than usual. Certain people and things are rubbing you the wrong way, and you're not sure why. Here's why: the High Priestess is a card of intuition, solitude and hidden knowledge. Pay special attention to dreams, and utilize that love of research and learning you're known for to suss out any messages your subconscious is sending you. Once you do, you'll find yourself noticing certain things in your waking life that have escaped your radar. Pay attention to your intuition. If something feels off or wrong, pay attention to it. Don't over analyze it. Your subconscious is not a moron.

Capricorn the Goat (December 22- January 19) The Fool
Have you been feeling a bit antsy? Like you're restless and nervous about things to come? Well, if you peek up to what I just told Sagittarius about the subconscious not being a moron, this same thing applies here. What you're picking up on is the new phase of your life that's about to start. Opportunities in many areas of your life are making their way. But, that usually means change, and Earths signs don't really care for change generally. This is where the advice of the Fool comes in. It's okay to be spontaneous every now and again. While it is good to have your bases covered, sometimes all it takes to get your life truly rolling is a leap of faith.

Aquarius the Water Bearer (January 20-February 18) The Empress
This card, while the archetypical Mother card, also represents the beauty of nature. It also is related to Venus, the planet of Love and Beauty. Yes, romance is highlighted here, so don't be too surprised if you're getting a bit more attention than you're used to. But, aside from romance, Venus represents relationships of all kinds. If you feel that your relationships with friends and family aren't all they could be, that they're pulling away from you, then address those issues. Call up someone you haven't seen in a while. But, also this card asks you to nurture and take care of yourself. Heck, pamper yourself. Just don't overdo it and get lazy.

Pisces the Fish (February 19- March 20) The Chariot
So, remember that pushover label I told you to shove into the trash during the Spring? Well, you're turning it into roadkill with the Chariot. Your energy and focus won't be denied, and the effort put in from the Spring pays off. So, if you find yourself on the receiving end of some glory and admiration, soak it up! My only advice is to not let it go to your head. Pride is a good thing. Arrogance, not so much. Please, note the difference.

The cards used in this reading are from the Rider-Waite tarot deck. ∎

6 THINGS CAPTAIN AMERICA: CIVIL WAR KNEW THE FANS WANTED, AND DELIVERED MASTERFULLY

By Ethicus

FILM & LITERATURE
Captain America: Civil War

Iron Man, Captain America, Black Panther, War Machine, Falcon, Bucky, Vision, Scarlet Witch, Black Widow, Hawkeye, Ant-Man, and Spiderman. Each of these Characters has decades of story and background that fans came into the movie with. This was a treat for all Super Hero fans and it raises the baseline for what comic book movies need to achieve. Here are 6 things that Civil War delivered to the fans masterfully.

1 Captain America vs. Iron Man and their Civil War

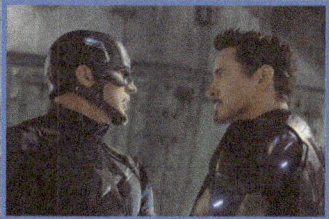

Even within the comics, Tony firmly believed that there needed to be oversight for the Avengers' actions, while Steve saw a future where the Avengers were the puppets of governments with larger agendas. Through the intensity of battling super heroes, political shenanigans of the government, and the glorious action of a Marvel movie, we needed to feel the fight between their contrasting opinions, and how their actions would trickle down and affect all that would come afterwards.

With an excellent story that answered any plot questions arising within the movie, it delves into deep political issues that escalate in relation to having increasingly active Super Heroes. The political battle between Captain America and Iron man is a battle of the old world hero mentality where Heroes stood for what they believed is right and a modern reality where governments believe their power must be controlled.

The movie's villain working behind the scenes, Baron Zemo, pits these two beliefs against one another and he acts as the main instigator: building the divisiveness among allies. It feels like a battle of belief, and each groups' champion was either Iron man or Captain America.

2 Division of Audience

There was clear tension between fans of the characters long before we even knew the full story. The movie elicited genuine allegiances to one side or the other and made the audience care and consider both sides of the argument as the events of the story played out.

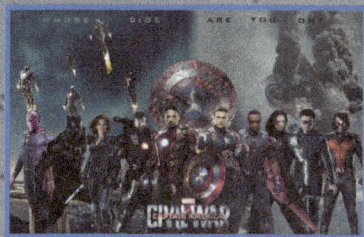

By the end of the film, even with the actions of Baron Zemo coming to light, the audience found themselves still split between who to root for. The writers continuously made it a point to not make the fight seem one sided or that one side was more right than the others. Both had valid arguments that the audience could relate to and side with.

Zemo's reveal of the real events behind Tony Stark's parents' death was a twist that shook the emotions of the crowd whether they were on Captain America's or Iron Man's team. Marvel did an excellent job at letting us live out our Comic book fandoms and side with the heroes we look up to.

3 New Arrivals

The Black Panther and Spiderman are two extraordinarily big names in the Marvel Universe and this movie did them justice. The introduction of both characters was done comfortably, and fluidly into the story – they were meant to be here and it felt right for them to be.

Not only did these two iconic heroes join the fray, but Ant-Man added his talents to the Civil War. Just as comfortably as it was for Black Panther and Spiderman to join in, Ant-Man fit right into the movie and on to #teamcap.

Each Character, including the other Heroes on the teams, all were important to the movie and the audience could understand their role in the larger picture.

4 Scaling of Powers

Throughout the movie, they meticulously placed key moments for each character to showcase the expanse and limits of their power. You felt the difference in hand-to-hand fighting prowess between Captain America, Bucky, and Black Panther.

You could feel the strength difference between normal Humans like Black Widow, Falcon, or Hawkeye, versus

FILM & LITERATURE
Captain America: Civil War

the enhanced individuals like Captain America, Bucky, Spiderman, and even Vision. War Machine felt heavier and bulkier than Iron man, and they acknowledged the differences in their gadgets and weaponry.

A vastly important aspect of super hero stories is the ability for fans to argue one hero's skill level against another. In the movie, they excel at giving every fan a reason to argue for or against any of the heroes shown.

5 With Great Power, Comes Great Responsibility

You could see the effects those with great power had on those around them. Marvel worked consistently to bring attention to the collateral damage caused within the Marvel cinematic universe.

Showing a montage of the destruction they've caused, Secretary of defense Thunderbolt Ross (who you may know from previous Hulk movies constantly chasing after the gamma giant) tells the Avengers of the mounting damage they cause as they attempt to stave off catastrophe.

The Sokovia Accords was a treaty crafted by over 170 governments to bring oversight to the Avengers. It is created specifically so the *responsibility* can be given to the *powerful* governments. Showing the collateral damage further aided in building the argument that people on #teamironman would have against the opposing team.

Responsibility was a recurring factor and an important aspect of the power each of the heroes held.

6 All-out Battle of Heroes

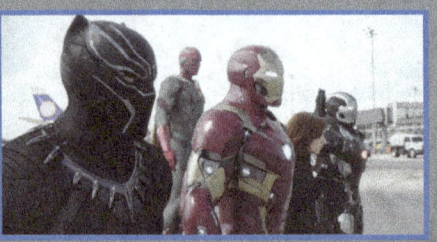

Of course, we all expected a face off and subsequent spectacular battle among the heroes. The audience was gifted with a glimpse of how magnificent these heroes are on the big screen and how magnificent all of these heroes using all of their powers are. We were able to see the strengths and weaknesses of each Character as they battled it out against every other Hero present.

Captain America: Civil War, like the first Avengers movie, was a pivotal point in showing the world what can be done on the big screen with characters just as big. It is an instant classic that will be watched years from now as people review and recap the most important movies in the Marvel Cinematic Universe.

JACK THE RIPPER IN GOTHAM?
A Look Back with the Writer of
"GOTHAM BY GASLIGHT"

By James Donnelly

The time is February of 1989, and comic fans are in a fever pitch over everything related to Batman. Tim Burton's feature film was hitting theaters in June, but thanks to trailers that ran ahead of Warner Brothers' Oscar-winning "Rain Man" which debuted late 1988, and the various articles and set photos that circulated in national newspapers and shows like "Entertainment Tonight," Bat-fans were salivating. Even the infamous 4-issue "Death in the Family" arc in which Robin's fate would be decided by fans calling one of two 1-900 numbers was not enough. They wanted more, and more would be exactly what they got with a book that would not only be one of the most successful Batman comics ever created, but would kickstart a movement in DC Comics that would change its landscape for quite some time. That book was "Gotham by Gaslight," written by DC editor Brian Augustyn and art by "Hellboy" creator Mike Mignola, with P. Craig Russell on inks and David Hornung on colors. "Gotham by Gaslight" was, unofficially, the first comic in DC's 'Elseworlds' imprint; an alternate universe in which a Victorian-era Batman confronted the most infamous villain of the period, Jack the Ripper.

In the years since, "Gotham by Gaslight" has taken on a life of its own outside the realm of the initial publication. In 1991, it spawned a lesser-known but not lesser quality sequel, "Master of the Future." This comic was also written by Augustyn, but with art by celebrated artist Eduardo Barretto and colors by Steve Oliff,. "Master" saw a Bruce Wayne who had put his dual identity aside until a megalomaniac threatened all of Gotham. Bruce must spring into action once again. Augustyn revisited the alternate universe again almost 20 years later in 2008 in "Countdown Presents: The Search for Ray Palmer: Gotham by Gaslight," where heroes, searching alternate Earths for Palmer, came across Earth-19, the Earth where this incarnation of Batman resided. This same Batman also appears in the Multiplayer Online Battle Arena game "Infinite Crisis," which features major characters and their popular Multiverse counterparts. If you look on the internet and YouTube, you'll also find concept art and some crude animation for a "Gotham by Gaslight" video game. The concept art clearly shows not only how this tale has created a fervent following amongst comics and gaming fans, but its influence on Steampunk culture throughout the years.

I've known Brian as an editor and writer since "Gotham by Gaslight" first hit the direct market shops in 1989. Not long after moving to the Phoenix area in the mid-2000's, I've gotten to know Brian as a friend and mentor. He's a font of knowledge about the industry with great love for comics and genre literature as well. Like Chicago, the city we both grew up in, he is also armed with a somewhat sardonic and dry wit and a passion for storytelling. So we met recently to discuss the genesis of "Gotham by Gaslight" as well as the legacy it left on not only the character, but the industry.

FILM & LITERATURE
Gotham by Gaslight

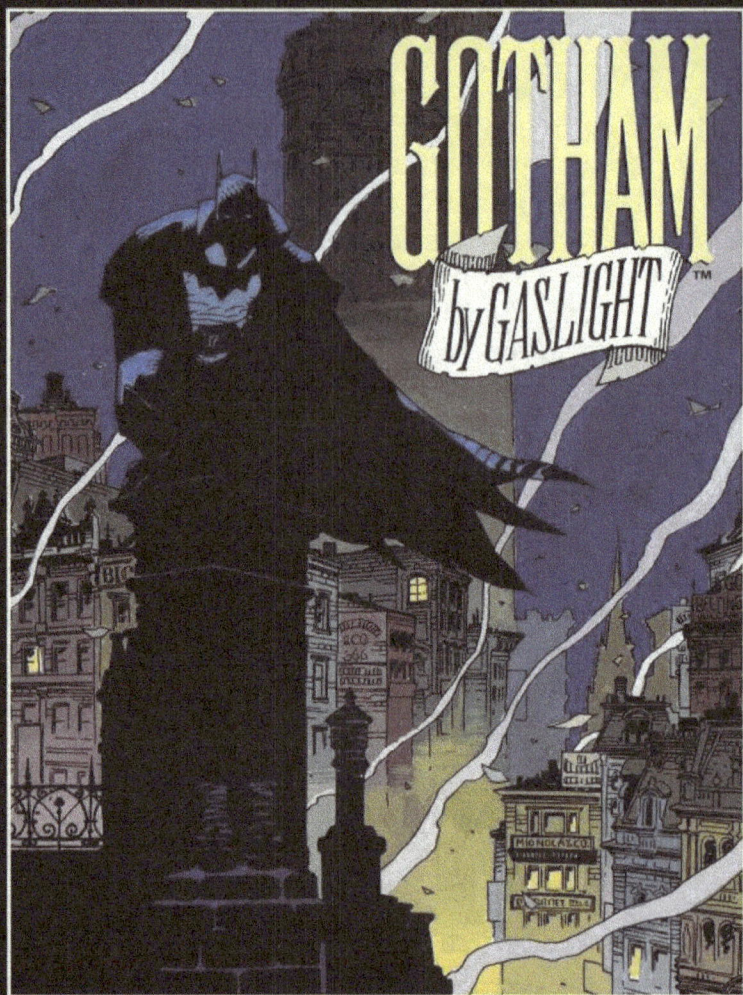

Brian Augustyn ◆ Michael Mignola ◆ P. Craig Russell ◆ Eduardo Barreto

[James Donnelly]: So let's begin by talking about "Gotham by Gaslight." As far as it being the first unofficial Elseworlds title, was that an editorial decision? Was that a company thing, or was that your thing?

[Brian Augustyn]: It was an absolute accident. Technically, I guess it was a combination of editorial and me. There was no real request of anything of the sort. I'd been at DC for about a year when the whole idea of the original seeds of "Gotham by Gaslight" came about. My buddy Mark Waid… I'm not sure whatever happened to him (laughs); he and I were both associate editors. We had become good friends because we had, you know, more than any of the other people hired at the time, we had a real sense of DC. Mark in a much more detailed fashion than I, but my reading went back quite a ways, so it drew us together. We're still very good friends to this day. We were both editing whatever we got our hands on as newbie editors would, and he had inherited "Secret Origins," which in a lot of ways was a dream job for him to use all the history he had internalized. So he did about eight months where he did all the stuff he wanted. He revisited the Superman origin to find a different angle. There was a Flash story in "Secret Origins" where Barry Allen became the lightning bolt that gave him his powers. That was one of Mark's earliest… I would refer to them as love poems to comic books, and it formed everything that he and I would later do on "The Flash." After doing all these wonderful things he was dying to do, he got an annual, and he was told with the annual, since they had never had one on that title before, "Make it special." How do you make it special? This was on the cusp of Tim Burton's "Batman." So he mused about this for a few days; he mused and he agonized and he laid on the floor and made sounds like a wounded kitten (laughs) and he came up with, what I thought and still think, was a brilliant solution. He said, "What if our annual is origins… inauthentic origins?" His touchpoint initially was we tell the origins, you know, we can do Superman, Batman, Green Lantern, Flash, whatever; because we're not repeating ourselves. We're inviting the writers to find a clever way to do an inauthentic origin. So that's where we started talking. [Waid] would call me at night because he was panicking, so finally I said, "What if they are authentic origins but they're *alternative* origins?" He said, "Okay… what would that be?" Pure top of the head, "What if Batman took place in the Victorian era? A *gothic* Gotham City?" Waid said, "Okay, I like that. What would he do? Who would he deal with? Would he be dealing with a Victorian Joker?" And I said, "No. Jack the Ripper." The next morning, I gave him a two-page overview, still not thinking I was going to write it. Again, this was supposed to be an annual; no big deal. He loved it, and he went to Dick Giordano, who was the editor-in-chief… a wonderful human being, my mentor in a lot of ways. He hired me, and we said, "Here's our premise for the annual. We'll do this, and maybe a Superman raised in Russia or something." Dick read over the overview, came back to us and said, "This is great, but it's not an annual. You shouldn't throw this away. If you can find a special enough artist, we'll do a stand-alone." So we come out of there thinking, "What happened here?" At this moment, having delivered the last pages of "Cosmic Odyssey," Mike Mignola's wandering the hallway. It's a chain of happenstance. It's my favorite part of all of this.

[JD]: Happy accidents.
[BA]: Yes. Mike is the perfect guy for this; a gothic Victorian city. We sat him down, and he says, "First off, I'll listen. You've got ten minutes, but even if I love it and say yes, I'm already committed to a 'Wolverine' graphic novel with Walt Simonson over at Marvel. I have to see that through, and I want to draw Wolverine; that'll be a real money-maker." So he listens. We do the ten minutes and he's engaged and says, "Okay, I'm interested. Tell me more." Within another fifteen minutes, Mike was contributing scenes. Things are springing from his visual imagining of what it would look like, and then he's giving plot points. I think one of the last things he said was, "I'm going to use Boris Karloff as the model for the Ripper." Then he looked at us and he said, "Oh, shit. I'm drawing this book, aren't I?" So the same day Dick said "find the right guy," we walked Mike into Dick's office and said, "We found a guy." Dick loved Mike and was always a cheerleader for him as we all were, deservedly, and I think two days later, Dick came to us and said, "It's not a one-shot anymore. It's now Prestige format; square-bound graphic novel." And the rest... is the rest. So we get an October launch; Halloween, since it's Jack the Ripper, and the movie is two months old. Everything Batman went through the roof.

[JD]: You found it being helped and not hindered by the film's release?
[BA]: I'm sure it would have done well, but we did phenomenal business because of the film and the interest it generated in Bat-products.

[JD]: Onto the sequel, "Master of the Future." Obviously with "Gotham by Gaslight," the timing of course, was...
[BA]: Lightning in a bottle.

[JD]: Yes, and not many people know there was not only one but another sequel in 2008 with "Countdown Presents."
[BA]: Yes, I got to revisit the era, that's right.

[JD]: And shortly after "Gotham by Gaslight," you were also editing "The Shadow Strikes."
[BA]: I had graduated to full editor and I was doing a whole bunch of stuff.

[JD]: And on that title, you were working with Ed Barretto.
[BA]: At the time, Ed was working on "Teen Titans" and had the not-wonderful job of following ["Teen Titans" artist George] Perez, and that book's editor Barbara Kesel said, "We've got to find this guy something good to work on." His work on "Titans," he had boiled it down to a very clean superhero style but he had started out doing comic strips for the European market out of Argentina. Three months later when they gave me "Shadow Strikes," I batted my head off the wall trying to figure who I could get, and remembered, "Oh yeah...". So I pulled out my Xeroxes of Ed's work and called him. Another happy accident. So when Mike had selfishly gone on to be a superstar (laughs) and priced himself out of the market, so who do we go to? Loved Ed, loved his work. He did a very different job but did a very wonderful job.

[JD]: Obviously the art styles are worlds apart. Ed has a grittier look and Mike is more expressionistic.
[BA]: Mike was very illustrative. A lot of what he did with "Gaslight" was in darkness, swathed in fog and that's just part of Mike's wonderful-ness. With Ed, we were going to get something different. He could get dark, as he proved with "Shadow," but he could do anything. He could do period very well. I then decided that we would give it a very different vibe.

[JD]: So it didn't have to come off with the expectations of the standard set by "Gaslight?" It could be its own stand-alone story either way.
[BA]: Right. We vaguely reference it.

[JD]: The cape and cowl hung away...
[BA]: He had retired. He couldn't see a reason to exist beyond his vendetta. So the story is really about Bruce Wayne growing into the bigger sense of responsibility.

[JD]: To the city rather than just to himself?
[BA]: To his heritage, yes. The first one I would characterize as more of a psychological horror story, certainly a thriller and a murder mystery. The second one was very much a Victorian science fiction story. I mean, we reference the hell out of Jules Verne but we also plugged in my love for history. I grew up in Chicago, and in 1892, we had the Columbian Exposition, you know, the celebration of Columbus's 'discovery,' also one hundred years before it was published as well. I had been collecting postcards about the Exposition since I was researching the beginnings of a novel I never finished about a detective hunting a serial killer, which was also based on fact. H.H. Holmes was a serial killer stalking the Exposition, and was also partially the inspiration for [novelist Robert] Bloch's work on "Psycho." I knew that was there, but we couldn't do it. We had done our serial killer story already. So the Exposition was chock-full of the new century about to be born, so that's how I decided where we'd be. The sense of a new world opening to Bruce, and the city moving out of darkness into light. The metaphors are... pretty sharp-edged (laughs). They're not subtle, but I liked it. We got to use Julie Madison, who had vanished into Batman's history. She had been his fiancée, even before Vicki Vale...

[JD]: Silver St. Cloud or any of the others...
[BA]: Yes, so we used her to be the voice of Gotham and the voice of responsibility. Probably as much about me growing up as it was about Bruce. Once that all came together and I knew the era, and I knew Jules Verne, it really began to tailor itself almost automatically for Ed. All that beautiful metal work in the airship and architecture.

[JD]: "Gotham by Gaslight" is generally labeled under the Steampunk genre...
[BA]: And we didn't know what Steampunk was at the time...

FILM & LITERATURE
Gotham by Gaslight

[JD]: People throw that term at it a lot, but it's "Master of the Future" that has a lot more of that element, with Antonio Diavolo, the robot that pilots the airship...

[BA]: It's much more what I would call 'clockwork' because clockwork robots existed. Antonio Diavolo is actually named after a famous robot used by a magician whose name I can't come up with [Note: Diavolo was the creation of Jean-Eugene Robert, later known as Robert-Houdin, a famous French magician of the 1800's], so to me, that was part of Verne. A lot of what Verne did was, in essence, early Industrial. It all just came together, but again, we didn't know Steampunk, but we are blessed to have been embraced. It's helped keep us alive. With the rather large Steampunk constituency here in Arizona, it was one of the first groups to sort of enfold me when I first arrived here six years ago. But it was with "Master of the Future" where we earned more of our cred.

[JD]: What was it like revisiting in 2008?

[BA]: I had actually pitched a few further graphic novels, but because we had invented, accidentally, this wonderful thing that became Elseworlds; ["Gaslight's"] third or fourth edition has the logo on it. Denny O'Neil, who was the Batman editor... Mark had left DC, he was not the editor for the sequel, but he helped us plan it... I started working with Denny, again, one of my heroes. I thought, "Oh my God, he's going to crush me." But Mark and I had written a "Detective Comics" annual for Denny which was a hard mystery and Denny put us through our paces. We got from Denny, "Even I don't think it's easy to do 'Play Fair' mysteries, but you guys did it." So, by the time we were doing "Master of the Future" with Denny, he was already inclined to go easy on me. We're both Midwestern boys too, so that helps.

By the time we got done with that, we pitched two sequels... actually, two more shots at the third book; again following the logic of thriller, science fiction, and keeping that era in mind. One of the things I pitched was Batman meets Cthulhu. Years later, they're building the subways, something is unearthed that was long-buried. I wouldn't have used Cthulhu, but I would have used the Lovecraftian feel. That would have been pure horror or metaphysical horror, and that just didn't pick up because Elseworlds was crowded. Everyone had six or eight of them in the boiler pots. I had pitched another that was specifically turn-of-the-century. There wouldn't have been a gimmick, it just would have been another thriller/mystery, but it would have been political... Boss Tweed and things like that. They never took off. So comes "Search for Ray Palmer." I was invited to be part of it before anyone knew what it was, but they knew they needed certain beats.

[JD]: Bouncing from universe to universe and Earth to Earth.

[BA]: Yes, so you had to have characters that could be taken along. We had to include characters but it couldn't be Batman, largely because Batman has no superpowers. I was given to create the idea, which I loved, and I would have loved to keep doing it, was to do the Victorian Justice League. They wanted someone who had, or who could be contrived to have, light powers. They needed things that worked in harmony with Green Lantern, so I pitched a Victorian Blue Beetle, based more on the original Blue Beetle who had energy powers. It is what it is. I would have loved to continue to populate Earth-19, and I think we've learned since then that this variant Earth continues to exist. It's part of the Multiverse.

[JD]: Do you feel, for lack of a better term, any kind of ownership? A legacy you helped to cement as far as that particular Earth? If it goes on without you, does it feel diminished?

[BA]: It would bother me, but it wouldn't be an insult. I can't own any variation of Batman. However, what that is, the very specific nature of the period and approach, especially on the heels of the sequel, I had a very healthy Batman...a very mentally stable Batman. They haven't continued it. When we have seen reference to it, it's been a sidebar. They acknowledge it exists by showing a scene. If someone were to write a series there... yeah, I would hope for a phone call (laughs). If I didn't get it, I would go to Bleeding Cool and whine about it (laughs). Actually, I wish I knew some of the editors. Everybody is so young and new now. Pretty much everybody I worked with has retired or simply moved on, because I would pitch something, a one-shot or something to acknowledge that in the Multiverse is this thing. I sent Dan DiDio an email a while back, but they're very busy rebirthing the DC Universe. But once they're done, the Multiverse is open again. They can play on a broader scale, so we'll see.

[JD]: Was the Elseworlds imprint very much on the heels of "Gotham by Gaslight?"

[BA]: Oh, yeah. A lot of the writers said, "Wow," and said to me, "Once you did that, you made it possible," Amusingly, I got pitched a couple of "Flash" Elseworlds, to which, at that point I was about to hire Mark to do it. I said, "You know, if we're going to do it, we really need to offer it to the regular writer." We ultimately never did because very quickly, it became really clear that there

FILM & LITERATURE
Gotham by Gaslight

was a lot of great stuff. "Superman: Red Son" was brilliant. "Batman: Red Rain," a lot of these things were great, but quickly it became what Waid would refer to as, "I got it: Green Lantern in the Peloponnesian War." So it became... well, there's a lot of great stuff and a lot of other stuff.

[JD]: Well, there was an entire year where all the annuals were Elseworlds stuff.
[BA]: We did one of those, in fact. We did "Citizen Wayne" ["Legends of the Dark Knight Annual #4] with Batman as the villain and Bruce Wayne as the hero. You know, that's what that is, though. Saturation.

[JD]: That's pretty much the comics industry as a whole.
[BA]: (laughs) Well, it's any entertainment industry. People keep doing what works until it stops working. But even if it's just me talking, it's a milestone to the Universe. I will say, talking about whether anything else will ever come of it, apparently there are possibilities for media extensions of some sort or another. "Gotham by Gaslight" is being considered for DC Animation. I'm not saying it will happen, but on the heels of "Killing Joke," two or three other projects have been pondered. I think ours and "Arkham Asylum," essentially "Bat"-product... you know, stuff happens. Things happen by momentum more than anything else. "Killing Joke" is the only one-shot book that outsells us in perpetuity. They've sold in the ballpark of a million copies in many editions. I believe the last time I saw totals for us, we were in the neighborhood of 900,000. I still get checks, not huge checks (laughs), but because it's still in print... I wish it were a salary!

[JD]: That's... I hesitate to use the words, "career-defining" because you have a much larger career.
[BA]: Well, I do, I guess. But that's certainly the thing... I'm proud to have my name associated, and because it's always in print, it's something I can hold up. You know, a lot of the stuff I did, I don't even remember doing it (laughs)... so I'm proud. You know, we did something right. Pure accident, pure magic, maybe completely out of my hands. Luck. Kismet. But you know, I was there. I'm proud of what we did. And on a weird kind of fanboy level, the fact that Mike Mignola and I are associated on something, it's like, "That's pretty damn cool company!" Because you know, he's amazing. Mark and I knew with Mignola, we had a comet by the tail, barely. We were lucky and blessed that he decided to see himself in the project. Perfect, you know. I don't know if it would have happened without him. I mean, even if we had gone and gotten someone else amazing, I don't think it would have been as right as it was with Mike. He's just the perfect person for that, for the initial storyline anyway. I love it, you know.

I still go back to it. I can't stand reading the words (laughs), but I love looking at the pictures.

[JD]: Another thing about "Gotham" is that obviously the tone of the book is dark, which is appropriate for the kind of book that it is...
[BA]: Appropriate for the book, appropriate for the era..

[JD]: You also present the Batman that was kind of the standard before Frank Miller and Grant Morrison coming in and doing these Batman as a force of nature kinds of books whether it's "Dark Knight Returns" or "Year One" or "Arkham Asylum.", In your book when Bruce is in prison, you have him as the detective, and one who had studied under the "London detective," which is open for interpretation...
[BA]: Oh, you don't have to interpret. It's Sherlock Holmes. And Freud. He was travelling the world honing various skills.

[JD]: So I guess my question is was having the detective side of Batman come through regarded well?
[BA]: It's been well responded, yeah. Mark was the editor and we were totally symbiotic in a way as we would be on lots of other stuff, but Dick Giordano obviously had worked on many variations of the Batman mythos, having helped Neal Adams sort of having reintroduced the Dark Knight...

[JD]: The era of the Dark Knight Detective...
[BA]: Right, but Dick was also a mystery buff, mystery novels and things like that. We lived very close to one another in Connecticut, so I had the wonderful thing of taking an hour-long trip with him every night going home and talking about... everything; picking his brain. And we talked a lot about hard-boiled mysteries and our shared love for that. For my Batman, doggone it, the one I grew up with was a detective. That was his "superpower." He was the World's Greatest Detective. So, if I do a Batman story, whenever I do a Batman story, there should be a mystery of *some sort*. There should be a threat that he has to unravel...a problem. Did anyone see it as a plus? I don't know. Dick liked it because it agreed with his vision of Batman and my vision and Mark's. Mark is a big fan of puzzle mysteries. They're perfect for the way he thinks. He's great at detail and trivia.

We were all on board, and I don't know that anyone said, "That's unlike Batman" or "great to see that come back." It never really came up. It was just something that was a natural... I mean, literally the third thing I said to Mark when I was verbally pitching what this became

FILM & LITERATURE
Gotham by Gaslight

was, "Okay, Victorian era, Batman in gothic Gotham City, Jack the Ripper has come to Gotham... oh, and the guy who can't account for what he does at night gets arrested: Bruce Wayne." So it had to be there anyway, solving the mystery from jail. I'd write that into a movie. You've been condemned, you've got three days before you hang and you can't move. I may steal it for myself and write it into a movie.

[JD]: Are you a "Ripperologist"?
[BA]: No. I studied it generally as part of just being a history buff and a mystery buff. I read up on it and then I immersed myself when I was writing the book, but I would not consider myself an "ologist." I was a dabbler and I love to research, so I buried myself in "Ripperology" for a while. That's why the Duke is on the boat and the doctor. Probably as a fanboy and a history boy, I know a little bit more, but no, I'm not. Also, I grew up in the midwest, and with Ed Gein… I guess if you're more darkly inclined. Richard Speck, John Gacy, you wind up with a fascination for that kind of evil. I read a lot of the theories and a lot of fiction. Robert Bloch introduces the book because he wrote, "Yours Truly, Jack the Ripper." Great story. Helped us find the voice.

[JD]: In "Master of the Future," the villain, Alexandre Le Roi, refers to himself as the "Man of Tomorrow" and is in this flying machine. His color scheme is blue and red. Is there any subtle inference to Superman there?
[BA]: In regards to interpretation, first, as far as "Gotham by Gaslight" is concerned, there's a wanted poster when we meet Gordon. It's the only Joker appearance in any of it, based on H.H. Holmes. I made it strychnine because it causes that rictus in the smile. But it's a throwaway. We didn't want to use The Joker because it's too easy. It's a nod, an Easter Egg as we now call it, and I have Gordon refer to him as a "jasper." The reason he calls him a "jasper" is because that's lingo of the time. Somebody wrote me a three-page letter… remarking on my brilliance for using "jasper" as a descriptive because jasper's a mineral that's bright green. I love research, but, you know… I almost never go huntin' up my own ass to find something, you know. That was too far, but I thought it was hilarious. The period, it would've been wrong for Gordon to call him an "asshole." So like I say, there are theories that get buried.

In "Master," the villain is really based on a Verne character or archetype, master-of-the-world type. He was a variant on Nemo. Nemo more than this guy affected my characterization because I was a fan of "Mysterious Island," "20,000 Leagues" and so on. In a lot of ways, he speaks the way he does because that was how Verne's characters did…that sense of science and the future; science over superstition, which is what Le Roi is all about. He's dressed the way he is because that's how Ed drew him. He's colored the way he is because [Steve Oliff] colored him. I think it's actually a French military uniform. So in regards to your question, it's no thought I gave it, but I'm pretty sure that's what the French military or cavalry wore. I guess I'm more brilliant than I know (laughs). A writer friend of mine says that all literary criticism is about writing, not about *the* writing. It's about the critic's vision of what writing is and not so much the product. If someone says, "Hey, I got this out of your book," you can't say it's not valid because whether you knew it or not, you wrote something they were able to turn into an interpretation.

[JD]: It was just a theory (laughs).
[BA]: I'm not criticizing; I'm flattered. But if Superman had shown up intentionally, he would have been a good guy.

[JD]: I only say that because of the idea of piggybacking off of "Dark Knight Returns" and how to this very day, Batman and Superman have been adversaries as much as they've been allies.
[BA]: They are day and night, literally. I'll agree with you that the influence of that book and "Watchmen." From simple things like getting rid of the thought balloons, it's the birth of captions as thoughts. It's the birth of talking heads on TV as narrative devices. We still use that. Those two books, and [Howard Chaykin's] "American Flagg." Those books taught us what the future of writing comic books was. Where I started reading into things, after the first two books, I was convinced I was writing "King Lear" as Batman. There are so many parallels and the scope of it is very Shakespearean. So I was kinda pissed off (laughs)… "Wait a minute, I came up with the perfect metaphor!" Later I was kind of happy because maybe someday I'll write Batman as King Lear.

[JD]: I'd read it.
[BA]: Well, if we're any good, we should never run dry. We might occasionally run stupid (laughs), but we shouldn't run dry.

"A Tale of the Batman: Gotham by Gaslight," the collection of both the first book and "Master of the Future," is thankfully currently available from DC Comics and based on the legions of fans of both comic and Steampunk culture. Hopefully, it always will be. ■

FILM & LITERATURE
Linnea Quigley

Actress Linnea Quigley is blonde, beautiful, and fit. She has been called the Ann Margret of horror for her work in many B-movies of the 1980's which have become cult hits. Of Scandinavian heritage, she was born in Davenport, Iowa to Heath and Dorothy Quigley, a chiropractor/psychiatrist and housewife.

Linnea describes herself as "really really really shy as a kid. I never thought I'd be a performer." However, Linnea loved watching horror, especially creature features. She and her friends would re-enact the death scenes and see who could die the best. "One of my favorites was *The Birds*," she remembers. "Afterwards, I got scared looking at birds. I also loved scaring my friends."

Linnea's family moved to Los Angeles after she graduated high school, and she got a job at a Jack LaLanne gym. This was the era when men and women worked out on different days, and the female trainers had to wear heels. Several of her co-workers and clients did extra work in films and encouraged Linnea to try it. She began by doing background and modeling. Though she never did porn, she often posed for the covers of adult movies.

Linnea moved up to small parts in such films as *Psycho from Texas* (1975) and *Stone Cold Dead* (1979). She was eager to do more, and says that "when I was just starting out I didn't always read the scripts. There were a lot of shower scenes and unnecessary nudity. I always felt judged on my looks."

Linnea admits that a lot of her early films were formula slasher flicks, horror or action/adventure, with predictable plots and characters. Some were silly but fun. The main one she regrets was *Silent Night, Deadly Night* because it was too much of an exploitation film - she was impaled on a set of deer antlers.

Linnea worked her way up to bigger roles, still as a sexy gorgeous babe, but also showcasing her sassy attitude and humor. She established herself as a scream queen with her work as Trash in *The Return of the Living Dead*, the 1985 zombie classic which gave us the famous cry "Brains!" and featured Linnea dancing naked on a grave. She particularly loves campy horror, which allows people to laugh at what scares them. "Life is serious," she explains, "horror shouldn't take itself too seriously." Linnea maintained her status as "Queen of the B's" with kooky films like *Sorority Babes in the Slimeball Bowl-O-Rama* (1988), *Night of the Demons* (1988) and *Hollywood Chainsaw Hookers* (1988).

Unfortunately, this era of horror portrayed women as sexualized prey for a mostly male audience. However, Linnea did not want to do heavy drama so she made the best of it. She starred in the first two films of the comedy series *Vice Academy*, but, being 5'2" and size 3, she was

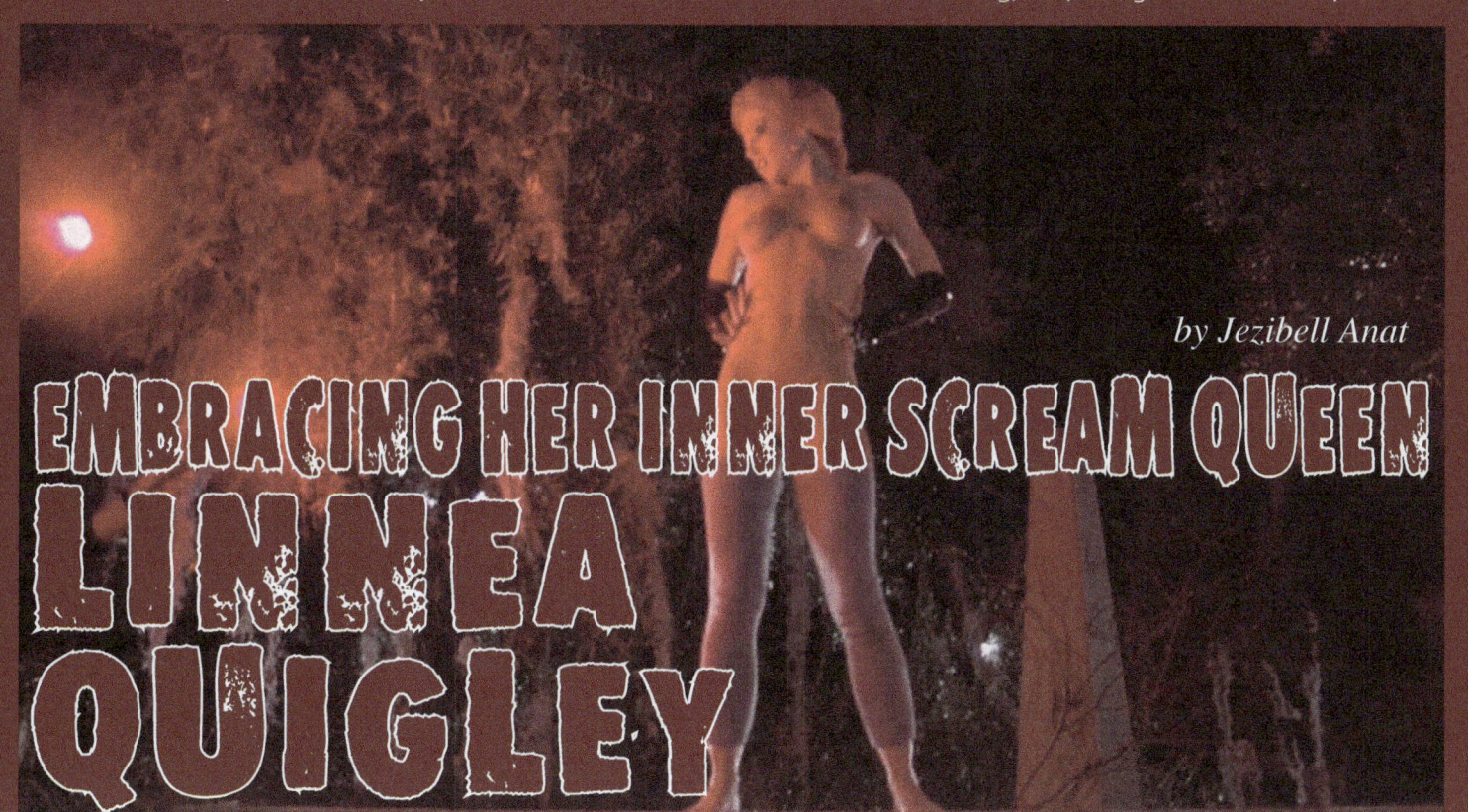

by Jezibell Anat

EMBRACING HER INNER SCREAM QUEEN
LINNEA QUIGLEY

FILM & LITERATURE
Linnea Quigley

usually typecast at a victim in horror. This was also a time that promoted female rivalry, not collaboration, since the public loves a good cat fight. Linnea says that, "there really was no competition between me and Michelle Bauer, my co-star in *Sorority Babes*, because we were such different types."

Linnea is thrilled that the role of women in horror is expanding. "Linda Hamilton in Terminator opened a lot of doors for women to play strong, tough characters. More and more female writers and directors are entering the field, and it's getting a lot better. There's less emphasis on looks, less gratuitous nudity, and fewer stupid shower scenes. And I'd much rather be the killer than the victim."

Today, women have a much greater range of roles, and horror is one of the few genres where a female lead can actually carry a film. Linnea does feel that some modern horror relies too much on special effects. "I don't like a lot of gore and prefer psychological horror such as Hitchcock, where all is implied."

Linnea appears at conventions throughout the country and loves meeting her fans. She has noticed a change in the con attendees. Once a primarily young male audience, women are attending more and more, attracted by the increasing power of women in the horror field and the creative opportunities of the genres. About her own work, she says "I like coming up with concepts, but don't have the patience to write the script. And I love to direct."

Linnea is always interested in new projects and challenges, and has become much more selective in terms of her films. "Now," she says, "I always read the script. I will not work in a film that does anything against animals, or has unneeded sexual scenarios such as threesomes or bondage." Linnea recently enjoyed playing the vampire hunter Agnes in *Blood River* and the vampire Countess in *Miss Strangelove*. Linnea is also an animal rights activist, an advocate of PETA, and a vegan. She currently resides in south Florida, maintains her fitness through yoga and weights, and looks after her furbabies. "Horror people," she declares proudly, "are the biggest animal lovers."

TORN CURTAIN
Cat People

By Sergio Manghina

As the great chef once said, to make a great dish it is necessary a perfect balance of the various ingredients. Val Lewton, producer of RKO Pictures, Jacques Tourneur - the director - and Nicholas Musuraca as cinematographer, were definitely a trio of masterchefs of the classic Hollywood era. Because into "Cat People" - each in his own role - these men probably infused the best of their artistic genius, developed over the years.

French actress Simone Simon is the perfect synthesis of Irena, a charming woman who works as a fashion designer in New York. Naturally, love is the first thing in her wish list. However, Irena also hides a secret, tied to her Slavian origins. An antique terrible legend weighs on her mind as a constant threat. As her Serbian ancestors, she might turn into an aggressive panther if overwhelmed by erotic passion or jealousy, and hence transforming her in a murderess. A dramatic epilogue is on the way, of course. When love strikes her heart, another woman could undermine her happiness.

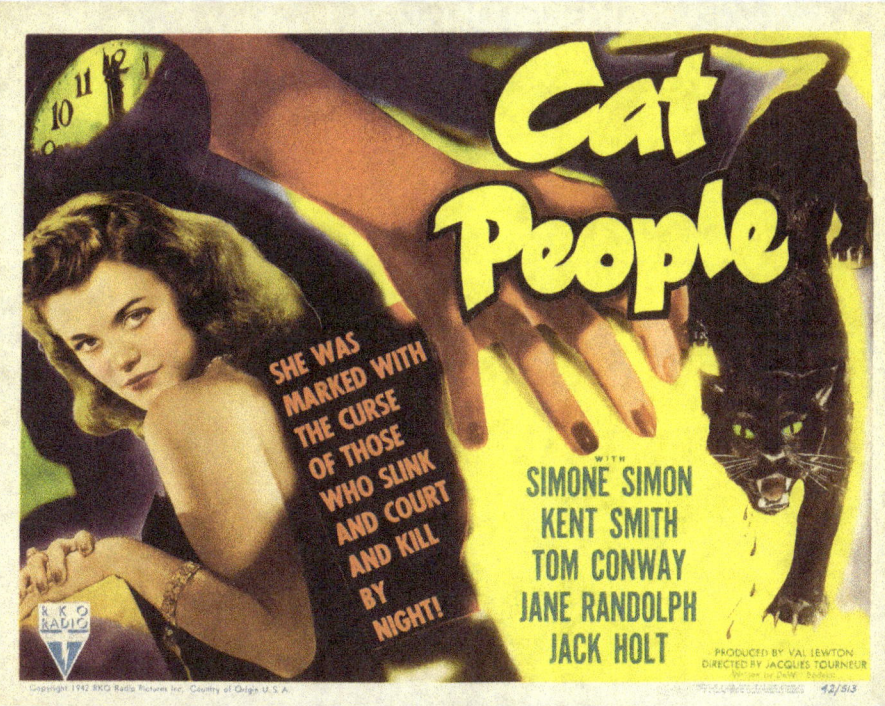

by JACQUES TOURNEUR
USA 1942
STUDIO: RKO
DVD: TURNER ENT. 2005
(plus The Curse of the Cat People)

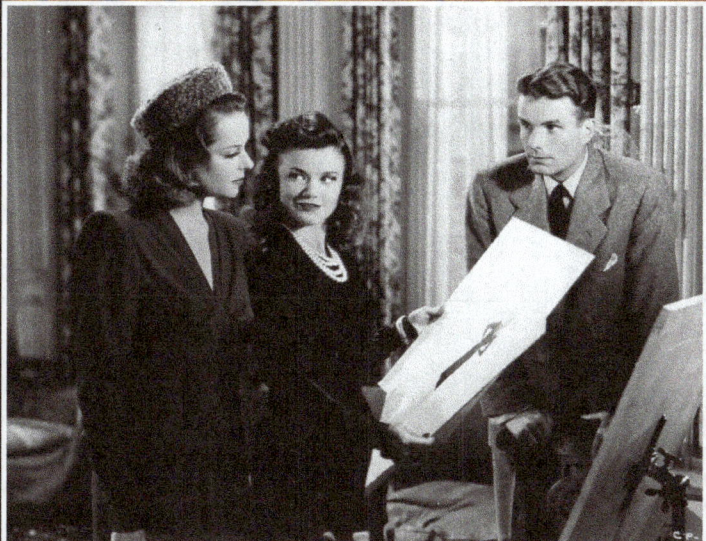

The plot is unusual and even daring, including an obscure satanic cult transposed from the Medieval Eastern Europe into the modern context of a metropolis. The intriguing canvas of Horror, Mystery and Noir, is expressed through wise touches of suspense, visual inventions, and - for that time - slippery psychoanalytical implications. Fear and terror are induced and amplified by the expectation of something terrible, ready to materialize at any time, and instead never really shown in its crudeness. Everything is played on alternances of shadows and lights, tensions and silences. The internal struggle, the conflict of the tormented Irena, is always impressed on her intense gaze, as well as the fear for an incumbent transformation into a feline.

What makes this film unforgettable is the awesomeness of certain images. The undoubted highlight is the scene in the nocturnal pool where Irena meets her (hated) rival Alice. It is only three minutes equally divided between glamour and fright, with moments of fierce and disturbing intensity. While swimming, Alice sees the furtive shadow of a panther reflected on the poolside hearing a menacing roar. All happens in complete absence of musical comment, focusing only on her screams in terror, where the frames are littered with clues for the viewer. Just to say, a roaming black kitten or the swimsuit torn to pieces from scratches of a beast are both part of the same suspense device.

Cat People did have a sequel, "The Curse of the Cat People," in 1943 (yet with Simon Simon), a spin off called "The Seventh Victim," and also a remake in 1982 directed by Paul Schrader, which certainly was not able to reach the charm of the original. ■

DARK CORNERS
From the darkest corners of our imaginations, soar the most beautiful creations.

SKELETON
By Asylum Attendant

Content with living a lie
An acceptable counterpart by his side.
The keeper thinks his skeletons are hidden away,
Waiting for another day.

Full of shame, guilt and sorrow
One skeleton took too many arrows.
The bones splintered into fragments
As the keeper became absent.

The skeleton yearned to be put on display
With the beautiful dolls made out of clay.
Instead doomed to inhabit the shadows
Never again to bask under a rainbow.

Long ago the skeleton had skin like porcelain
And eyes that glimmered like shiny tin.
Purity exuded from its soul
Before it disappeared down a rabbit hole.

Compliments and friendliness were enough to trap
Hope was lost as soon as the keeper patted his lap.
A pretty kink was the skeleton's destiny
Forced to forever feign ecstasy.

Emotions were strictly prohibited
Attachment was severely limited.
The keeper always got his way,
Even when the skeleton didn't want to play.

At last the skeleton was replaced
By another doll with a perfect face.
A goodbye wasn't even granted
A betrayal so underhanded.

The skeleton will mend its bones
And move on from throwing stones.
Because the keeper has to live
With a past no one could forgive.

WHAT IS NOW; WHAT COULD HAVE BEEN
By Dakoolah

I would like to compliment your soul, but my understanding of it or lack thereof transcends my ability to do so.

It will be a grim day when our incomprehensible youth rages war with the realization of growing, and in that time I pray our wiling behavior can still entice the ever-growing wonder of our spirits.

It is daunting, yet enchanting to think of what could have been; what could have flourished if not for these dark times.

Where my mind imagined us was a far-fetched place in which incalculable sources would've catered to our every demand and encased us in a translucent stage of euphoria where only we were law.

If only that scintillating notion could have come to fruition then and only then could our lives have mirrored the future we prayed for.

Although all is not lost, that which is incomplete will forever long for wholeness, and in that longing it will venture far beyond the reaches of the border placed on it by life, for that which longs for more will seek an excess of what the universe is willing to show it.

Let not this lay grief upon your heart, for you will only battle to remove it. Allow me, while in my space and sinew, to comfort your thoughts. We are a continuous singular entity of two halves that will continue to delve into life together.

Though we venture in sync, do not be startled when our equilibrium is broken, for it is that longing spirit returning from its journey into the universe.

We are us, we are what is now, and cannot know what we are to become.

The Gothic Cruise
"Hell Freezes Over"

August 16 2016
Roundtrip Seattle
Onboard The Carnival Legend

Ports: Skagway Alaska, Juneau Alaska, Ketchikan Alaska, Victoria BC Canada

Plus we will cruise the Tracy Arm Fjord.

With a Special Live Performance by:
THE GOTHSICLES
and **STONEBURNER**

Include
All of your meals/snacks
$100 free shipboard credit
A free bottle of wine
Access to all private events and parties
A free gothic cruise CD
In room champagne and chocolates on arrival

Mention
Carpe Nocturne
and receive $50 off per person

THAT AFTERNOON
By Dakoolah

It was that day when the clouds were gray.
The miss's left the house, but I decided to stay.
That day I learned my life was in repair,
for when she left I felt despair.

Like juxtaposing photo's she was by my side for true;
now that it's vacant I know not what to do.

Drowning in thoughts, it began to come;
the origin of where attachment is from.

The loneliness spreads far,
it only attacks when you forget who you are.

I pondered and thought from where I could see,
I was stuck to the jewel that life brought me.

How could this happen in such swift time? We just started,
she's barely mine.

With this heart so golden, do I love too strong?
Should I keep going or would that seem wrong?

It was these questions that pummeled me left and right.
I could barely sleep that night.

It was hard to believe how far my feelings went.
She seems so regular, but I know she's heaven sent.

She's drenched in God's glory,
but knows well how to ignore me.

I feel in debt to her love, for I know it's from above,
but am I drowning in a river of unrequited love?

By no means is this the fault of her,
it is me who knows not how to differ.

She is innocent in all,
for I have made myself fall.

This lesson will forever reign true,
knowing the pain it brought.

For me it is just another lesson that life has taught.

I will live for myself and learn the ways of I,
before I lose my mind and my heart goes a rye.

Soon you will see me new,
but things will be the same like no one had a clue...

LOVE'S FOOL
By Rising Phoenix

Who ever said love isn't supposed to hurt
Never met you.
When it's good, it's oh so good
When it's bad, it pierces to the core
And though I try to don this façade
My countenance falls
I weep bitterly
I walk through the town
My soul lay bare
Blind men wipe my tears
I love one that shan't be loved
I hate that which I should love
I forgive one that shouldn't be given forgiveness
I curse those I should hold dear
After all, what do they know about this love?
They are trying to hold me back from happiness
I know what I'm doing
Just move forward clutching your chest
The pain shall subside
Forget about all that has transpired
Forget standing there waiting for him to return
Dinner on the table growing cold
Eyes growing heavy from exhaustion
Perhaps he'll return tomorrow
Retire to bed
The sunlight hits my face
My hand wanders to the empty spot where love should be filling.
Ahhh...clutch your chest
The pain shall pass
Keep moving forward in your ignorant resilience.
Learn nothing from your mistakes
Forget them
Each pain feels brand new to the mind
But not the body
The body feels every single blow
It absorbs all the damage and has no chance to repair.
Then one day you look into the mirror and have no clue who's standing there....who am I?
I am Love's Fool.

Think your poetry is good enough to be published in Carpe Nocturne? Send submissions to mj@carpenocturne.net subject line "Poetry." All submissions must be under 250 words, and will be judged by Managing Editor, Michael Jack and Assistant Managing Editor, Zahara. The best entries will be featured in our next issue along side of our very talented staff.

FICTIONAL ANECDOTES
The Life Mechanism

THE LIFE MECHANISM

By Jesse Orr

The sweep began his shift every day atop the tower at the center of the metropolis. From there, he could look out over city, as far as the eye could see to the jagged horizon, skyscrapers dotting the line like teeth. Once, this tower had been white. Now, after decades of exhaust belching from the smokestacks leading to the fuel sources, the tower was a dark sooty gray.

There was little to do here at the very top. This was for tourists, sightseers and artists, the windows to be kept polished around the clock. The sweep set up his ladder and went to work with a blue liquid. He began squirting, scrubbing and polishing his way around the tower's huge paneled windows, removing grease from dozens of filthy little hands leaning against it. This was his favorite part of his shift, up in the light, watching the great city awaken as it rotated before him.

All too soon, though, it was time to stow his ladder in its space within the wall and enter the tower. A flight of steel stairs took him to the control room. At this hour, there was but the night's skeleton crew of three into the last hour of their shift, yawning and ready for the showers. The sweep knew from conversations those in his line of work can not help overhearing that the three night boys were there to call their supervisor if anything changed in the slightest, and were nothing more than backups for the part of the mechanism which handled alerts. The mechanism had been at work for so long, all the gears and combinations so well tested, it was foolproof. It needed no backups.

The sweep took his time in the control room, sweeping and mopping around the stolid night crew as they moved again and again out of his way. The great brass levers and their dials were growing tarnished and he buffed them with vigor. They were a slovenly lot, these controllers, and the sweep was damned if he would catch hell again for not picking up properly after those pigs.

The next level down was dim and lit by an uncertain yellow light which stuttered weakly. A large circle was described on the outer walls with two sets of hash marks on either side. As the sweep swept the floor and washed the walls, the hash marks advanced two ticks. At this level, the mechanism moved so slowly there was rarely anything to clean.

Stowing his cleaning supplies in the level's disguised utility closet, he opened a trap door and descended a set of stairs spiraling around the outside of the tower. The walls were split into a grid, and at times parts of the grid would move laterally or vertically by two or three cells. The sweep descended through thirty feet of stairs and opened a door to the huge room at the center of the tower.

Gears of all sizes were linked together, filling the enormous room. There were monsters with teeth the size of boulders, and some the size and weight of dinner plates all woven together. Some were spinning at a high rate of speed and by each of these on a platform stood two men, taking turns bathing the hot metal in a water-based lubricant. Some gears were barely moving, others clanking one or two teeth every few seconds. The sweep did not clean here, for there were constant metal shavings and this department employed its own constant cleaning methods. He merely visited each station, manned and unmanned, working his way down the colossal structure, and verified each was being maintained properly.

At the final station at the bottom of the mechanism there were two mammoth cables coming up from the floor and attaching to the mechanism's base. Here, the sweep paused and gazed upwards, reflecting. It could be dismissed, ignored, and misunderstood, but some knew. Life itself depended upon the mechanism, and they had done everything in their power to make it run. They had only to feed it and it would continue to provide them with life. The sweep considered what would happen if the very planet ceased to turn, and shuddered. If he did his job right, at least he would never have to see that day.

He went to the door in the center of the mass of gears and pulled a brass lever. The door to a lift yawned open and he stepped inside, yanking a matching brass handle. The door shut and the lift began to creep downward, slowly at first, then picking up speed. The sweep held on to the brass handle with white knuckles. He had never enjoyed this part of his job. It didn't matter either way, it had to be done. The machine had to be fed. After a few moments, the door opened, and a cold rank smell assaulted him. He grimaced. He had arrived at the fueling level.

Stepping out of the lift, he sat down on the little bench in

a small room lit with cold fluorescents and removed his shoes. Once, he had not donned the protective rubber boots and worn his shoes. Only once. He had never worn those shoes again. He pulled a poncho over himself and a mask over his face. Fortunately, he had never gone without the mask. He had heard stories of what happened when you got the stuff in your mouth.

Putting on gloves of heavy black rubber and steeling himself, he pushed open the door leading to the cold dark chamber beyond. Here where he could see his breath, the fluorescents were farther spaced, dimly casting light on dozens of large coffin-sized objects all connected with piping. A flicker of electricity sparked, a flash illuminating the mist creeping around the room. The sweep wiped an arm across his forehead. The humidity in here was the worst.

With the air of a man holding his breath in a fetid outhouse, he moved through the room with a cart, stopping at each coffin to tap the side of it with a brass hammer he took from his pocket. Each time he heard a clink, he smiled and moved on, his sense of relief growing. Some days were better than others. Some days they all echoed.

The next coffin echoed.

The sweep sighed. He only had one left in this room to check and he had been hoping to walk back out without doing anything more. Pulling a knife from his pocket, he slit the black viscous membrane which developed over the tub and reached in, feeling around. Sometimes this part was easy too. But not this time. He sighed again and peeled the membrane fully back from the tub, tossing it on the floor.

What once had been a young woman lay on her side, her skeleton as though black slimy latex had been painted over the top of it. Her hair was nearly gone, disintegrated into a black puddle in which the remains of her head lay. Her eyes had deflated and lay on her cheeks in little black clumps. The sweep attempted to grab the woman by what remained of her shoulders and pull her into a sitting position. With a slimy plop, her midsection separated and he was left holding her torso with one arm hanging from a thread. He attempted to better his grip to pull her from the tub and his fingers punched through the soggy black flesh. With an oath he heaved himself into the coffin and wrapped the torso in a bear hug and heaved it into the cart. Looking down at himself, he grimaced. There were chunks clinging to his poncho. He scooped them up in a double handful and tossed them into the cart.

This left the bottom half of her, which proved particularly difficult. Each time he grabbed one of her bones, the joints would come apart and the flesh sloughed off the bone. In the end, he found himself crouched in the coffin scooping up endless double handfuls of disintegrating black flesh, fighting his gorge and wishing he'd remembered to grab the shovel from beside the door.

When the worst had been transferred to the cart, he hosed out the coffin and replaced the its drain plug before turning the hose on himself. The mess gurgled across the floor and down a hole, leaving the larger bits on the floor. Crossing the room to the huge door, he slid it to the side.

Row upon row of the coffins were arranged, lidded and stored upon shelves without end. Going to the nearest row, the sweep grabbed a handle attached to the side of the coffin and pulled. With a whisper it followed, rolling on silent bearings. He maneuvered it beside the empty one and removed its lid. The countenance of a young boy regarded him from beneath a substance like thin jello, eyes half open, a vacant expression frozen in them forever. The sweep ignored the boy as he disconnected the pipes from the empty coffin and pushed it aside. Once it was clear, he moved the boy's coffin into position and reconnected the pipe. The spark as the connection was made was brief but brilliant. This boy was a powerhouse, with the ooze channeling his energy into the mechanism, he alone would power the entire city for a day.

The sweep decided to knock off for the day once he'd recycled the empty. Cleaning out the woman had been a bad one, one of the worst. Pushing her empty coffin before him, he trundled off to the changing room to punch out. He needed a drink. ■

LIFE & STYLE
Freya

Between The Vikings television series on the History Channel, and the Thor franchise, there has been a renewed interest in the culture of the Norse. Of the two, I much prefer The Vikings. Even though there are some historical inaccuracies, I really feel it captures the spirit of the era, and the visuals are stunning.

On the other hand, I have never been thrilled with Marvel's Thor, and I was particularly disappointed with Lady Thor. There are so many wonderful goddesses and giantesses of Norse mythology that there is no need to transgender Thor. Freya would make a splendid super-heroine, borne proudly in her chariot drawn by great cats, or flying in her falcon cloak.

Freya (Freyja), or the Frowe among Germanic peoples, is the most popular of the Northern goddesses, for she represents the power of the feminine in nature and magic. Her name means lady, and she is the pre-eminent female of the Vanir family of deities. The Vanir were most likely the deities of the Finno-Ugric peoples who inhabited Europe before the arrival of the Indo-Europeans. The Vanir represent the earth and the sea, the life force which nourishes and preserves, encompassing abundance, prosperity, deep wisdom, intuition and prophecy.

She has a twin brother, Frey (Freyr), Fro Ing among the Germans, a god of phallic fertility whose name means lord. He is the ruler of Ljosalfheim, home of the light elves, one of the Nine Worlds of Norse mythology. He is a god of kingship and wealth, the patron of the ripening fields and crops. He rides the shining boar Gullinbursti (Golden-Bristles) and possesses the ship Skidbladnir (Sails Over Everything) which always has a favorable breeze and can be conveniently folded into his pocket when not needed.

These twins were the offspring of Njördhr/Nerthus, an extremely ancient god/dess (both names derive from a root meaning "under") that may have originated as a single deity and eventually divided into two separate beings. Njördhr became the god of

Freya, Goddess of the North

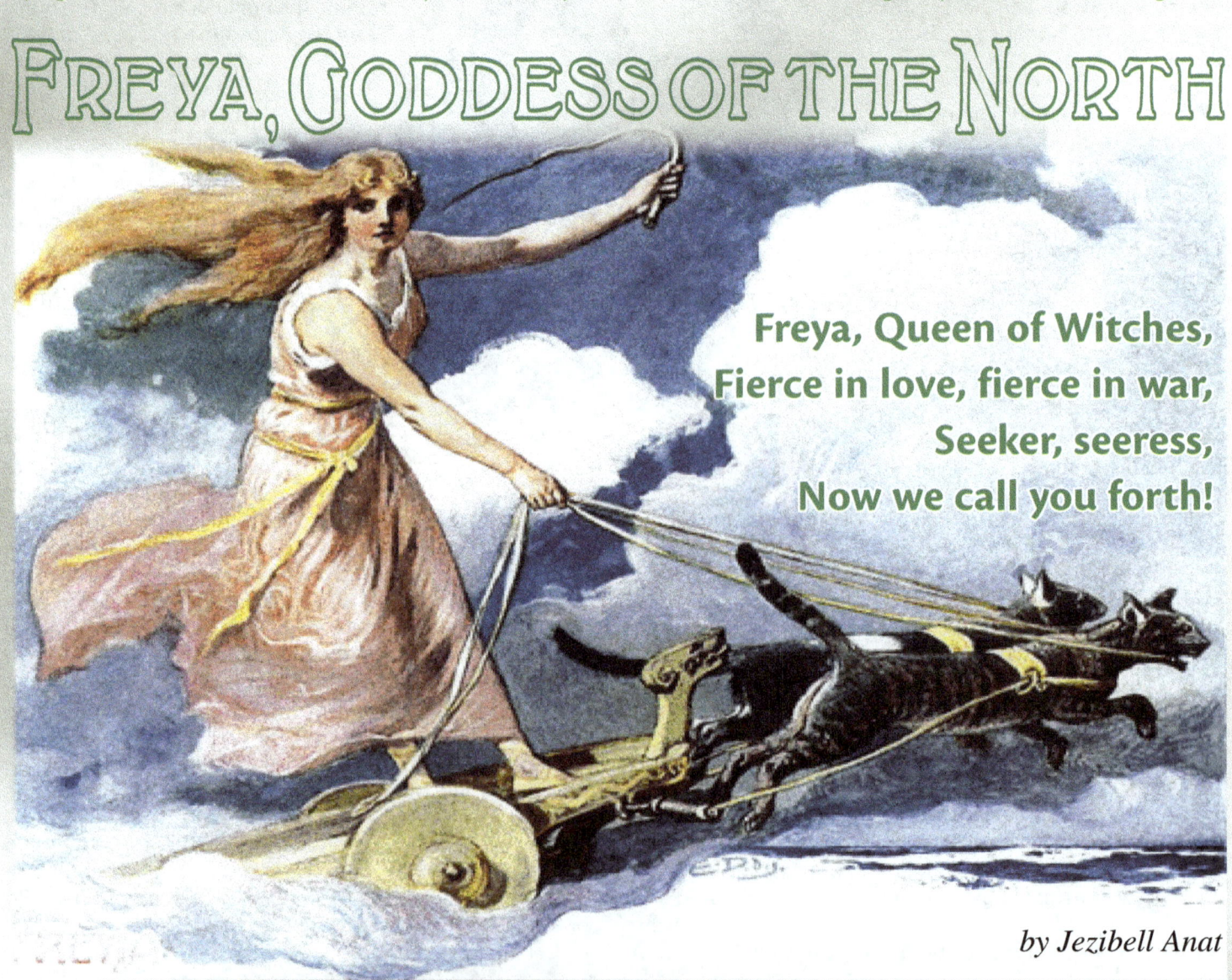

Freya, Queen of Witches,
Fierce in love, fierce in war,
Seeker, seeress,
Now we call you forth!

by Jezibell Anat

the sea and Nerthus became the earth mother. United, they rule the Vanir world of earth and water, whose sacred places are islands and bogs. Male-female polarity is important to the Vanir, and Vanir deities were usually tended by a holy person of the opposite gender.

The more familiar Norse deities Thor, Odin and Frigga are part of the Aesir, the Indo-European sky gods of wind and thunder, the forces of conscious creation, deities of activity, strife, and change. The Vanir and Aesir are from the main pantheon of the Northern tradition, along with other divine and magical beings such as giants, dwarves, and elves.

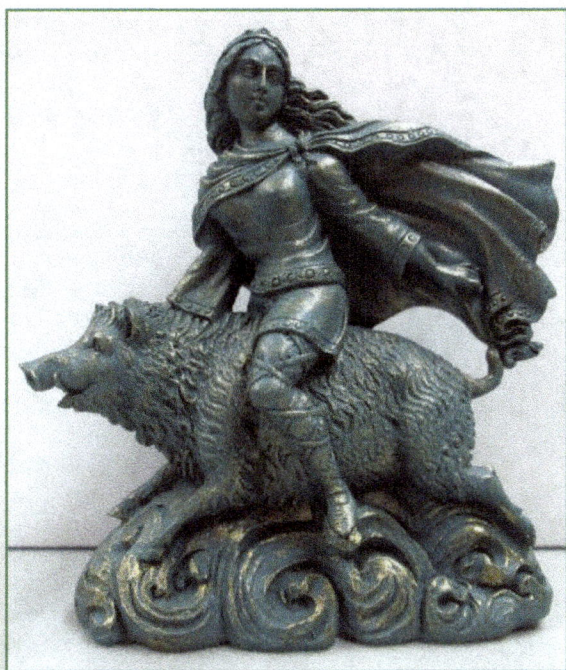

Much of our information about the Norse deities comes from the *Eddas*, an Old Norse word which may mean "great-grandmother" or "poetry." The Eddas were recorded in 13th century Iceland from earlier sources. The *Prose Edda* is a collection of poetry including accounts of creation and myths of the deities and heroes. The *Poetic Edda* is a manual of poetics that include many mythical stories.

Norse cosmology envisioned a world tree called the Yggdrasil which contains Nine Worlds. Asgard is the highest realm, the domain of the gods. Midgard is earth, the place where we live. Helheim is the lowest world, the place of the dead presided over by the goddess Hel. Though the Christians named their fiery hell after her, Helheim is actually a place of bitter cold and darkness. Hel is represented as being a half beautiful woman and a half rotting corpse.

Though Hel was feared, Freya was very beautiful and much admired. Her energy is solar, not lunar. Unlike the Greeks and Romans, the Norse viewed the sun as feminine and the moon as masculine. Freya's sacred animals are cats, pigs and falcons. Sometimes she flies in a cloak of falcon feathers; at other times she travels in a chariot drawn by big cats, or she rides upon the back of her great sow Hildisvini (Battle Swine). Her color is red, and she loves gold and amber.

Freya is no domestic goddess. She wanders the worlds in search of adventure and magic, taking lovers from the gods and mortals. However, she will say a very definite NO if she's not interested. In one tale, the Aesir wanted to marry her off to a giant, and her refusal shook the halls of Asgard.

Freya wears a great golden necklace known as Brisingamen (probably from old Norse *brisingr*, meaning fire), which she acquired when she undertook the long journey to the dark caverns of Swartalfheim, the world of the dwarves. Short, thick-bodied, ill-tempered and stubborn (think of Gimli from *Lord of the Rings*), the dwarves were exceptional smiths and metalworkers who lived deep in the earth. Through hard physical labor, they forged objects of power and beauty, including Thor's mighty hammer. They were known for their loyalty and honesty.

Of course Freya wanted this magnificent necklace, but one of the tenets of Norse society is exchange - a gift demands a gift. She offered gold, but the four dwarves who made Brisingamen had plenty of gold. Their price was that she spend a night with each of them, and that is how she earned her necklace. In a more spiritual context, these four dwarves represent the four directions, all linked to Freya in her role as solar goddess. From a pragmatic view, four nights are four nights, but a golden necklace is forever.

Though some of the deities mocked her for this, she was happy with her choice. Freya is a primal force, which encompasses sexual instincts. Even before Iceland was Christianized, writing *mansöngr* (lovesongs and poetry in Freya's honor) was outlawed because of their erotic nature and inflammatory consequences. The sagas suggest incestuous connections between her and her brother Frey. In another poem, Loki, the trouble making giant, accuses her of sleeping with all the gods and elves, and it is actually her father Njord who defends her saying, "It is no crime that a woman have both husband and lover."

Freya's particular specialty was *seith* (*seidr*) magic, a very old form of prophetic trance. The Roman historian Tacitus describes this practice among the ancient Germanic peoples. *Seith* is a shamanistic ritual in which a priestess called a *volva* sits upon a high seat, and songs are sung to bring her into a trance. The *volva* makes prophecies to guide her people and also hexes their enemies.

Freya was the goddess of the *wicce* – *wicce* is the Anglo-Saxon word for witch or sorcerer and does **not** mean wise one. Many people tend to think of the neopagan religion of Wicca as Celtic, but its historical origins are Germanic. The origin is an Indo-European word that means bend or twist. The witches of *Macbeth* would have been more accurate in calling on Freya instead of Hekate.

Freya is sometimes considered a consort of Odin, and she taught him the secrets of her *seith* magic in

LIFE & STYLE
Freya

exchange for his knowledge of the runes. She and Odin also divide the heroes slain in battle, and she gets first pick. She takes half of them to her hall Folkvang, which means "field of the host," while Odin brings his half to Valhalla. (I always imagine Freya choosing the cute ones!)

Freya's actual husband is a little-known god called Od, who may simply be as aspect of Odin. They have a daughter Hnoss, goddess of desire. There is one story where Od departs, and Freya weeps tears of gold for him.

The Aesir goddess Frigga is usually considered Odin's wife, but because of the similarities of their names, and their connections with Odin, Freya and Frigga may have been originated as one goddess who morphed into two aspects. Freya's roving ways, her practices of trance magic, and her unbridled sexuality were viewed as inappropriate for the position of Odin's wife by the time of the Viking Age (ninth to eleventh centuries) and were even less acceptable to the Christians.

Frigga appears to be more proper. She is a wise and powerful queen, the goddess of marriage, childbirth, and weaving. She rarely leaves Asgard, and conforms to the most common role of women in Norse culture, mistress of the house. This was a position of great responsibility and honor, since it encompassed feeding, clothing, and managing the daily life of the family in an era when food had to be grown and clothes had to be made. For a royal household, this would be the modern equivalent of managing several factories.

Frigga is no doormat. She challenges Odin at times, and she is the only other deity who is allowed to sit upon his High Seat and look out over all the worlds. Frigga is also associated with prophecy, and in one tale she slept with Odin's brothers. Interestingly, her name is the origin of the word "frig." So these goddesses are not as dissimilar as they may appear.

Most of our weekdays are named after Norse deities. Thursday is Thors' Day. Wednesday is Odin's Day (the Germanic form of his name is Wodan). Tuesday is named after Tyr (Tiw), the Aesir god of justice. We are not sure whether Friday is named after Freya or Frigga or possibly both.

Today, Freya is gaining new popularity among Neoagans. Her independence and fierceness appeal to both women and men, and her associations with felines attract cat lovers. My husband Joe is a priest of Freya, and we have ten cats. He always says that with his luck, when he dies, he will go to Folkvang, and Freya will hand him the great golden kitty litter scoop. He will be cleaning her cats' boxes for eternity.

LOST FAVORITES
Hardware

By XXX Zombieboy XXX

"THIIIIIS is ANGRY BOB the man with the Industrial DICK! Comin at you loud and clear on W.A.R. Radio! Rise and shine folks! It's a beautiful day! Just look at that sky! It's a work of art! HA! Nature NEVER knew colors like THAT!"
- Iggy Pop as Angry Bob

Hardware aka M.A.R.K. 13, is a fantastic and beautifully harsh sci-fi/horror/apocalypse film starring a very young Dylan McDermott along with Stacey Travis (Earth Girls are Easy, Highlander: The Series) and some very surprising and amazing cameos. It will take you into a sweltering and arid heart of darkness where old decaying machines run a militant and dystopian landscape. The future is not bright... it is radiated, and the machines are likely to eat you.

The plot involves a soldier named Moses, returning home from some war that is never clearly defined. Out of the wasteland walks a nomad trading in salvaged metals and machinery. Moses (Dylan) buys the head of what he thinks is a maintenance drone from the Nomad. The head is actually the remains of an auto independent, artificially intelligent, and self-repairing killing machine. This is his Christmas present to his semi-abandoned girlfriend Jill (Stacey). The android repairs itself and wreaks havoc in her apartment.

One of the things I love most about this film is the amazing cameos. Lemmy from Motorhead shows up as the water taxi driver, Iggy Pop (voice only) steals the show as Angry Bob the DJ, and Carl McCoy (Fields of the Nephilim) plays the nomad. Even GWAR shows up on the TV playing music by Ministry!

The other thing I love about this film is the soundtrack. It is purely brilliant and atmospheric, with some great classic moments from Motorhead, GWAR, P.I.L. and Ministry.

Overall, the look of the film is so saturated and low key that is sinks you into itself. At times, it even gets a little trippy. The action is excellent and there is plenty of violence for you gore hounds out there. This is honestly one of my favorite films of all time and that is saying a lot.

This is what you want? This is what you get!

LIFE & STYLE
Belly Dance

Belly Dance Contradictions
"Belly" Rolling with the Punches

By Zahara's Tangled Web

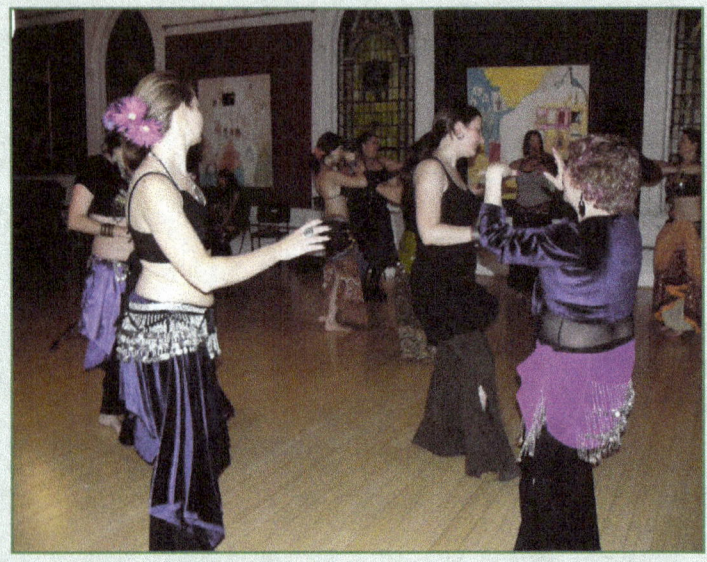

The tribal and fusion belly dance scene here in the US has been going through some pretty big changes over the last year. As with any artistic community, there are times of growth and contraction. Certain regions are seeing a decrease in the number of new students and attendance has declined for certain shows and workshop weekends. Tribal Fest in California ended last year, and 3rd Coast Tribal held their last festival at the beginning of this year. Both are tremendous losses in terms of educational, performance, vending, and bonding opportunities. But life is full of cycles, and the belly dance community (locally, nationally and internationally) is no exception. Change isn't always a bad thing, although it can certainly be uncomfortable and disappointing at times. What should you do when your local belly dance community seems to be shrinking? Listed below are a few things to keep yourself motivated and to keep "belly" rolling with the punches.

Video and Online Training - If you're having trouble finding classes or local studios are closing, you can still keep training. Instructional videos are available on YouTube and through your local library for free. Netflix has started streaming some belly dance titles, and many instructors offer Skype lessons. Contact the instructors you'd like to learn from, and they can steer you in the right direction. Rachel Brice's powerhouse Datura offers online courses for a low monthly fee, and features a variety of teachers (www.datura.com).

Workshops - Consider taking workshops in other styles of belly dance. There's always something to learn! This also gives you the opportunity to meet new belly dancers and visit with friends. Try a workshop on Egyptian combinations or saidi with cane. When I wasn't able to attend Tribal Revolution in Chicago, I started digging around locally to see what else was offered that year. I've taken Bhangra, Persian and Tahitian workshops that were fantastic! It was a chance to meet other dancers and share information about cultural dance courses being taught nearby. I highly recommend getting out of your comfort zone... you'll grow tremendously as a dancer if you do.

Haflas - Not many performance opportunities in your area? Why not host your own hafla (dance party)! As dancers retire and move out of the area, so do their events and shows. It's not necessary to host a huge workshop weekend and organize a massive show, if all you want is the chance to visit with friends and try out a new choreography in front of an audience. You could host an informal hafla at your studio, school gymnasium, or community center (often for free). If a rental fee is involved, then you could charge a nominal door fee to cover that cost. Ask guests to bring a dish to share, let dancers bring their music and keep the performances low-key. It's important to reach out to fellow belly dancers, because if you're feeling isolated and uninspired with the changes in your area, then chances are they're feeling the same way.

Research - Take advantage of the down time by doing some research on your artform. Read some books or take a college class in art or dance history. Read some old belly dance magazines. "Fuse" is a more current offering, focusing on tribal and other forms of belly dance fusion. "Gilded Serpent" is a fantastic online resource for all things bellydance, including magazine listings and back issues. Now is the time for you to brush up on the foundation

LIFE & STYLE
Title

and history of this artform, where it came from, and the different styles of belly dance and belly dancing music.

Drum - Many belly dancers drum, and there are tutorials that can help you learn to play the basic Middle Eastern rhythms. Look for Karim Nagi (www.turbotabla.com), Issam Houshan (with the Bellydance Superstars) and Jeremiah Soto (of Solace fame). All three are amazing drummers, and you can see where they're teaching workshops and if they offer online or video tutorials.

Hopefully, you have some ideas for staying inspired and motivated during your belly dance journey, no matter how the landscape changes in your community. Stay connected and stay active... and stay creative!

LIFE & STYLE
Steampunk Powder Room

Steampunk style is influencing more than conventions and wardrobes. Home decorating and supply companies are riding this trend and offering elements of Victorian Science Fiction for every room. The bathroom or powder room would be a perfect space to incorporate some of these details. Why do we list both rooms? Aren't they the same thing? Well, not exactly, although we don't typically use the term "powder room" anymore. A powder room (now known as a "half-bathroom") is a separate room with only a toilet and sink, and no bathtub. In Victorian homes, powder rooms were considered guest bathrooms or the main floor half-bathroom, making it the more public facility. The full bathrooms with tubs or showers were located closer to the bedrooms, keeping them more private and accessible to just family members. We'll be drawing inspiration from the Jules Verne classic "20,000 Leagues Under the Sea" to create a Steampunk bathroom or powder room, full of vintage nautical elements.

When considering wall colors, it's easy to rely on the neutral and sepia tones so popular in the genre's color wheel. However, there are several beautiful shades from the Victorian era that would work perfectly in a bathroom, especially a smaller powder room. Obvious choices for a nautical theme include seafoam green, dove gray and pale blues. But expanding your palette to include sage greens, mauves, plums

The Very Steamy Powder Room

By Zahara's Tangled Web

LIFE & STYLE
Steampunk Powder Room

and rose shades will give you a more unique look. You could draw inspiration from the sea itself, her inhabitants, or the heavily decorated rooms of a sailing vessel. A deep purple could be another interesting choice, although it could present a cave-like effect in a small powder room when used on all the walls.

Many large bathrooms are tiled, which minimizes the areas that can be painted. Decorative tiles are a great way of updating a tiled wall by carefully replacing individual tiles or by adding a decorative tile trim above the existing ones. Metallic tiles can be added as a backsplash, even in a powder room. Copper accents, decorative tiles and fixtures fit the nautical theme and provide a more vintage look than common silver accents.

In most Victorian homes, a clawfoot bathtub would have been the room's focal point. Clawfoot tubs are still available through most home decor and construction stores, as well as through online suppliers such as Vintage Tub (www.vintagetub.com). Clawfoot tubs are even available in copper, if you're looking to incorporate one large metallic feature. However, if your budget is not prepared for such an expensive item, you could always add a copper detachable shower head to your existing tub or shower area. Another way to create a stunning vintage piece of bathroom furniture would be to install a beautiful basin sink into an old wooden dresser. Copper fixtures in the sink and tub blend with the nautical theme very well.

A large mirror is a must in any bathroom or powder room. Consider mirrors that have a more antique look to them, perhaps with an ornate frame around them. A cluster of interesting old mirrors could be added to one wall, creating a piece of wall art that's both functional and beautiful. Strategically placed mirror portholes will create the look and feel of being inside the ship.

Decorative glass elements were often seen in homes of the Victorian era. Antique lighting or sconces could be added on either side of an existing mirror or vanity. Stained glass items are perfect here, even in a tiny powder room. Rather than replacing entire windows, you could hang a piece of decorative stained glass in front of one for a similar effect. It's a delicate way of using a piece of art in a room that could get hot and steamy. Tiled pieces of art could also be used.

As with most Victorian rooms, you'll want to add layers of textiles to create depth in the room. Lacy window treatments and shower curtains will soften a room that's heavy with copper pieces. A floor rug would be helpful near the tub area to prevent falls and bring out the other colors in the room. And of course, towels can be used to either compliment or contrast the main colors of the room. In a small powder room, pay extra attention to decorative hand towels, carved soap, and pretty soap dishes, as those are often the only items that will fit on the sink counter.

Many of the updates listed here are fairy inexpensive. Try searching online for pictures of the sea and her creatures, nautical items, and vintage bathroom details for ideas. Etsy is a wonderful stop on your decorating journey for one-of-a-kind towels, soaps and artwork. You'll be surprised what you can add quickly to the room and completely change the look. ■

SERGIO MANGHINA in
CHAINED SHADOWS

COPYRIGHT MMXV BY CARPE NOCTURNE MAGAZINE
NEW DARK CULTURE COPYRIGHT SECURED - ALL RIGHTS RESERVED

A GATHERING OF THINGS IN NOIR STYLE

I remember "Garden of Delight" as one of the top songs included in "Favourite", Pinkie Maclure's second album published in 1995. John Wills, former member of the eclectic-electronic band Loop, was the producer behind the scenes but soon became the other half of Pumajaw, the following project of this Scottish duo.

PINKIE MACLURE
Favourite

RECYCLE CULTURE
WW

Recycle Culture (Eric Molin) is a prolific, iridescent and multifaceted entity which absorbs voraciously, like a blotting paper a lot of sonorities reminiscent of Ambient, Electronica and Trip-Hop. Sometimes the product is very good in other occasions it appears frankly too dispersive.

Anyway - "WW" - has a brilliant aura. "White Window" is a percussive downtempo designed for an Oriental trip and enriched by the voice of an unknown vocalist that seems coming from nowhere. It is Operatic-Pop in a certain way. A piece of great atmosphere, really evocative... Having to think about a film, then this could be certainly a classic Noir, characterised by strong supernatural elements. I imagine a large room decorated with immense chandeliers and a sumptuous stairway. A mansion however also inhabited by obscure presences, uncanny shadows and some unmentionable secret hidden just behind the windows. "Iheal" is the second track, introduced by a piano and still focused on that otherworldly voice, surrounded by percussions and always painted with a Far Eastern flavour. This EP is a small and precious chest of intriguing cinematic fragrances.

A flying carpet of drums, able to evoke exotic and turbulent horizons. Pinkie's voice sensuously draws abysses and heights, a lament in mid-air similar to a thoughtful lonely cloud on the edge of a smoky stage in some vicious club of Macao, Shangai or Tangeri. Noir, after all, is a nowhere place, clippings of images lost in time, scents and flavours locked into an old film or a cinematic trip. Every frame tells a story, every mind builds his personal game.

PUMAJAW
Song Noir

Twenty years later, "Song Noir" seems a hypothetical bridge back towards that old work. A blatant declaration of love to certain atmospheres and moods attributable to the Hollywood dream factory. Pumajaw sign the mental coordinates of their own Noir attitude. And Pinkie adds her original touch entering fully in that list which includes chanteuses such as Jennifer Charles of Elysian Fields and Lana Del Rey, among others. Her voice is very different now, more darkened, black and bluesy. Classics revisited such as "Misty", "Peter Gunn" and "I'd Rather Have the Blues" take a new life and also the new songs have small moments of glory. Noir glory, precisely.

THE CRAMPS
Psychedelic Jungle

Crossed destinies on the roads of California. They are The Cramps. Some crazy guys addicted to a dazed psychobilly-punk filled with massive doses of rock'n'roll, blues, voodoo, sex, horror, zombies, flying saucers and crime-b movies. A soup of low low pop American culture dissolved into a festival of oddities. "Gravest Hits" (1979), "Songs the Lord Taught Us" (1980) and "Psychedelic Jungle" (1981), built the legend of this band. The derailing guitar of the femme fatale Poison Ivy, and the vocals of that Elvis in acid called Lux Interior, became the trademark (often imitated) of one of the most popular groups of those incredible Punk years.

THE GUN CLUB
Miami

Actually, the dark world of the Cramps is absolutely made of chewing-paper and lends itself to large doses of macabre humor. It is up to The Gun Club of Mr. Jeffrey Lee Pierce the true dirty game, painful and desperate. In fact they play a hallucinated rock-blues absolutely wet and sick such as the Delta swamps are. "Fire of Love" and "Miami" are great albums containing great songs, dotted with memories of the old bluesman Robert Johnson and echoes of murder ballad, often authentic nightmares in grey and black. However, there is more than a connection between the two bands and it is no coincidence that, at the time of "Psychedelic Jungle", just a Gun Club member - Kid Congo Power - will replace on drums the retiring Brian Gregory, inside the Cramps. On the one hand the harmless grin of the easy-going Mr. Lux, on the other side the mournful expression of Jeffrey Lee. But the coin, despite having two sides, is always the same. Heads or tails, and you always win. ■

DEARLY DEPARTED
Prince

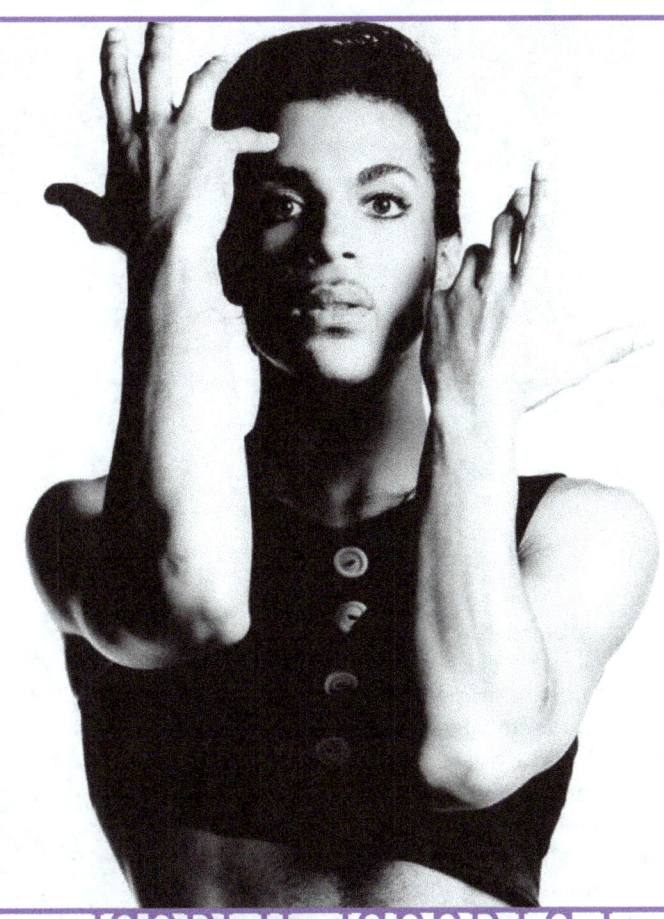

dearly departed

by Chirality

I cannot believe this year. There are so many good, talented artists, actors and so on we are losing in 2016, and it really seems like it won't stop. Gothic or not, everyone cannot deny the impact these people have had on our lives. When I heard of Prince's passing I wept a bit. He was another artist whom I knew as a child and growing, and he seemed invincible. Whether or not you were a fan, you cannot deny his impact and his sexual appeal. The world has been purple these last weeks with showings of Purple Rain. It seems all the good ones are leaving us and it is indeed scary. As you get older, and see these generations passing, it's sad because you know the future will not know these talented people. Only their memories.

Prince was another artist who was so many things wrapped in one package. He was an innovator and a true artist. His appeal was astounding, even to a non-fan. I don't think there is anyone who can say they hated Prince. We all had that one song. I remember singing "2000 part over oops out of time," when the ball dropped in 2000, or singing about "Little Red Corvette," or my personal favorite, "Raspberry Beret." His appeal weaved through generations and time. Prince may have been odd to some at one point changing his name to a symbol, but he was always relevant and changed with the tide. He helped many artists launch their career, and mentored many and wrote songs that hit the charts. Most we never even knew. He had fourteen platinum albums with Purple Rain going platinum thirteen times. He wrote one of the greatest love songs ever: "Nothing Compares to You," which we all remember as the debut of Sinead.

Prince was only 57 and known as a true sexual icon, with a voice and movements that made even the most prude swoon. He defined a genre and drew people into funk and hip hop. He married the two perfectly, and was flawless in doing so. As I write this article, I do not think there is a clear cut reason as to why he passed. Rumors fly, but I don't think anyone still really knows for sure.

Transcendence is the word for Prince. He painted a picture with his words. I am not really sure what else to say. We all know his accomplishments, and I am sure someone has a story of a song or album that they loved, even in the Goth community. A lot of my friends mourned because we can all appreciate a visionary who was one of a kind, and I don't think anyone will be like him ever again...the way he sang, the way he moved and the way he enraptured people. Prince. Another gone too soon and I don't think I am liking 2016 too much with all these wonderful artists leaving us. This article is a short one because I don't think I need to go into his albums, songs and movies. We all know, and we all know he will be sorely missed.

MUSIC
Valentine Wolfe

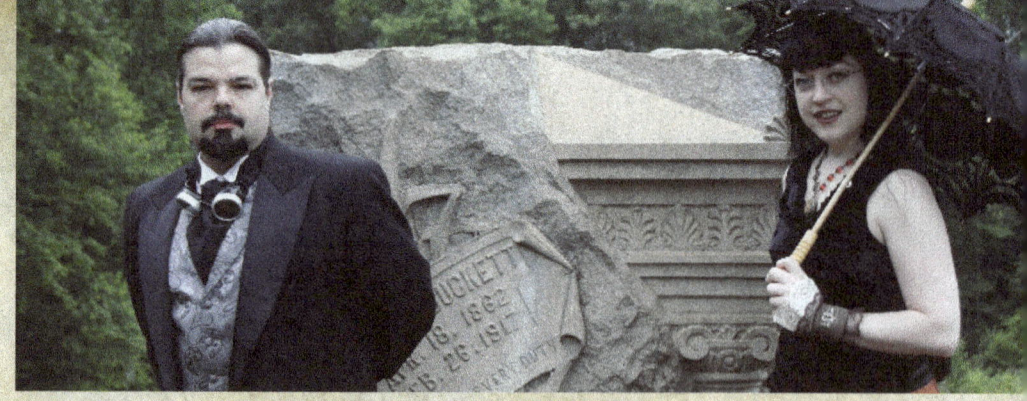

Valentine Wolfe

By Chirality

Valentine Wolfe, formed in 2006, is a band that mixes Victorian and dark gothic sounds to create a nice ambiance of sound. The band is Sarah Black on electronics and vocals and Braxton Ballew on bass and electronics. They hail from Greenville, South Carolina. When I heard them they were a little reminiscent of Switchblade Symphony. Sarah Black has a nice clean voice that sounds sweet (check out "Morning Hush"). Weaving tales of darkness with a lovely macabre sound and pulling you in with decadence in the truest gothic form.

Valentine Wolfe say they draw their influences from Emilie Autumn, Nightwish, NIN, Iron Maiden and so many more (quite a wide list). They use the term "Victorian Chamber Metal" and I agree that this is a decent title. As they say, metal with a Victorian sensibility. With those words I am truly on board. They mention on their webpage that they draw from all things Victorian creating a nice following from the Steampunk scene. They certainly draw paintings with their lyrics drawing inspiration from such things as *Penny Dreadful*, *Game of Thrones* and works by Hans Christian Anderson. This goth/rock hybrid sound is certainly one to check out. Originality at its finest with Sarah's voice giving a lovely sound to each piece of music. The thought that goes into each song is beautifully crafted and makes this not only music and songs but an experience into a divine gothic world where metal, rock, symphonic sounds and tones blend together to create an ethereal experience. The listener will certainly gain a unique experience when checking them out.

The band is currently on tour in support of their album "The Nightingale: A Gothic Fairytale", touring various places on the east coast. I strongly suggest you check them out and see if they are playing a town near you.

http://valentinewolfe.com/index/
https://www.facebook.com/Valentine-Wolfe-94664088700/?fref=ts

MUSIC
Bourgeois & Maurice

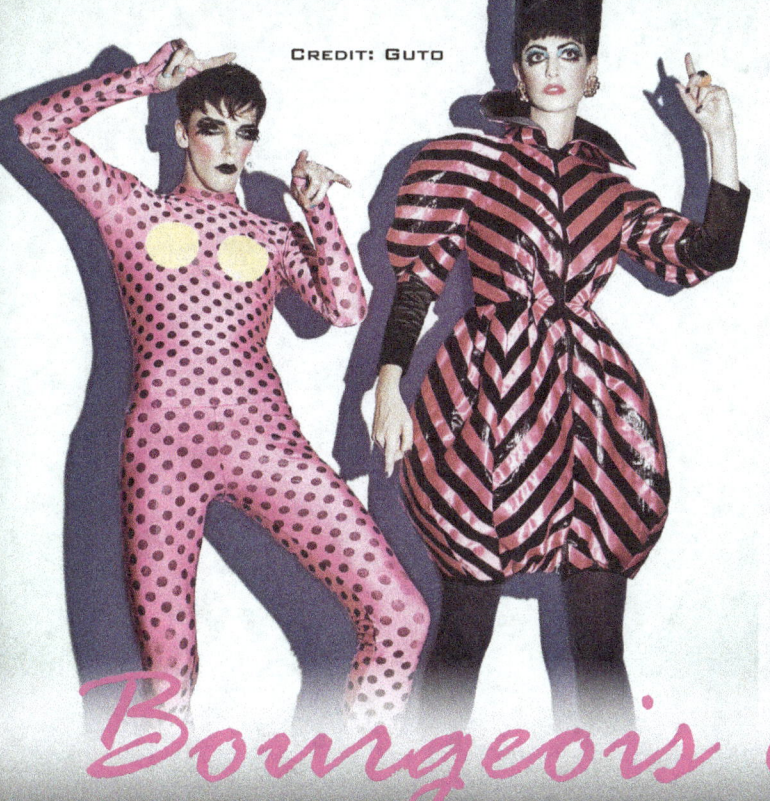
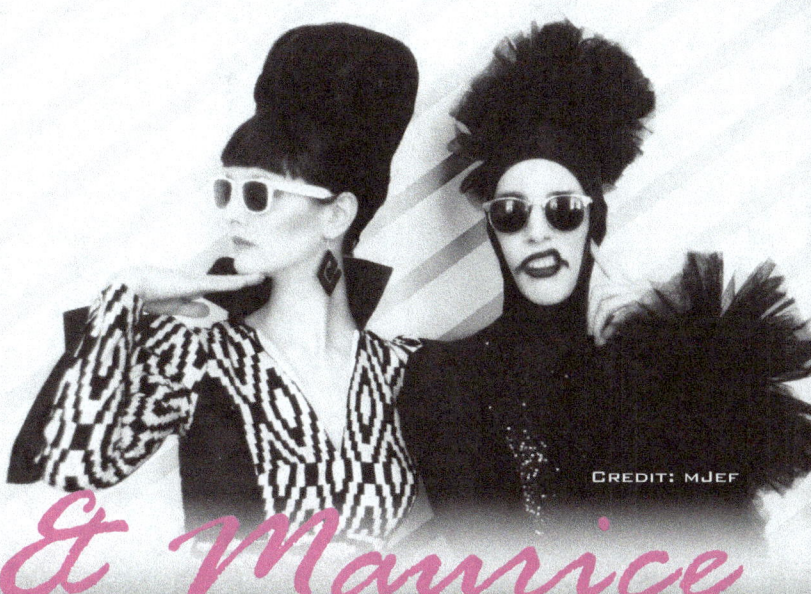

Bourgeois & Maurice

By Asylum Attendant

I think we all appreciate a good dose of satire once in a while. Combine that satire with dark cabaret stylings and outrageous fashion and you get the fabulous musical duo of Bourgeois & Maurice. Their influences range from Siouxsie Sioux to Klaus Nomi and they may in fact be aliens/siblings according to their website biography. No topic is taboo for Bourgeois (George Heyworth) and Maurice (Liv Morris), who make a mockery of overmedicated children, art school snobs and even taxes. The duo sing their hearts out to ridiculously funny lyrics while wearing beehives, excessive sequins and outfits made completely out of hair. Don't even attempt to up them in the fashion department because they will always out outfit you.

Bourgeois & Maurice met and formed in 2007 while attending the University of London together. The duo are described as neo cabaret because they write and perform their own original songs rather than covering old songs by other artists. They released their first album "Musical Couture" in 2009. The album opens with "Cyber Lament", a hilarious story of a girl who was taken advantage of on the formerly popular social networking site Myspace. Bourgeois croons as if he were the girl with leaking silicone implants as Maurice sings backup and plays piano. "Ritalin" is a stand out track that will have the listener joyfully singing along to the horrors of medicating children for no reason. There is a strong message behind the sarcasm and comedy that isn't preachy or boring. The song features a super artsy music video, much like many of the pair's tracks.

Bourgeois & Maurice's first show *Social Work* received stellar reviews and earned the duo an Argus Angel Award. They also won an alternative Eurovision title in 2010 from *Time Out London* for the sassy electropop song "Out Outfit You". This song is a departure from the usual piano driven songs of the pair, but the big personality and blunt lyrics are still present. Plus, it totally fits the format of a Eurovision competition song with a freaky twist. The duo released their second album "Shedding Skin" in 2011. One of the highlights is the 50's vibe on "Retro", an energetic number about society's obsession with the past. Hey, I think Jack the Ripper was fascinating, too.

The duo's third album, aptly titled "The Third", was released in 2013 featuring re-workings of some of their most popular songs such as "The Lizard Men" and "C.H.A.O.S.". Currently, Bourgeois & Maurice are almost ready to release their very own musical. Apparently, it is not about them, so I'm very curious to see what this will look like. Other than that, they are dazzling audiences at many shows around the world, maintaining their fashion icon status and blurring the line between fact and fiction. I wonder what social issue they'll expose (quite literally) next...

http://www.bourgeoisandmaurice.co.uk

MUSIC
Heathen Apostles

Based out of LA, Heathen Apostles are known to many as a Gothic roots band, but their description and instrumental techniques extend much further than this. We spoke with founders Chopper Franklin (The Cramps) and Mather Louth (Mather Louth & Radio Noir) to find out more about their sound and style.

[EB]: I guess you're quite known as a Gothic roots project. For anyone who's not familiar with your sound and style, how would you describe it?

[Chopper]: It's taking some traditional sounds and instruments of the past and combining them with really dark song writing and production techniques. We have mandolin, banjo and violin playing along with screaming guitars and synths. It makes for a very unique combination.

[Mather]: These days, I enjoy using the descriptive "bloodgrass," as it implies both to the bluegrass instrumentation we oftentimes employ, as well as the dark landscape we create with the storytelling and music.

[EB]: Have you always been interested in the darker styled lifestyle choice from an early age, and can you remember what first pushed you down that path?

[Chopper]: I was a punk rocker as a teen in the 70's, so it's always been there. I wouldn't say I was pushed down the path as much as I had been looking for it all my life.

[Mather]: I can definitely recall having an interest in the darker side of life from a young age- as a young girl. The subway tunnel filled with impaled heads was always my favourite scene from Ghostbusters II! I suppose I've always considered myself an indigo child, and have felt somewhat disconnected to my age and generation. With that, came an innate sense of my mortality, and as I grew older, I became increasingly aware of the dark side of humanity through both personal experience as well as macabre historical accounts. Darkness is ingrained in all of us, and it's fascinating to me what brings that darkness to the surface in an individual.

[EB]: What and who are your biggest influences for your music?

[Chopper]: Howlin' Wolf, The Gun Club, Merle Haggard, Bauhaus, 16 Horsepower, also Hammer Films, William Faulkner, and Cormac McCarthy.

[Mather]: Definitely Howlin' Wolf, Hank Williams, Nick Cave, old-time murder ballads, and as of late, the exposure of an incredibly corrupt political system.

[EB]: You use a lot of instruments: the fiddle, vintage guitar, upright bass, drums, mandolin and banjo to name a few. Are there any others you'd like to learn?

By Emily Bielby

BLAZING THE BLOODGRASS PATH
HEATHEN APOSTLES

MUSIC
Heathen Apostles

[Chopper]: We've been using Middle Eastern instruments recently, especially on the new remix album, but mostly as samples. I'd like to start playing them more often.

[Mather]: One of these days, I'm going to talk our violinist Luis into teaching me the cello!

[EB]: With there being a number of talented musicians involved in the band, you've managed to infuse a lot of different styles. Is that what you intentionally set out to do when you started the band?

[Chopper]: We didn't really come into this with a plan. The main thing I wanted to do was take the energy and emotion of some of the crazy bands I've been in and combine that with the traditional instruments and see what happens. We've been very happy, and somewhat surprised, with the results.

[EB]: How did the band form all those many years ago?

[Chopper]: I had known Mather for a while, and we ran into each other at a party and started talking. I told her what I was trying to do with this and the rest is history.

[Mather]: It's been a hell of an interesting ride these past three and a half(ish) years!

[EB]: Mather, I read somewhere that you have a heavy hand in aesthetic work for the band. Were you always interested in art and design at school?

[Mather]: I definitely always cultivated an interest in the arts from a very young age, and I have my mother to thank for encouraging that creative expression (be it through music, sewing, acting, or any one of numerous visual arts media). When Chopper and I first started writing music together, it was clear to me that this band called for a particular and specific visual aesthetic, and I'd like to think that we've managed to stay true to that aesthetic throughout our catalogue of work.

[EB]: Your imagery, and not just the band's look, but music videos and promotional material is very dark, mysterious and almost theatrical in some way. Where do you gather inspiration for this?

[Mather]: I come from a theatrical background, and though I grew up out of acting due to the anxiety it caused me, the theatrical spirit never quite died in me. As it turns out, this band is the perfect platform for theatricality. There's a lot of inspiration to be found in various historical eras, dark subcultures, classical paintings, mythology and folklore. One can never really tell where the next spark of inspiration will come from, but you certainly feel it when it hits.

[EB]: You use a lot of different costumes, and I suppose costume play and acting, in various videos. 'Dark Was The Night' and 'Fools Gold' are two of my favourites. Can you talk me through the concepts for these, and do all your music videos tell a story?

[Mather]: We certainly always aim to create a compelling story that brings a complementary vision to the sound. Our friends Victoria Vengeance and Gris Grimly approached us to direct 'Dark Was The Night,' and they brought to life a very beautiful visual interpretation of the song's story of mourning over the death of a lover, with dashes of the Occult thrown in for good measure.

For 'Fool's Gold,' we had wanted to step outside of our Victorian-inspired aesthetic. The violent (yet strangely heroic) antics of the Dillinger gang in the early 1930s provided a great inspiration for our story of a bank robbery gone wrong. We collaborated with the incredible Nicole Loretta of Paper Moon Vintage so we could dress the cast in authentic wardrobe as well as shoot the video in a period-appropriate location. It's an arduous but satisfying process bringing these videos to life, and we appreciate the positive feedback we receive from fans upon each video's debut.

[EB]: The fashion actually in 'Dark Was The Night' interestingly seems like it goes back to the Victorian era, which is another favourite of mine. Are you all fans of that particular fashion style?

[Chopper]: Absolutely, and not just the fashion, the Civil War, the Old West, and the authors and artists of the time, too.

[Mather]: The Victorian era certainly is one of my favourites with regards to fashion. There was so much painstaking detail put into patternmaking that simply doesn't exist anymore

MUSIC
Heathen Apostles

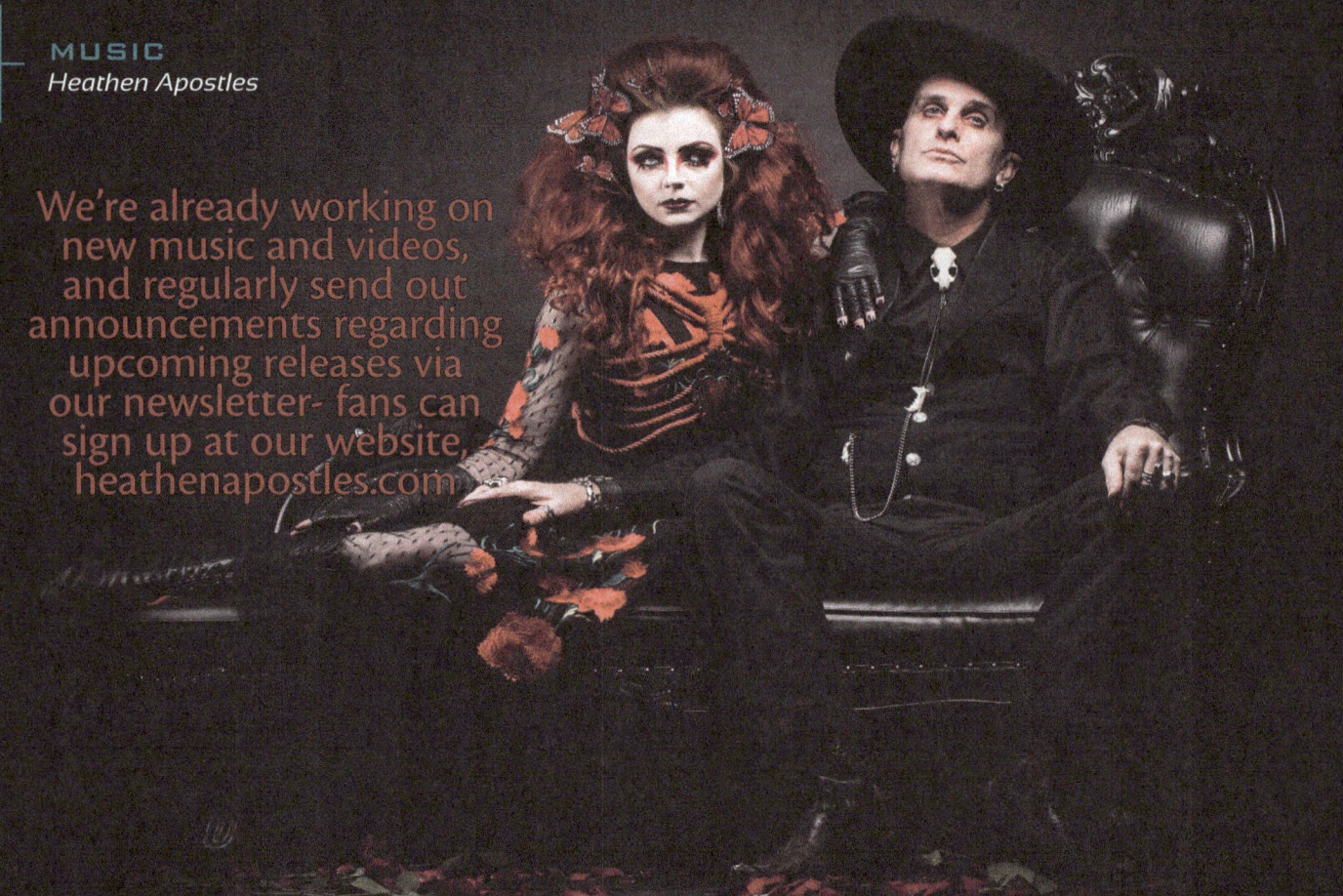

We're already working on new music and videos, and regularly send out announcements regarding upcoming releases via our newsletter- fans can sign up at our website, heathenapostles.com

(outside of the world of haute couture, of course). Not to mention the mourning culture that was enacted thanks to Queen Victoria- there's something absolutely breath-taking about all of the cultural customs and very particular stages of dressing while in mourning. The Met in New York had an incredible exhibit on mourning attire a few years ago that I had the chance to see. As morbid as the motivation for that fashion was, it was also wholly romantic and birthed from a place of love.

[EB]: What is the Victorian/Gothic culture like back home in LA?

[Chopper]: There are a few annual Victorian/Edwardian events, as well as some Gothic nightclubs, but not as many as there used to be. We play at the nights that have live bands and it's always great.

[Mather]: In California, we're blessed with the Edwardian Ball, MYTH Masque, Labyrinth of Jareth, Dickens Festival, Bats Day, and countless other subculture events throughout the year- we are spoiled!

[EB]: Your latest record, Fire To The Fuse, has been out for a good few months now. Are you pleased with how well it's been received?

[Chopper]: Yes, we've gotten great feedback about it, and it's also always great to see where it's coming from. We have hardcore fans from country and blues music, as well as from the gothic and punk rock side. It's actually not our latest record. We just put out Requiem For A Remix, and it has some really crazy remixes of our songs.

[EB]: I really like the album coverwork. Can you talk me through the concept of it and who was behind the design idea?

[Mather]: Thank you! It's always important to me to have a strong visual accompaniment to the music, particularly with this album since so many of the songs came from a deeply transformative period in my life. When we knew that 'Fire To The Fuse' would be appearing on the album, the phrase struck us both as a strong visual, one perfect to sum up the album itself. So, I crafted a ribcage with a fuse running to my heart, with Chopper lighting the fuse at the other end...the idea being, out of darkness, light. The butterflies I am surrounded by also allude to the idea of a sort of death and rebirth.

[EB]: I see you worked with Jyrki on the track Evil Spirits. Can you talk me through how this came about?

[Chopper]: We did a 4 song EP with him last year. He and Mather both sang lead on a song and, they did two duets. He and I have a side project we do called the 69 Cats. Jyrki is a good friend.

[Mather]: I had written 'Maylene' (one of the duets) years ago, and had always envisioned a spooky baritone male vocal to counter my own. Once we started receiving demos of the vocals from Jyrki, it was clear that he was the perfect person for the job. I couldn't be happier with how the song (and EP) turned out.

[EB]: What plans have you got lined up for the rest of the year, and will you be working on any other projects?

[Chopper]: We just put out a video for 'Murderer of Souls' (from Requiem For A Remix), and we may be filming one for our cover of Echo & the Bunnymen's 'The Killing Moon' that is on the same album.

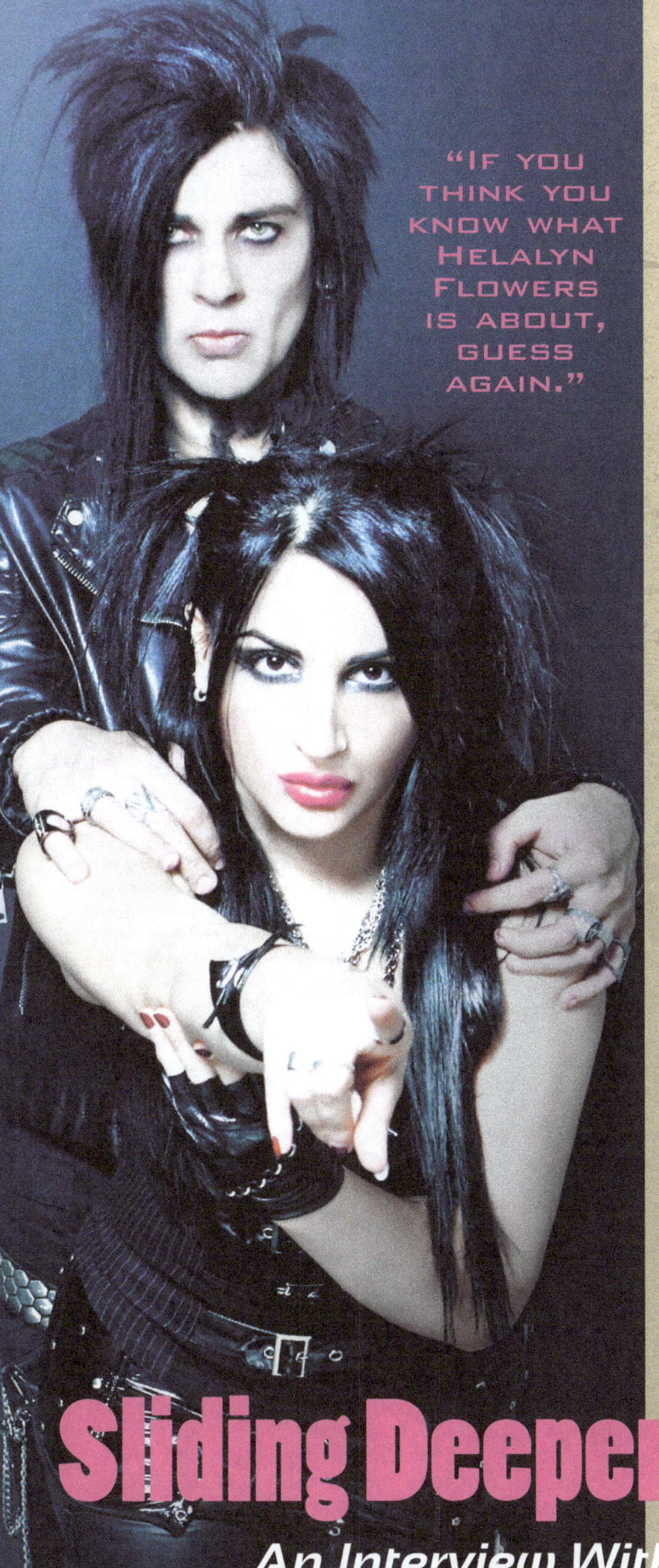

MUSIC
Helalyn Flowers

"IF YOU THINK YOU KNOW WHAT HELALYN FLOWERS IS ABOUT, GUESS AGAIN."

It was two and a half years ago when I received the email. White Me In Black Me Out had just been released. As a fairly new Music Editor, I was ambitious. Helalyn Flowers seemed like Gods to me. I was such a huge fan, and the new CD was completely brilliant. I wasn't sure if they would respond to my interview request. Some bands do and some don't. So, when that email came back agreeing to the interview, I was ecstatic. I immediately emailed the then owner of Carpe Nocturne. He was shocked, and stated he had been trying to get an interview with them for years. If I could manage to get a bunch of photos from Helalyn Flowers, he would put them on the cover and run a pictorial as well. Helalyn Flowers graced our Spring cover of 2014, and the pictorial became the first of it's kind for Carpe Nocturne. Afterwards, when everything was done, I thought to myself, "I just might be good at this." Helalyn Flowers did that for my confidence as an Editor. Now they are back with their fourth full-length album, "Sonic Foundation," and I reached out to them once again. As a rule, I never interview people I have already interviewed before. This is the only exception I have ever made. Maxx and Noemi are not only two of my favorite artists, but their talents stretch out far beyond Helalyn Flowers, and you might not even be aware. It is my extreme delight to bring you my interview with the amazingly gifted artists who combine to form the unstoppable force that is Helalyn Flowers.

If you think you know what Helalyn Flowers is about, guess again. "Sonic Foundation" is a completely different album from anything the duo has ever done before. It is darker, heavier, more industrial, more experimental, and imposingly cataclysmic. It is almost impossible to believe this is the same band who released "Stitches of Eden." Among the twelve tracks of electronic infused metal mayhem are collaborations with Angelspit and Chris Pohl of Blutengal. That should clue you in to what this album is about. When asked about the direction this release took, Maxx explained, "WMIBMO was already starting our progression into darkness. I don't think it's voluntary. I prefer to believe that it's something written in the Helalyn Flowers' DNA. During the works for 'Sonic Foundation' we noticed the songs were taking a different direction than the previous albums, especially our earlier ones, as well as reflecting a strange, dangerous mood. Simply we didn't force anything and let the whole album follow its natural development. Our work is a reflection of our lives. We don't make up things, and we must be faithful to our own nature."

Sliding Deeper Into Darkness

An Interview With Helalyn Flowers

By Michael Jack

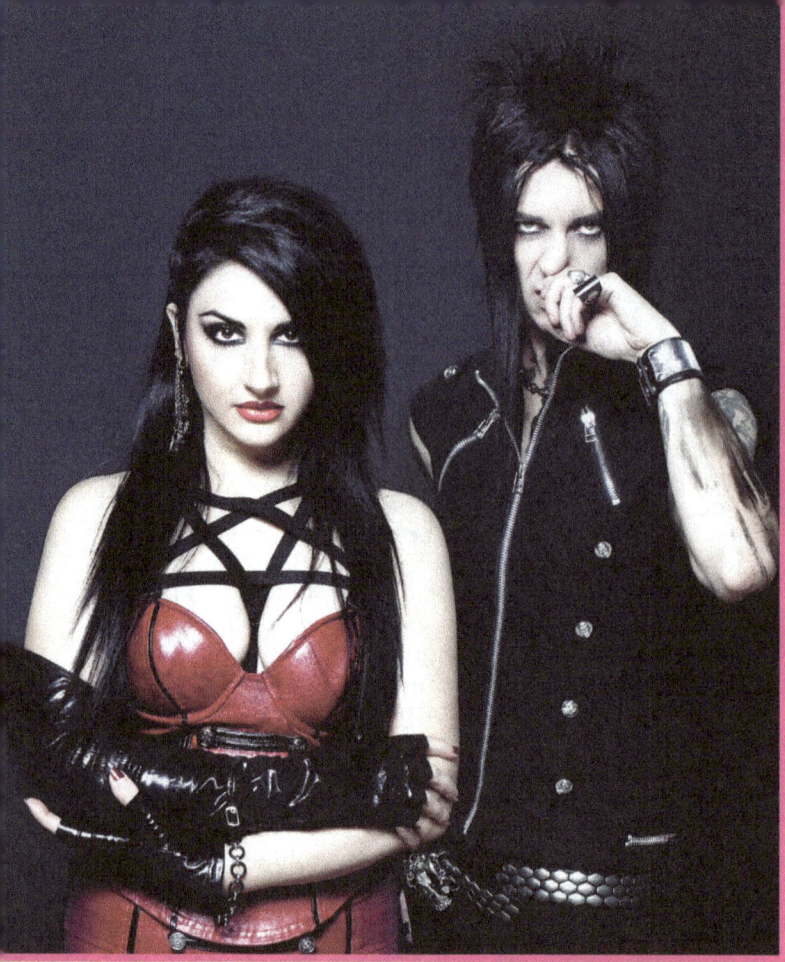

more like a large band playing loud than a man sitting in front of a monitor checking eq's and stuff. In fact, there's been sweat, bleeding fingers, headaches and all kind of consequences of a strong physical effort. The result is what we started working for since the album's early conception: a wall of sound for the sonic foundation."

This is the first time Helalyn Flowers have ever had guests on their release. The result was two amazing tracks that fit right into the style of the album, and simultaneously explodes into an opus of their own. When asked about the process that went into the collaborations, Noemi Answered, "I think one thing you have to do when you collaborate is actually respect the people that you work with, and both Blutengel's Chris Pohl and Angelspit's Karl are artists that we value both for the professional and creative approach they have for music."

The first single from the new album was "Beware of Light." It is the second track on "Sonic Foundation," and the second version of the song, featuring Chris Pohl, stands as the last track. Although both versions are incredible, it is the last one that really caught my attention. Noemi and Chris' voices work so well together. The transitions between the two are flawless, and, in fact, you almost feel like you are listening two different songs perfectly fused into one hypnotic nightmare. The collaboration with Angelspit is a different beast altogether. "Maths of Chaos" is the most aggressive track on "Sonic Foundation." Noemi commented on this song, "Our collaboration with Angelspit came out pretty natural. We already had the chance to join Angelspit on their track 'Fight Dirty,' included on their album 'The Product.' It was awesome to melt our forces, and we promised to do it again in the future. So, when we wrote 'Maths Of Chaos,' we thought it was the ideal song to host Angelspit on a Cyberpunk adventure made of sweat and rebellion. Zoog's involvement was immediate. He took care of synth-basses, voco-drums, noises as well as male vocals. The result was exciting, like we expected!"

Noemi further commented on Helayln Flowers' ever evolving sound. She states, "I'd rather define our musical path as a sound metamorphosis, some kind of brainchild that always evolves without losing its genetic. I think a true artist should never be afraid to change. Changes bring new ideas, developments and improvements. 'Sonic Foundation' marks for Helalyn Flowers a fundamental stage, a solid platform from which we'll take off from again. We'll just keep on sounding 'fearless'."

> "WE WROTE MANY MELODIC MID-TEMPOS, BUT IT'S DIFFERENT FROM DOING A BALLAD."

Strange, dangerous, and fearless are all great adjectives to describe the sound that is now "Sonic Foundation." This album will give rise to a whole new set of fans who hadn't taken notice of Helalyn Flowers before. The older fans no undoubtedly will remain. "Sonic Foundation" bridges a gap between the retro metal sound of WMIBMO and what would be considered modern Industrial Gothic Rock. For this album, the duo experimented with many new sounds, adding a very complex layer to the songs created. Maxx explains the process. "We aimed at getting a more 'physical' sound. We use lots of Korg machines and expanders, TC Helicon technologies and always we're faithful to the Spectrasonics Instruments. We created lots of samples of drumshots, fx, noises and played 'em with a digital drumkit by hand or experimented with different microphone positions to capture guitars and vocals in a new way. I think this is all audible in the album. It sounds

There are just so many great tracks on "Sonic Foundation," but it would have been near impossible to get in depth with each one. Instead, I was curious to find out which song gave the creative duo the most trouble. I can't say I was surprised by the answer. Maxx explains, "New Days Of Babylon" has been a very long journey! It underwent different metamorphoses so it's been difficult to manage. Sometimes one thing is the original idea you have in your mind, and another is the unexpected result. The song develops through at least four different parts and moods, so we had to take care to let 'em flow unroughly. The song showcases different shapes of our musical spectrum: Dance, Metal, Death Rock and even some Hip Hop grooves are audible here and there."

The song on "Sonic Foundation" that surprised me most was "I Saved an Angel." If you know Helalyn Flowers, you

know they don't do ballads. I had to ask a question about it, and how their fans' reactions have been. Both Maxx and Noemi had a lot to say about this particular song. Noemi: "I Saved an Angel" we define as our very first ballad, or better, an industrial ballad. It was born from my piano and vocals, and we decided to include it on the album as 'goodbye-track,' leaving it simple and clear, keeping vocals in the foreground. We are really fond of 'I Saved an Angel.' This is a passionate track about how to survive this World by refusing a distressing reality that human beings created against their own nature. When our fans discovered this song, their reaction was fantastic and we're collecting amazing comments day by day. It also has been defined one of our best tracks. We never played it live so far, but if we'll perform it live in the future, it will be overwhelming!"

Maxx further expanded on Noemi's answer. He had this to say about the uncharacteristic down-tempo song: "We didn't sit down and note that we had to do that. We wrote many melodic mid-tempos, but it's different from doing a ballad. You feel that you have lot of room to place stuff, but at once you understand that 'silences' and breathes do much more than putting parts on parts. It could have ended by sounding like a big Hard Rock one, kinda maudlein for girls, but "I Saved an Angel" is not that case. It's one of the most intimate songs we have ever wrote so far. Absolutely it represents the perfect leave for the album for it's able to exorcise all the Evil we evoked during the album. Not only have people reacted so enthusiastically, but this is among the very first songs that the crowd underlined when we launched previews of the album."

Besides redefining and building upon their existing sound, Maxx and Noemi have been busy on various other projects. Maxx has been producing music, and has worked on the most recent Lovelorn Dolls album, "Japanese Robot Invasion." Maxx is also working with frontwoman Kristell on her solo project, SIN SIN. If you have listened to either of these, you know how amazing the works are. I had to ask Maxx about what he helped to change about Lovelorn Dolls' sound that made their second release so fantastic. Maxx replied, "My idea was that they needed a bigger sound, able to give exposure to the many faces of their music spectrum. They engaged me for their second album, of course, because they know me from my work with Helalyn Flowers. I didn't put 'Helalyn Flowers' to their record, however. Simply, I spent a lot of time working on their best ideas and let 'em stand out. I'm not just a sound engineer who adjusts a couple of eq's or does standard mixes while asking you for a hell of lot of money. I want to do a unique, crazy, brave work. If the band is with me then we can go far. Sin.Sin album is ready and probably is scheduled for a late 2016 release. The first EP "Fairytronics" is already out via Alfa Matrix." As for doing more producing in the future, Maxx added, "I don't know what the future brings. I can tell you that I do that just for myself. I love to fill up my days with music. It's the air I breathe."

Noemi is going strong with her visual design company, "Toxic Visions." Launched in 1999, Noemi has helped to create artwork and merchandise for many bands, including The Psychic Force, Elyose, and of course, Helalyn Flowers. She describes her style as Dark Metal Fantasy and Rock n Roll appeal. When explaining her work in Toxic Visions, Noemi states, "I dedicate night and day to my project, since it also includes our audio productions. It takes lot of energy, but I love what I do. I help bands to find their style and I can translate their ideas into something real. That's fantastic. There's no way to stop when you do something with passion." The passion is apparent, and taps into her early roots of art, photography, and digital illustration. The design she is most proud of is a mixed media canvas she released several years ago called "Pan," and it has been exhibited at the Modern Art Gallery of Savona, Italy, during the famous 'Espoarte' venue.

If you are not a fan of Helalyn Flowers, it may be time to give another listen. Their ever evolving sound leaves an archive of diverse music that is certain please fans of almost any genre. Their newest release, "Sonic Foundation," is the boldest addition to their discography to date. It debuted at #50 on the iTunes Top 100 Rock Music Chart, and is one of the most purchased albums in the Bandcamp Alternative Section. This release is drawing in new crowds to the ever growing fan base of Helalyn Flowers, and their momentum isn't slowing down. Expect to see a video later this year, and for "Sonic Foundation" to keep climbing up those charts.

Building an Army of Love with Kerli

By Asylum Attendant

MUSIC
Interview with Kerli

Over the years, I've loved many music artists, but none are as special as Kerli is to me. I discovered her quirky goth pop at the darkest time in my life, when I had no purpose and had lost all hope. Kerli's uplifting breakout single "Walking on Air" made me realize that I could accomplish absolutely anything in life and that no dream was too big. When I met her four years ago at a pride festival, she was just as loving and bright as you can imagine in her panda bear platforms and tinsel pigtails, even with a windstorm going on around us. Kerli has kept up the magic all these years later and it was a privilege to ask my idol about her new music, her homeland of Estonia and her Moonchildren.

Kerli's new single "Feral Hearts" from her upcoming album is about shedding parts of yourself that aren't natural and honest. "To me, 'Feral Hearts' is a reminder of who we really are - beings that are created to live in harmony with nature. It is a story of freedom and realizing our potential to experience the utmost beauty and magic existing both inside and around us. I guess you could say that it's an offering to the majestic spirits of the wilderness." The fantastical music video features Kerli as a white stag, a mermaid, a tree spirit and a spider goddess. She never disappoints in the visual department.

Kerli wasn't always proud of her restrictive homeland Estonia. Now that a bunch of time has passed, she feels differently. I was curious about how her feelings changed so drastically. "Yes. I have a very interesting and complex relationship with the place I'm from. My childhood was a really depressing time for me because I felt so misunderstood by other people. Now in retrospect I don't know if it was about the place I'm from or the society in general, but I always felt a deep sense of loneliness, like I was an alien. So I had to escape to see what else the world had to offer. After traveling and pursuing my dream for over a decade I realized I was missing something really important - my roots. I left home when I was just a kid so I never actually took the time to create a relationship with my land as an adult. Last year everything changed - I started feeling an extremely powerful calling towards the plants, animals, magic and a simpler way of living. So I left everything behind and moved to the forest of Estonia where I lived for 9 months in extremely humble conditions. I basically had nothing else but my music making gear with me. It was a scary thing to reset my whole way of existing this way but I believe this was hands down the kindest thing I have ever done for my spirit. I am also feeling a lot of love coming from the people here which makes me feel welcome in my real home. It is very touching."

Kerli's fans, which she named the Moonchildren before it was the cool thing to name one's fan base, have waited a long time for a new Kerli album. Her first album "Love is Dead" was very dark with glimpses of light, while her 2013 EP "Utopia" was euphoric and filled with rave anthems. Naturally, I wondered what this new album would sound like. "It's definitely leaning more towards the 'Love is Dead' era, but without the angst. It's more deep than sad as I was feeling extremely free and powerful while creating this body of work. Sound wise, it's a mix of electronic and organic elements - all of that sprinkled with the elven choirs I befriended in the woods."

Kerli was originally signed to Island Records by LA Reid, but she never felt creative freedom being tied to a major label. She's now an independent artist in total control of her destiny. "To me, it's all about the art so my goal is to just make good art - music and visuals - with no one constantly censoring and judging its selling power. It was painful for my heart to keep writing hundreds of songs and never being 'radio friendly' enough to have them released. It's like selling your soul to the devil for a false sense of security and status. I feel like I don't need anyone's seal of approval to feel good about my journey anymore. I'm just here to make something beautiful of the short time I have here on Earth."

I've learned many important life lessons from Kerli, such as ignoring fear, working my ass off and how to DIY stripper heels. However, Kerli's Moonchildren are equally as inspiring to her. "Moonchildren really make me feel like I'm not alone because I'm just as lonely as everyone else. I love hearing their stories and opinions about things. They are a colorful bunch. And of course it's just a really humbling feeling to lay your soul out there for people to touch and them getting something meaningful out of that. That's really what it's all about - the energy exchange." I've always felt like Kerli's friend, not her fan.

Kerli created the Bubblegoth fashion movement of blending dark and light, including teddy bear gasmasks

MUSIC
Interview with Kerli

and black PVC mixed with lace and bows. Nowadays, she's embraced more Pagan/Wiccan fashion with long flowing dresses and minimal details. "My ancestors were nature worshipping pagans so after living in the woods and intensely connecting with the magic of my land for 9 months, I guess it's natural that all of that would bleed into my art as well. To me, it's really not separate. I don't think about it very much. It just comes and I run with it as long as it feels good in my gut. I don't really plan these things out. As of fashion - I love fashion as a form of self-expression intensely and am working on setting up exciting stuff on that front as well." A Kerli fashion line needs to happen.

Kerli is never shy when it comes to performances and baring her soul. Though, we all regret some of our choices, right? "I'm embarrassed for the times in my career when I listened to the people who didn't have my best interest at heart. I have a lot of regret when it comes to not always loving myself enough to shut the doors that weren't promoting healthy values. But I guess you live, you learn. As of fashion, no, I'm not embarrassed. It's actually really fun to look back and see the evolution from the first home-made and poorly stitched up performance outfits to the latest creations and collaborations with some of the best designers in my country. I'm definitely getting much more mature and minimalistic with my style. Every color, shape and accessory needs to have purpose. I used to just pile it all up Harajuku style - the more the merrier. Haha!"

I've watched Kerli grow from an intense, stubborn girl with an unstoppable dream to a regal woman at peace, completely in tune with the universe. But, her epic journey is far from over. "Thank you so much for this beautiful compliment! I guess we'll never know what life has in store. But I feel very on the right path and extremely connected to my army of moon children so all I can promise from my end is that I'll be creating these pockets of magic until I can. There are so many places and worlds I wanna build - starting with finishing my geometric glass temple/studio in the woods of Estonia that should be done this summer. Life is all about play."

I'm certain that Kerli will never stop creating powerful, touching music and visuals that make the world a better place. She saved my life and I know she saved many others as well. Grab "Feral Hearts" here (http://smarturl.it/getferalhearts) and follow Kerli into zero gravity.

Integrity. Love. Unity.

http://spoti.fi/1XgprZY
http://youtube.com/kerlimusic
http://fb.com/kerli
http://twitter.com/kerlimusic

Amazing Tracks: *Sounds From a Secret Cave*
By Sergio Manghina

Album: LA SALA DEI CRISTALLI
Artist: ALIO DIE & MARIOLINA ZITTA
Label: Hic Sunt Leones
2010

Caves are fascinating places, a mix of wonder, magic, mystery and then often can become hazardous adventures for truly passionate people.

Since 1992, Mariolina Zitta is a field recording artist active in a personal exploration into natural sounds and her interest is focused precisely in caves. After all she's also a skilled speleologist. This album is the turning point on her career, the passage from a strictly orthodox research towards something different. "La sala dei cristalli" is in fact the fruit of her collaboration with Stefano Musso aka Alio Die, internationally well-known exponent of the dark Ambient scene with an exterminated discography behind. He intervenes electronically on the material recorded in various caves in the regions of Sardinia and Liguria. Stalactites, sonorous stones, batcalls, rattles and shells, a gathering of sounds powered by arcane depths. I personally visited some of those caves many years ago and I keep a very special memory of that experience.

Living beings and stones, however, are both actors - perhaps unaware or maybe not - crystalized inside their own endless present where time appears almost immutable. Mariolina captures the essence of that moment and then Alio Die, for his part, adds further effects as sensitive and competent as himself.

What comes out is something similar to a trip back in time in a distant era.

CARPE NOCTURNE
SOUNDS OF THE LIVING DEAD
ALBUM REVIEWS

Artist: Black Tape for a Blue Girl
Album: Remnants of a Deeper Purity (20th Anniversary Double-LP Vinyl Release)
By Trixxi Divine

The 20th anniversary re-issue of Black Tape for a Blue Girl's "Remnants of a Deeper Purity" is a great cause for introspective fête. Neoclassical Darkwave has always been an elaborate Gothic niche which requires patience by the listener and this cult classic is a defining body of work, both in that it stands out as an archetype of everything the genre can aspire to as well as in its thematic preoccupations of beauty and darkness. Originally released in 1996 on the Projekt Records label, this obscure, mournful music captivates with deep, lushly arranged passages, emotional vocals and haunting melodies of genres already less voyaged. "Remnants of a Deeper Purity" is worthy of re-visitation for any collector of this Gothic genre as well as for new listeners looking to procure classic artists at their apex. Formed in 1986 by Sam Rosenthal, founder of Projekt Records (keyboardist, guitar and production), Black Tape for a Blue Girl has seen various formations but it is this particular release which brought the band notoriety. "Remnants of a Deeper Purity" features also Lucian Casselman on vocals, Vicki Richards on violin and Mera Roberts on cello. Their best-selling release was the catalyst for the band's first live performance at Projektfest'96. This breath-taking neo-classical gothic album is presented on vinyl for the first time on a deluxe vinyl double LP in celebration of its 20 years in cult status.

Opening in the epic sweep of "Redefine Pure Faith", the vocalists solicit for a sexualized crux of faith, melancholy, intrigue, purity and flesh. Protracted deep tones are weaved by penetrating rich vocals from Oscar and Lucian respectively. Intricate violin arrangements from Mera are complimentary to the cello in which Vicki contributes to the numerous tracks. The results are deeply enchanting yet maudlin in their styling. The synthesized string section of the notable "Fin de Siècle" which succumbs to its condemning weight on the world; perhaps an allusion to the susceptibility of the close of a century threatened and exposed to be marred with dissolution. For the listener, this conjures a feeling evocative of the unsettling visceral certainty that numerous shared in the mid-90's: that this was edifice to something absolute for the millennium, that we were all standing on the fracture and feeling the distant vibrations of something so inescapably big and peering over the edge but would never grasp it until it became too late. With the key elements of conviction, apocalypse and ruined greatness, the rich pleasures of the flesh and the cold darkness of the world in mind, the album proceeds to tell a love story. This is the grandiosity of desires and sorrows, of timeless actualities, antediluvian and merciless. It is melodramatic and cumbersome in its solemnity but earns it through the sheer elegance of its construction, returning gothic music to the vast, light-filled intricacy of grandeur. It describes a huge, edgeless form that one cannot get far enough away from to see its extent. "With My Sorrows" is a wistful song which concludes with a fascinating take on an old Spanish poem. The album ends dreamily with the stunning "I Have No More Answers" and final soul-bearing declaration, "Here I stand; all of me before your eyes, no more lies, no more lies. Just me. Pure me".

Artist: DPERD
Album: V
By Sergio Manghina

Dperd make me think when I spent time in a cottage nestled in the wood, hosted by friends. For once, away from the annoying din of the city.

Yes, because Valeria e Carlo are like a shady corner under a burning sun, the fresh reticle of branches and leaves of the European music scene where time flows slower and paradoxically every sensation beats faster. Their fifth album is the ideal continuation of "Kore". However it needs more plays to be fully assimilated, if compared to it.

"Frenetika" starts with the great vocal performance of Valeria Buono in perfect balance throughout the entire album with the instrumental work of Carlo Desimone surrounded by guitars, bass, keyboards and drums. "Aggrappata al silenzio", "Aspettare che il mondo passi" and "But I Love You Song" are well-oiled devices of high melodic crafts, in the tradition of the duo.

Germs of the best Italian Progressive Rock live happily inside "I Believe in You", "They Do Know Song", but - above all - in "Vorrei una vita semplice". This track gifts an irresistible airy melody, under the pressing drumming of Carlo and an - as ever – superb interpretation by Valeria. The melancholy of their soft-dark soaks each sound as well as each word. It is a true connotation of life, but without ever being tedious or oppressive.

As always comparisons abound, from Cocteau Twins to Lycia and so on. That is their cultural humus. But, honestly,

CARPE NOCTURNE
SOUNDS OF THE LIVING DEAD
ALBUM REVIEWS

Dperd have certainly an original allure, maybe due to their different origins, occupying a segment that belong only to them.

Artist: Ayria
Album: Paper Dolls
By Asylum Attendant

She's back…and stronger than ever. I always wait with baited breath for the next Ayria release and I've never been disappointed. Her fifth album "Paper Dolls" features the usual hard-hitting dance beats and poignant lyrics that Ayria is known for. This album explores themes of emptiness, a loss of humanity and isolation. Haven't we all felt like a paper doll at some point, especially in a technology obsessed society full of conformists? Ayria isn't afraid to call out the destruction and damage she encounters with her biting vocals.

The album opens with "Underneath the Water", an example of the bad events that can happen when a person goes against the norm. "Feed Her to the Wolves" continues with the theme of killing a person's soul through an invocation of fear and judgment by the majority. These dark themes are strewn against equally heavy, yet energetic industrial instrumentals. "Crash and Burn" slowly builds into an attack on the wealth-obsessed who care not for the welfare of the rest of the world. The injustice and anger flow through Jennifer Parkin's vocals.

Other songs on "Paper Dolls" address the vapid social connections and apathy everyone can relate too. The title track features heavy synth distortion in the beginning, launching into a lonely break from reality. "Deconstruct Me" is very intriguing. The lyrics encourage allowing another person to tear you apart and reassemble the parts in a way they like, much like Frankenstein did to his monster. I happily imagine shocking and confusing an ex with this song. Pain is preferred over loneliness on "Sticks and Stones", a slower song with emotional vocals that displays Ayria's vulnerability.

The album closes out with "Chameleon", a track about an uncertain future open to interpretation. All in all, "Paper Dolls" is an album full of melancholy feelings I often experience. Except Ayria always tackles tough topics with plenty of spunk and sassy electronica. Watch out: she'll take scissors to your perfect paper dolls…

Artist: Ophelia's Sweet Demise
Album: Sonata Noire
By Sergio Manghina

The publication of a new album by Ophelia Sweet's Demise is something similar to a cold case. I already knew this band from Milwaukee, their sound, unique and dramatic, scattered into only a handful of works published between 1997 and 2000. An EP "Absynthe" and two full-length albums, "Dark Serenade" and "Ashes to Lashes". Finally breaking their silence. Daniel Kufahl and Kat Minerath are back at the commands and fortunately always able to write some absolutely precious pages. Yes, because the tracks of "Sonata Noire" certainly are worthy to play in the Major League of Goth.

A patina of indefinable melancholy pervades these sounds. Melancholy in rhyme with mystery, magic and nostalgia.

"Let It Go" has an airy structure in debt with a vaguely early seventies sound. "Domain" is a powerful piece, with its heavy guitar, solemn and epic at the same time. "Sonata Noire", the title track, is a terrific Romantic ballad. Dotted by piano keys, and masterfully played by the voices of Kat and Daniel. It makes a pair with "Sister Cashbox" about melodic delight. The dreaming "Only You" is poignant and longing, with more than an evident psychedelic touch.

It captures the essence of the gentle side of Darkwave. "Bad Sands" is instead more metallic and sharpened, a new wave gash, opening the door to the following and surprising electro-pop of "Blue". This one is an irresistible dance floor-friendly track disseminated with refined pitfalls and perilous ambushes. Four minutes of a captivating game, seasoned with palpitations of the eighties.

Introduced by translucent keyboards, "Dangerous" falls back in the darkness, placing the strongest pawns on the chessboard, a piece of rare dramatic effect.

The vaporous sonic interweaving of guitar and electronics on "Winter Songs", not unmindful of some shades of English Progressive, is the final jab of an album which offers moments of authentic beauty and even fun, which we believed lost. ∎

MUSIC
Sounds of Seattle

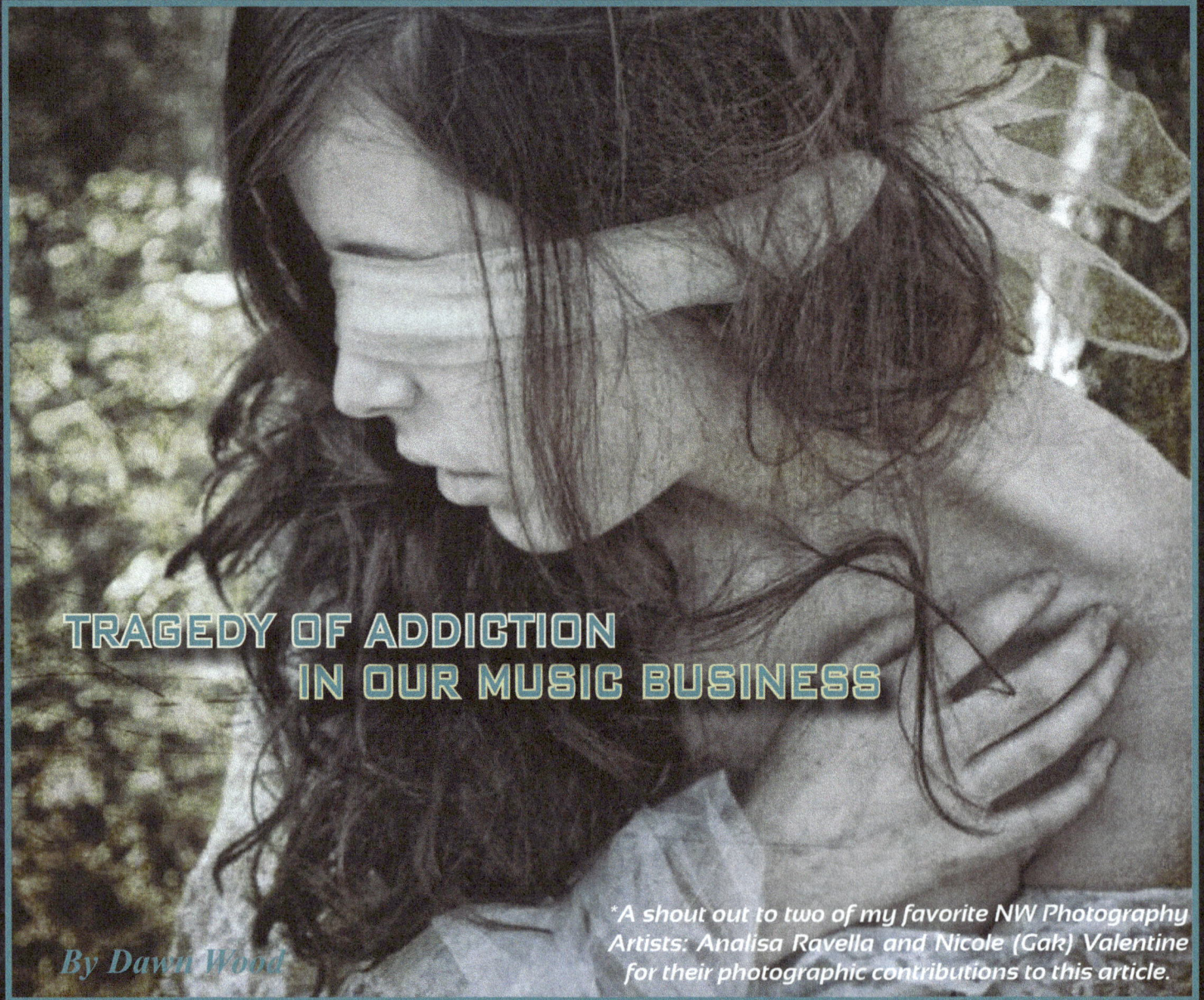

TRAGEDY OF ADDICTION IN OUR MUSIC BUSINESS

By Dawn Wood

**A shout out to two of my favorite NW Photography Artists: Analisa Ravella and Nicole (Gak) Valentine for their photographic contributions to this article.*

This is definitely the most difficult article I have ever penned. I spent two months brainstorming and sorting out my thoughts and deep-seeded, buried hurts on this topic. I thought it might help to interview musicians in the local Gothic/Industrial/Metal Scene here in the Seattle area. At first, many spoke up and were eager to lend their thoughts and experiences, but I found that as the deadline approached, the resounding response I heard was: "This was too difficult," "too painful," "too hard to put into words." The closer I got to my own deadline, I found myself struggling as well. You see, I am not an addict. I have... however, loved quite a few addicts and learned the painful lessons of "existing" in an addict's life. My first experience, was as a teenager living with an abusive, drug addicted/alcoholic step-father. To "escape" this life, I started dating a very nice "recovered-addict" and while I was in my first year of college, made the mistake of marrying him. My life suddenly went from bad to worse. I watched him turn from a slightly annoying jealous person, to a methed out, abusive, threatening, terrifying monster who would hold me at gun point if he dreamed up some reason to be upset with me. I made it through college and I ran for my life. I packed up very little, left my family, friends, my dog and all my belongings and moved to Seattle to start my new life in the music industry. Finally! Escape!

Soon after I moved to Seattle, I discovered this......no matter what band I joined, there was at least one addict. I found that being in a scene I loved so much and felt acceptance in, meant I would be surrounded by, date and be in relationships with.....more.....addicts. I would go through the rollercoaster of really good days/really bad

days and really "why on earth are you so: depressed/suicidal/angry/cold?" days. THEIR addiction affected my life and well-being. Isn't the very definition of insanity, as according to Albert Einstein: "Doing the same thing over and over again and expecting different results" or, is there a lesson here?

Recently, we heard of the iconic super pop star Prince's untimely passing. Details have come out about his long struggle with pain and his addiction to opioids. Some turn to drugs for physical pain, emotional pain, fear, loneliness, ego. Unfortunately, I have seen all of these reasons and don't understand the addiction any more than I did as a terrified 17 year old girl. It is tragic that we have lost such amazingly talented Icons in the Music World: Prince, Michael Jackson and Whitney Houston due to drug overdose/interactions. Also, in our Gothic/Industrial/Dark Metal genre, we have lost very influential artists such as: Wayne Static, Paul Grey, Gidget Gein, Josh Chooper, Cadavérico, Jason McCash, Myssi Sauder, Jeff Hanneman. As I think of these legendary talents and how their passing affects us (mere appreciative fans), I wonder, who was left behind in each of these performer's lives, and affected by their addiction?

Research supported by the National Institute on Drug Abuse (NIDA) has fought to prove that "addiction is a complex brain disease characterized by compulsive (often uncontrollable) drug craving, seeking, and use that persist despite potentially devastating consequences" (to themselves and to anyone around them.) Further, "As a person continues to abuse drugs, the brain adapts to the overwhelming surges in dopamine by producing less dopamine or by reducing the number of dopamine receptors in the reward circuit. The result is a lessening of dopamine's impact on the reward circuit, which reduces the abuser's ability to enjoy not only the drugs but also other events in life that previously brought pleasure. This decrease

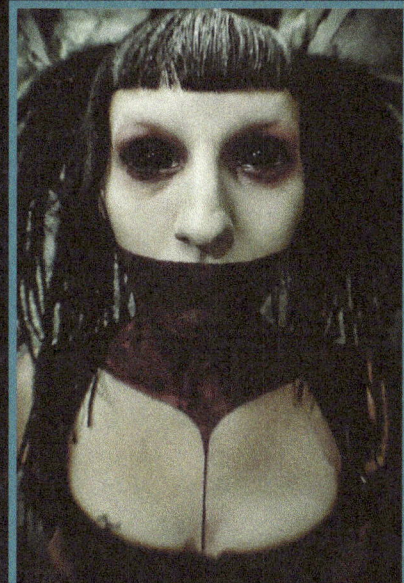

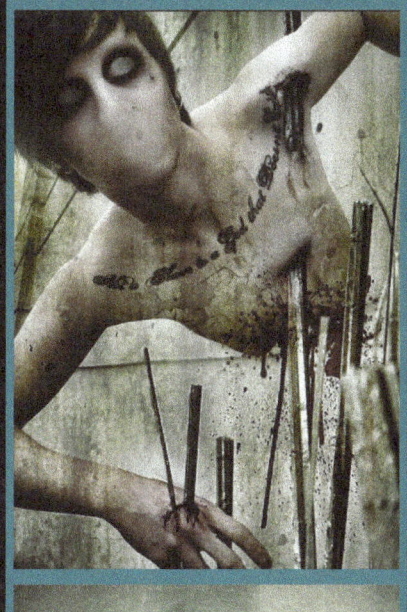

compels the addicted person to keep abusing drugs in an attempt to bring the dopamine function back to normal, but now larger amounts of the drug are required to achieve the same dopamine high—an effect known as tolerance.

Long-term abuse causes changes in other brain chemical systems and circuits as well. Glutamate is a neurotransmitter that influences the reward circuit and the ability to learn. When the optimal concentration of glutamate is altered by drug abuse, the brain attempts to compensate, which can impair cognitive function. Brain imaging studies of drug-addicted individuals show changes in areas of the brain that are critical to judgment, decision making, learning and memory, and behavior control. Together, these changes can drive an abuser to seek out and take drugs compulsively despite adverse, even devastating consequences—that is the nature of addiction." Essentially dealing with a drug addict is dealing with an entirely different person. So, if you feel that someone "stepped in" to your boyfriend/girlfriend/husband/wife/best friend/bandmate, it is because indeed someone else DID.

Ultimately, the choice of addiction IS in fact a choice. Both for the user and for the people in the addict's life who are affected and the casualty of the "abuse." There are counselors who specialize in PTSS/PTSD and who have worked with addicts to help a person in this situation better cope. There are also Nar-Anon groups located in most cities across the country: www.nar-anon.org.

There is also the choice to walk away. The best choice is the best choice for you and your well-being. Always keep your safety and well being at the forefront, and know there are others who have and continue to live this pain. I would like to see more people, especially in the music business, speak out. Strength in numbers. ■

GOTHIC BREWER'S GUIDE
...Because Black is a Thirsty Color

Because Black is a Thirsty Color
By Michael Jack

Where do I even begin to describe what I love about summer beers? Well, for one, most summer brews are meant to be session beers. Stated simply, this means they were crafted to be enjoyed all day long. If mass consumption is your intention, then you will be as big of a fan as I am. Think about it...summer means picnics, cook outs, drinking with friends on the patio, and throwing fabulous parties. Guests will be feeling good and returning to the cooler often for another round. Summer beers keep the party going. They are light, crisp, and go down very easily. They are also infused with a decent amount of citrus hops, so they are refreshing to the pallate. In every possible way, these beers scream summer.

Seasonal: Bell's Oberon Ale

When summer nears, one of the very first things I do is seek out the Oberon. This beer is everything you would expect from a summer brew, and so much more. It is an American wheat pale ale, with very strong citrus notes. To pour, it is a cloudy, slightly orange color. You expect the haziness with any wheat beer, and a decent amount of foam on top. The Oberon doesn't disappoint. The aroma is citrus, and the taste is simply delicious. Orange dominates the flavor, but there are very subtle hints of hop spices and malt-yeast flavor. This beer hits the full spectrum of mouth-pleasing thirst-quenching happiness. Brewed by Bell's out of Kalamazoo, MI this fantastic wheat ale is 5.8% ABV, so it can be enjoyed for many hours. However, it is slightly more potent than many summer beers, so maybe mix in a water here and there. Besides, if you are out in the sun all day downing one of these after another, which isn't hard to do, then you will get dehydrated. Water will ensure you can keep going well into the night.

Year Round: Founder's All Day IPA

If you love that citrus flavor, if you love IPA's, if you are looking for a session beer that tastes as great when you pour your eighth as it did when you poured your first, look no farther than Founder's All Day IPA. Honestly, the name says it all. This overly pleasant ale is the second straight one in this article brewed in Michigan. Grand Rapids, to be exact. If you are thinking road trip, so am I. The All Day has everything you want from an IPA. It has strong orange accents, slightly sweet and slightly tart. It has hops that are obvious to the taste. The color is a beautiful golden orange. The aroma is fabulous. More hops and citrus. It goes down very easily, smoothly, and it is refreshing. This beer is not heavy at all, and yet it packs an explosion of flavor that hits your taste buds immediately. Founders All Day is easily one of the best IPA's I have ever tasted, and it is a staple in my house, at functions, and on vacation. The All Day is 4.7% ABV, which is perfect for a session. You can drink this phenomenal gift to the beer world, well...all day (and all year round).

Theme: Anchor Steam Beer

From Michigan, we turn to San Francisco, and the oldest craft brewery in America. Anchor Brewing Co. was established in 1896, and has roots that go as far back as the California Gold Rush. This founding father of American beer was brewed with German craftsmanship, and quickly became popular around the city. The Anchor Steam was the brewery's flagship beer back in 1896, and it still is today. This steam beer (the actual style it is), is still crafted the same way it was one hundred and twenty years ago. Technology may have improved, but the Anchor Steam is still handmade from the same blend of all-malt mash in a traditional copper brewhouse. I don't claim to be an expert, but everything I just mentioned screams Steampunk to me.

So what about the taste? Is this American classic still drinkable? How does the flavor stand up to the changing palliates of the nation? It's still here, and it is more popular than it has even been. That should be an indication. Not only is the steam a rare style in America, it is a nice alternative to the typical hoppy beers. Remember, this one is more malt, and that's what you taste. There is a good amount of carbonation, the color is a clear amber, and it's very light in texture. Basically, it looks like a non-craft beer, but with craft taste. The Anchor Steam is 4.9% ABV, and by all means a solid session beer.

GOTH COLLAR WORKER
The Blog for the Career Goth's Lifestyle
www.gothcollar.com

Personal Recommendation: Flying Dog Fever Dream Mango Habanero IPA

Every now and then I discover a beer that gets me VERY excited. This just happened. Imagine me stepping into my regular watering hole, and yes, I have a regular watering hole. I sit down, the bartender greets me by name and hands me a list of their current beers on tap. I skim it over, already knowing I'm going to order an Oberon, which they just tapped. Suddenly, my eyes are drawn to something I have never seen before. Right near the bottom of the list is printed, "Flying Dog Fever Dream Mango Habanero IPA." Mind blown. I know Flying Dog Brewery, based out of Frederick, Maryland, and they are fantastic. Their Raging Bitch IPA is among the best I have ever tasted. I look up, point down, and say, "I'll have that." There was no way I was leaving the tavern without trying it.

The combination seems strange, I know. That's what drew me to the Fever Dream in the first place. Plus, you usually don't see hot peppers mixed in with beer. The bartender, Alicia, tipped the glass and tapped a hazy dark orange looking beer. The aroma was incredible. It smelled like what I would expect from a double IPA...uber hops and uber citrus, but it is not a double. I sipped, not knowing what to expect, and it was magical. The mango flavor was tender, smooth, mixed in well, and yet, you could still distinctly pick it out. The habanero was there on the back end, slight spiciness, not much, but just enough for you to know it was there. The spice didn't linger at all, but was noticeable on every sip. The IPA had the right amount of hoppiness for a stronger IPA, and I fell completely in love. This standing ovation of a product is 7% ABV, but I continued to order it all night long. I was a little tipsy when I left, but it was worth it. I highly suggest seeking out the Fever Dream Mango Habanero IPA, and trying it. Not only will you not be disappointed, but you just might fall in love.

By XXX ZOMBIEBOY XXX

ZOMBIEBITE

It recently occurred to me that I have not addressed probably the most pressing issue regarding the zombie apocalypse. What in the hell do you do if you get bitten?

Have a friend shoot you. You're fooked. End of article.

...Still here? Good. That means you think outside of the box and don't give up easy. And why should you? Almost every movie we have seen agrees on one thing. You get bit, you turn, end of story. Some last a few days. Some last a few seconds. Let's examine this however. They are movies. Period. Getting bitten by anything isn't a good thing unless, of course, it's your significant other and they're in bed and they are *not* a zombie. But I digress. I think it important to note two things before I go too deep into this article.

One, there are so many variables involved in even discussing the treatment of a zombie bite. The most important being the source of the zombies. Is it an infection? Is it radiation? Is it possession? Is it a "dark magic" of some kind? The reason behind the spread has everything to do with what you do next. My approach will lean towards infection.

Two, this is all very speculative and it is written from a perspective of anarchy and chaos, not of our present society. If a living person or an animal bites you, don't be a dumbass. Go to the hospital. Period.

Bites are nasty wounds, yes. They are usually jagged, hard to close and easily infected. Let us look at this injury however from a more scientific perspective as opposed to just assuming that you are totally screwed. We shall proceed from the perspective that there are no hospitals, there are no antibiotics readily available, and we are on the road surviving the best we can.

So you got bit. How careless of you. First FIGHT because you are probably surrounded and outnumbered. Once you get to a safe (ish) place, the first order of business is to clean the wound. A combination of vinegar, salt and water will help if you can procure any. Clean it the best you can with what you have. Even alcohol if there is nothing else, and put a stick in your mouth because this is really going to hurt. With luck you may only walk away with a bruise. With slightly less luck, you will have puncture wounds. Worst luck of all, however, is a gaping hole. Two out of three of these you will be bleeding a good bit.

Next, stop the bleeding. Apply pressure to the wound with the cleanest thing you have. I should note we touch on a lot of this in the Alchemist's Closet column so I will not belabor it all here. Be sure to read that however because it relates! Elevate the wound above the heart. This will help slow the bleeding. DO NOT have someone try to suck out the poison. It doesn't work on snakebites; it certainly won't work on a zombie bite. Chances are it isn't poison in the first place. Then, if it is an infection or a disease, well, in that case you and your noble friend now have it!

If you have noted that the spread of the zombies is due to infection, wrap a bandage or bandana tight around the bitten limb to slow the progress. If it is an infection spread by a bite causing all of this, then it may be necessary to amputate the limb. This has worked once or twice in the movies, and the idea has merit. I however would not even consider such a radical and dangerous procedure unless I have already seen countless cases of zombie bites treated properly with no positive results. If there is even a chance you can go forward without cutting off an arm or a leg, then take the chance, because being without one or the other, you probably won't last long anyway.

If the zombies are radiated, then you have radiation poisoning likely as not. Assuming that radioactive particles have traveled into the wound of course. Symptoms of this can be nausea and vomiting. The longer it takes to get nausea (in general) the less radiation. There are three potential cures and they are not exactly easy to come by.

Potassium iodine heads directly for your thyroid and in a way blocks other iodine that has become irradiated. This radioactive iodine is then pissed out. Diethylenetriamine pentaacetic acid or DTPA, binds to at least three different types of radioactive particles and speeds up the bodies removal of them. Finally, Prussian Blue which is a dye, will scrub out the particles (mostly) and help you crap them out.

Finally, there are magic and spiritually produced zombies. The upside is that these don't tend to bite. They may however try to club you with a gardening tool or strangle you. There is little to discuss on the subject of bites here. There is a great deal of folklore regarding these creatures, and the sources of magic that power or awaken or enslave them is varied. One common end to the fight is to give the zombie salt. Otherwise, a bullet to the head is still pretty reliable.

In the next issue, we will discuss how a field amputation is performed, consulting with medical professionals on this dangerous procedure. Stay sharp! Don't get bit!

VOICE OF THE NEW DARK CULTURE
Mental Health

I Am Mental

By Chirality

Times are trying. This is going to be a tad raw and real on my end, but please bear with me as I sort out my brain and put this to type. I admit to having horrible anxiety and depression. I also admit to not being able to handle it lately. Between work and daily stresses, it has sort of fallen into a tailspin. I spoke to my doctor who gave me Xanax. While this is an easy band aid quick fix, this is not a total solution. The solution is speaking to someone, whether it be Psychiatrist or Psychologist. For now, I saw a Nutritionist to change my diet in hopes of not only weight loss, but eating foods that may help with depression and help with physical ailments. They say some foods are not good for depression and anxiety, so we will see.

Through all of this I have been a tad hidden, a hermit. I have a small group of friends message me and some keeping tabs which is nice. I had one who once told me I was like a sister to him, and he really looked at me as a dear friend, so when he asked me how I was doing I spoke the truth. I told him I was struggling and I fully admit I was struggling to stay alive. Everything was pointing to me just not wanting to wake up. When I say it was bad, it was bad. I am still struggling by the way, but I am a bit more productive in seeking a solution and help. Call it Mercury Retrograde or whatever, but this was the worst it has been in a long time. Anyway, when he asked, I answered. I told him I was extremely depressed, that work was killing me and I had a panic attack driving there one day. I told him it was harder to find reasons to wake up and that I was afraid. We spoke briefly and that was that. A few days later he messaged me and told me how lonely he was, and that he was also feeling depressed. I listened and offered advice. He then said to me that when I talked to him the other day he was annoyed, and said the thought that ran through his head was, "Get the fuck over it." Now, reading those words pierced through me like a shot. I was dumbfounded. This person who considered me a sister wanted me to 'get over it.' I was so stunned I said that I was very hurt and was logging off and that was that. He went on to further explain, but I did not read it and we have not spoken since (3 weeks).

I couldn't believe the lack of caring to someone's mental health and a FRIEND. This was not, "Oh I am so depressed Nashville got canceled." This is, "I do not want to live anymore, please tell me you are there and all will be ok." I still can't believe after so long and all these years there is still this stigma to mental health. Most people think I am the A typical "depressed" Goth which is so funny because most Goth people I know are generally happy with a knowledge of darkness. I know dark, I live it daily. I am proud of myself for standing up for myself, but so seriously hurt because I never know now if we speak if he will truly care. I do not know what the future holds for our friendship. All I know is that mental health is real and scary and not to be made fun of or having eye rolls. Whatever happened to compassion? Love? Have we lost sight of all this? I can be cynical and hard around the edges, but recently I have found myself needing my friends. Most rose to the challenge, but I am sad for my friend who did not. I wonder if I was really severely depressed and did something, possibly suicide, how would he feel? Then I think of the countless people who probably heard the same line and DID do something, how those people felt.

I had someone else tell me the classic "some people have it worse." I shot back and quoted from something I read that said, "I know some people have third degree burns but my first degree burns do not hurt any less." He apologized. I get people do not know what to say. Sometimes we don't want them to say anything other than I love you, I am here for you. Mental health and illness is the real deal. Nothing to be ashamed of and nothing to feel bad about. There is help and people who care. I wanted to share my experience in case others read this and felt the same way. Please, if you are feeling suicidal, call someone. Get the help you need. You are worth it and loved and times change. I do not know what the future holds for me, but I am hanging on, maybe by a thread, but I am still here hanging on and I beg for you to hang on as well. Get the help you need and deserve. There are people who care and want to listen. Mental health is no joke and I wish more people would take this seriously. I wish I had better support from my friend, but at least now I know who NOT to go to… If you are feeling suicidal, please call 1-800-273-8255- National Suicide Hotline. It is confidential, and free. No judgment, just someone to talk to to get the help you so deserve. I am working on this every day, and I encourage you to do the same. You are loved. ∎

TECHNOLOGY
Guild Leaders

Guild Leaders

By Zannie Campbell

TECHNOLOGY
Guild Leaders

The term Guild Leader (GL) or Game/Guild Master (GM) refers to individuals that administer over a guild. If you play a Massively Multiplayer Online Game (MMOG or MMO), you know that guilds are the foundation of the world. You can quest and grind on your own, but only for so long. Sooner or later you will be seeking out like-minded individuals to share your adventure with, either through raids, dungeons, or quests. Guilds allow you to cooperate and compete with other players you will meet from all over the world. With this piecemeal system, there must be some kind of order, and Guild Leaders act to create that order as they lead their Guilds to success.

In most of the popular MMO's today there can be dozens or even hundreds of guilds. Each of these guilds can recruit hundreds or even thousands of players. With the expansive reach of the internet and Social Media, it becomes possible for all of these guilds to adventure, trade, raid, and quest throughout epic worlds.

Why are there so many guilds? It depends on what you want to do in each game. All guilds are unique, made up of different kinds of players and some of these players have several different characters that are in many different guilds that fit their many characters' personalities. Some guilds focus on being the middlemen between other guilds and trading products or services.

What is often less known is that not all Guild Leaders personally manage their guild. Most appoint officers and advisors to aid in managing the varying aspects of running a guild. If your guild is PvP (Player vs. Player) or PvE (Player vs. Enemy) that also plays an important role in who leads the guild. Not all Guild Leaders are great at the intense skill based combat of fighting other live players in PvP gameplay. They may be more oriented with PvE dealings where they are well versed in the many aspects of the world and computer controlled enemy characters. Depending on the Guild Leaders strengths, they'll appoint officers to handle the other roles they may not be able to fill as effectively.

The Guild Leader, Officers, and Raid Leaders are the visionaries, the motivators, and the people guild members will trust. They are the leaders people can entrust to raise moral when needed; and in raids it is very much needed. They need to be confident, positive and able to communicate effectively.

We had the chance to interview two Guild Leaders with years of experience at running Guilds in different games. We wanted to peer into the mind of someone with the discipline and ability to run a guild.

TECHNOLOGY
Guild Leaders

[Carpe Nocturne] Please introduce your character name, the game you play, your guild name and server if available.

[Typhus Dathromir] Hello, I play Typhus Dathromir in Elder Scrolls Online, Rookwood in World of Warcraft, and Nefaric in Star Wars: The Old Republic. Currently, I am inactive in WoW and SWTOR, and leading House Dathromir in ESO, which is a Daggerfall Covenant, Vampire/Werewolf Breton Noble House RP Guild on the American Mega Server. I have been playing MMO's for almost 12 years, and been leading guilds since the first 4 months of that tenure. I have a lot of experience, and have made more than my fair share of mistakes, but have lead some pretty successful guilds as well.

[Dr. Z] Hello, I'm known as Dr_Z in the game Elder Scrolls Online on the North American Server. I'm an Owner of 2 Guilds. The First guild is a Social Guild called the, "Disciples of Bloodlust". It's more of a private and discreet guild made up of close friends I have encountered playing this game. The Second guild I own is a successful trade guild called, "The Mercantile".

[CN] Is it possible for a guild to push its members away by becoming too focused on progression or is it likely the members will conform? If they don't conform is there a compromise?

[TD] It really depends on the type of guild you started out to be, and what you told your members. If you intended to be a hardcore progression guild from the very beginning, and were open and honest with your members about that, and recruited solely for the purpose, you should have no issues with people leaving over being too focused on progression

However, and this is a mistake I have made personally, if you start out as a more-casual guild, and then decide one day you want to reach for the sky, you can very well lose members to changing your attitude. It is not a good feeling to lose friends because you lost yourself in setting your sights on something that not everyone wants to shoot for.

[Dr. Z] If a guild has very high expectations, it can and will have the ability to push members away. This happens if the guild, as a whole, does not take the time to help individual members who are struggling with any questions they might have so they too can get focused on the guild's goals and expectations. I could go further into this issue where "elitism" can evolve in a guild which I will not be a part of.

[CN] How can guild members handle an unchecked and overbearing guild leader?

[TD] The best way to deal with a GM like that is to try and sit down with them and explain how you feel. If they are not willing to listen, then the only alternative is to speak your mind and leave. That is the only way, that I have

Some of the common mistakes made by new guild leaders.
- Believing they are always right.
- Not listening to their members.
- Thinking they can take their real life anger out on people in a video game, just because that person can't see them.

found at least, that a GM who is too wrapped up in their own ego will see reason. You leaving by yourself may not cause more than a ripple, but if others follow you, it will more-than-likely force the GM to see that what they are doing is wrong. If not, then they are a lost case, and nobody wants to be in a guild like that anyway.

[Dr.Z] With so many guilds in all of Tamriel to choose from and so many new ones being created weekly, guild members will always have an option to find a better, well suited guild for them. Members will not stick around to be treated with disrespect. Guild Masters who treat members in this fashion will either have to conform to change, or step down from leadership, or watch their guild fall to pieces.

[CN] How do you determine promotion in your guild? What makes a person worthy of promoting in large guilds when you do not know everyone?

[TD] In my guild, I ask that members sign up to our website, and put in an application before they can even join. Once that is done, they are well-informed that they must read/sign 6 important topics on our guild forums that explain to them just how we work, and what we expect of them. Once that has been done, they must make the guild leadership notice them by speaking in guild chat regularly, helping others, showing up to events, and just being a productive member. Once I feel that person has made me take notice of them, I will give them a promotion.

Personally, I have always stayed away from bigger guilds. I feel that if the GM doesn't know it's members, then that takes a big part of the fun out of the guild. I can't speak to how bigger guilds promote members.

[Dr. Z] For my trade guild, The Mercantile, its promotions for the first few ranks are solely based off of sales performance and/or contributions. Any trade guild owner likes to see sales performance from all its members. Progression to the higher ranks in my guild can be a combination of sales performance, contribution, and participation. Participation is key in my book. What I'm talking about is, if a member makes a good lasting impression on other members by helping others and participating in guild activities, that person will go far.

[CN] Have you ever lost a guild? Was it your fault, the game, or the members?

[TD] Oh, yes. I have lost a few guilds in my time. Sometimes it was my fault, sometimes it wasn't. I have lost guilds due to being young, and power crazy, and just plain stupid. I have lost guilds because of disagreements between friends. I have lost guilds due to standing up to people who deserved to be knocked down a peg, but they had a lot of friends and crippled the guild after they left. And I lost one guild, and several very good friends due to being too focused on progression raiding.

[Dr. Z] As a Guild Master, I haven't lost a guild

[CN] What are some of the common mistakes made by new guild leaders

[Dr. Z] You can almost write a full book on this question and yes, it is true that guild leaders can make mistakes. One type of mistake would be, not being active enough, in the game, as much as a guild would like them to be. Taking time off from the game without giving a heads up to its members, or just plain not being around, is detrimental to a guild. Guild leaders must have a show of presence in the guild in order for it to be successful. Another mistake is, belittling its members. I have heard and seen this happen from many guild leaders and those guilds don't stick around long. In the same sense, if a member from the guild belittles another member, it too is a mistake if the guild leader does nothing about it. Showing or flaunting favoritism by a guild leader is another type of mistake that plagues a lot of guilds. It may be okay to have a bit of favoritism as long as the guild leader keeps it discreet in such a way that it does not draw the attention to others. I can keep listing more mistakes but I'd rather take the time to make a quick short answer on how to minimize mistakes, and that is, have common sense and give "...respect to whom respect is due...". Romans 13:7

[CN] What would you tell a new player interested in starting a guild; join an already established guild and get experience or start their own immediately and learn as you go?

[TD] Both possibilities have their merits, but the best way I would suggest is to have them join an established guild, work their way up into becoming an officer, and watch how a real team works before venturing out and creating their own guild. And I would tell them to be prepared, because being a GM is a lot of work. When things go wrong, it is your fault. And when things go well, very rarely do you get the credit. Many times, it can be a thankless job. But if you manage to build a good guild, it is worth every minute of the bad times, just to step back, look at what you've built, and realize, "I did that."

TECHNOLOGY
Guild Leaders

[Dr. Z] Before I give any sound advice to a potential new guild leader, they have to somewhat convince me they are ready for the responsibility of owning a guild. Many times I have been approached by people asking me questions about starting up their own guilds, and depending upon what type of guild they are interested in, I have always become their "Devil's advocate". I first start off by asking them, "Why do you want to start up a guild." This is a very tough first question to answer and if they can get past this one, I have more questions to follow. See, I bombard them with questions that give them a reality check because owning a guild takes a lot of responsibility and personal time. During this process, I always reassure them I'm not trying to discourage them from doing it, but tell them that they need to know what they are getting themselves into and not lie to themselves about whether they are ready for it. If they can get past me being their "Devil's advocate", and I'm convinced, I will give them my full support and advice to point them in the right direction.

[CN] Is it possible to keep a guild small and be effective? (Depending on the game, under 50, 100 etc.)

[TD] Oh, yes. It's very possible. Smaller guilds tend to be more-fun guilds, in my opinion. The members get to know one another. They form bonds. And they tend to look forward to spending time with one another more than in a large guild.

[Dr. Z] This question can be answered in two different ways. Yes, if it is a social, crafting, PVP, or PVE type of guild made up of members having the same common interests and goals. And, no, if it is a trade guild which gets its effectiveness from being large. You see, small guilds have a tendency to turn into social "tight-knit" families and nothing is more effective than a close family. With that being said, I'm surprised I haven't seen a guild by the name, "The Brady Bunch".

[CN] How do you handle recruiting? Do you recruit personally? Are you open to all players or do you decide after a review process? (Which works best)

[TD] Recruiting is one of my favorite things to do in MMO's. I have different methods of recruitment, depending on the game. But I am generally pretty good at it in any of the games I play. And I find it works best if I do the recruitment myself, because then I get to know each of the members as they are coming in, and they know me, so they aren't afraid to come to me if they have questions or need help.

It depends on the game. But for instance, my RP guild. I am not open to anyone joining. We impose an age limit of 21 or older to join, because we want a certain maturity level, and we have an open language policy. We also don't allow anyone in who refuses to join the website, or has a non-appropriate character name.

[Dr.Z] Glad you asked this question. Recruiting is an ongoing process and if left unattended can sink a large trade guild, including mine. I do have recruiters in my guild. I usually tell them to not recruit full time as I would rather have them enjoy the game first and recruit second. As for me, yes, I do the bulk of the recruiting as it gives me a chance to answer any new member's questions. When it comes time to recruit, my guild is open to everyone but we only actively recruit from veteran zones. The reason for this is, over 90% of my members are vet level and they will benefit more from new members who are about the same rank as they are. Other than that, I give all my members the permissions to send invitations to their friends and family who would like to join us. ∎

A Writer and Technology

The way people write has changed drastically over the course of history.

Millions of years ago, before the written word, people drew pictures on cave walls to communicate and tell their stories. Other cultures simply used word of mouth. Then came stone tablets, leaves, leather, papyrus, and very expensive paper. Along this path we found great works written in books made of cloth pages and scrolls made of skin. I'm sure I've missed something in between, but bear with me.

Skip ahead and mass manufacturing makes paper easily accessible to all. Just about anyone can afford it. A bird feather with some ink and a writer was in business.

Then skip ahead a little further and someone invents the typewriter and then the computer. The the face of writing changes again. Now we have laptops, electronic tablets, and phones. A whole world of information at our fingertips along with a quick way to write down our every thought i.e. twitter and Facebook. Not sure if those are the best for us as humans but I digress.

I realize I'm over simplifying things when it comes to the history of writing. I could cover this topic for days and still not be finished because it's ever-changing. I'm thinking about this topic because I write blogs on my iPhone, and I marvel at the fact that I can write pages and pages on a tiny device simply using my thumb on a tiny key pad. I could even talk into my phone and it will write down my thoughts for me. I never thought there would be a day where it would be too inconvenient to open my laptop or simply write my thoughts on a piece of paper. Today is that day.

Technology is a wonder! I have met very few that would not or could not transfer their thoughts to digital mediums. In this day and age it's the only way to get published. You must have or have access to the writing vehicle of your time or you won't be able to send your thoughts and stories to others. We have so many mediums to choose from it can be daunting, but once you find your favorite device of choice it can be so convenient. Maybe a little too convenient.

Now if you'll excuse me I'm tired of technology, I have a cave painting to finish.

A Writer and Technology